LOVE

xxxxxx

DUKE ELLINGTON

AN AMERICAN COMPOSER AND ICON

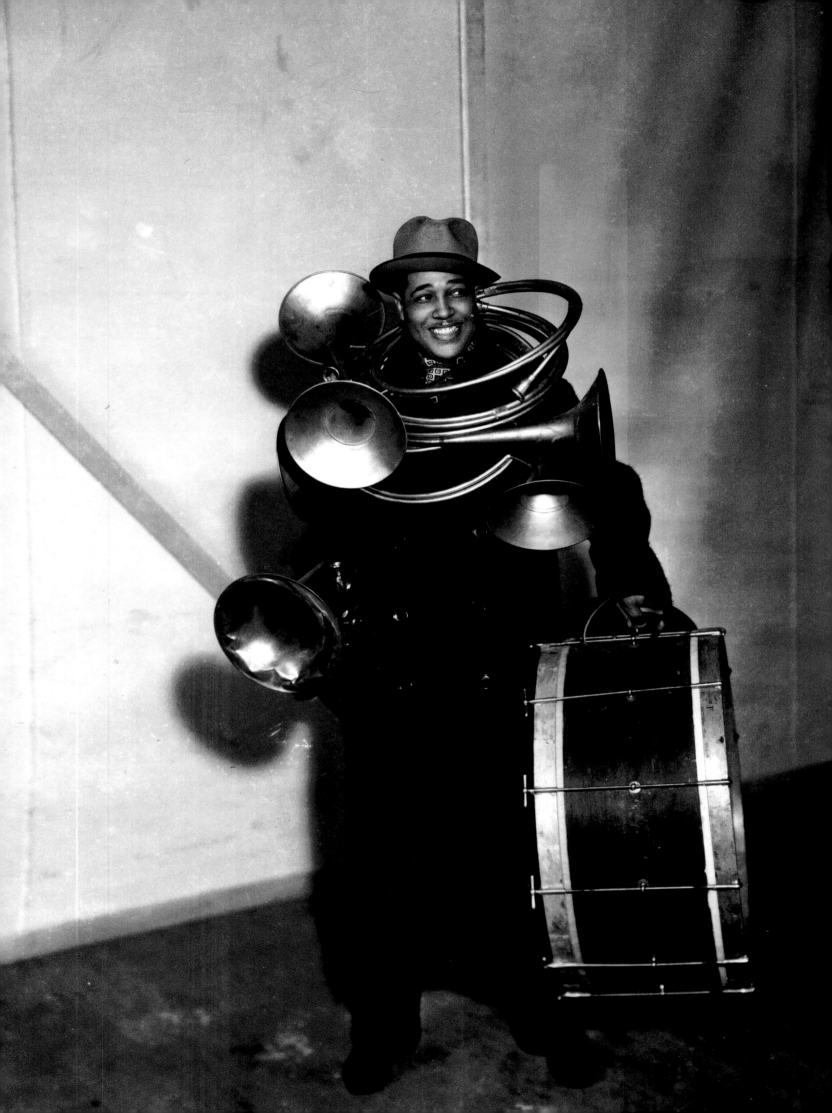

DUKE ELLINGTON

AN AMERICAN COMPOSER AND ICON

Mercedes Ellington & Steven Brower *Introduction by Tony Bennett*

RIZZOLI
NEW YORK

New York · Paris · London · Milan

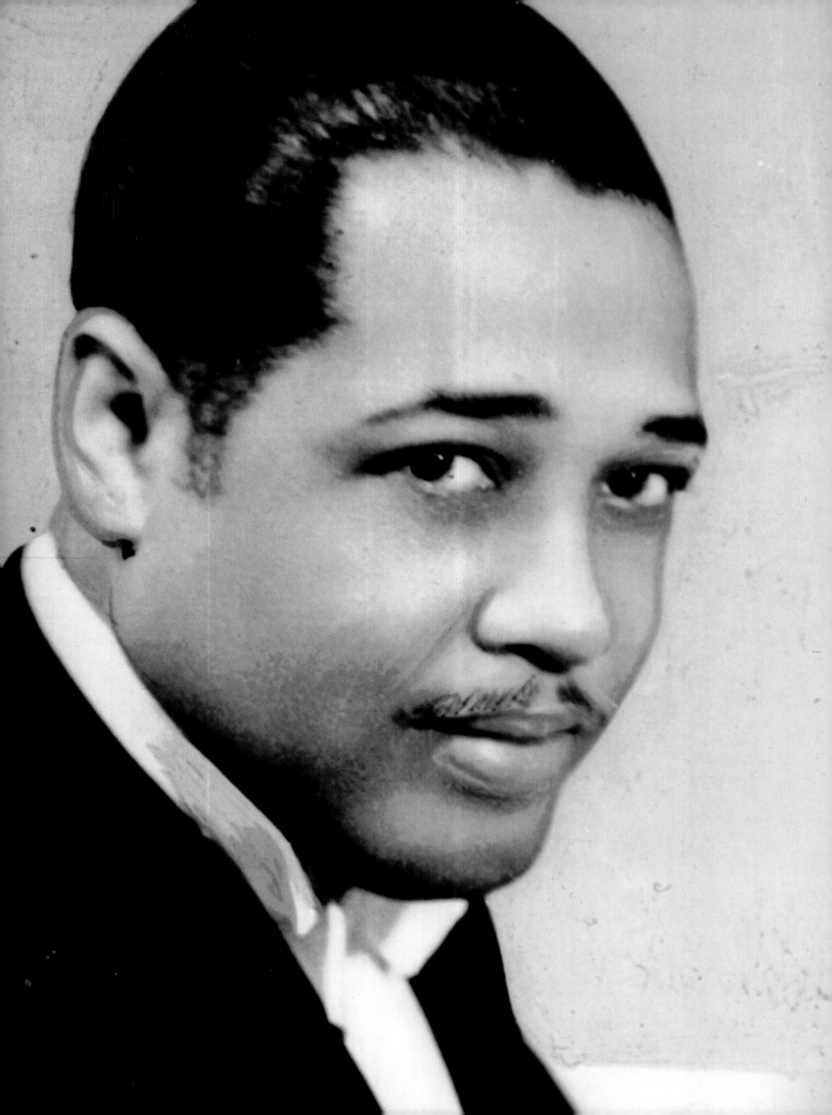

AMERICA'S FOREMOST CLASSICAL COMPOSER

Duke Ellington was and will remain America's foremost classical composer. The breadth and depth of his work is comparable to the work of Beethoven, Bach, or Mozart, and five hundred years from now, his music will be revered just as much as it is now.

His influential career spanned five decades and was comprised of world tours, an inexhaustible songbook, film scores, as well as written essays and poetry. Due to his inventive use of the orchestra, and his refined public manner and extraordinary charisma, he is generally considered to have elevated the perception of jazz to an artistic level on par with that of classical music.

I was fortunate to be able to call Duke a friend as well as a colleague. His family and my own became very close since we both lived in Queens, New York, and my mother loved to have him over for dinner. I owe so much to Duke, first and foremost because I am an avid fan and admirer of his work. Once I got to know him, his philosophy as a human being had great impact on me. He was one of the most generous and loving people I have ever known. I remember once in New York City, back in the Sixties, I was going through a rough time during the holidays. It was Christmas Eve and I was in a hotel, separated from my family, and Duke had heard I was a bit blue. From the hallway of the hotel, I heard music being sung, and it stopped right in front of my door. I opened the door to my room, and there was a choir singing "On a Clear Day (You Can

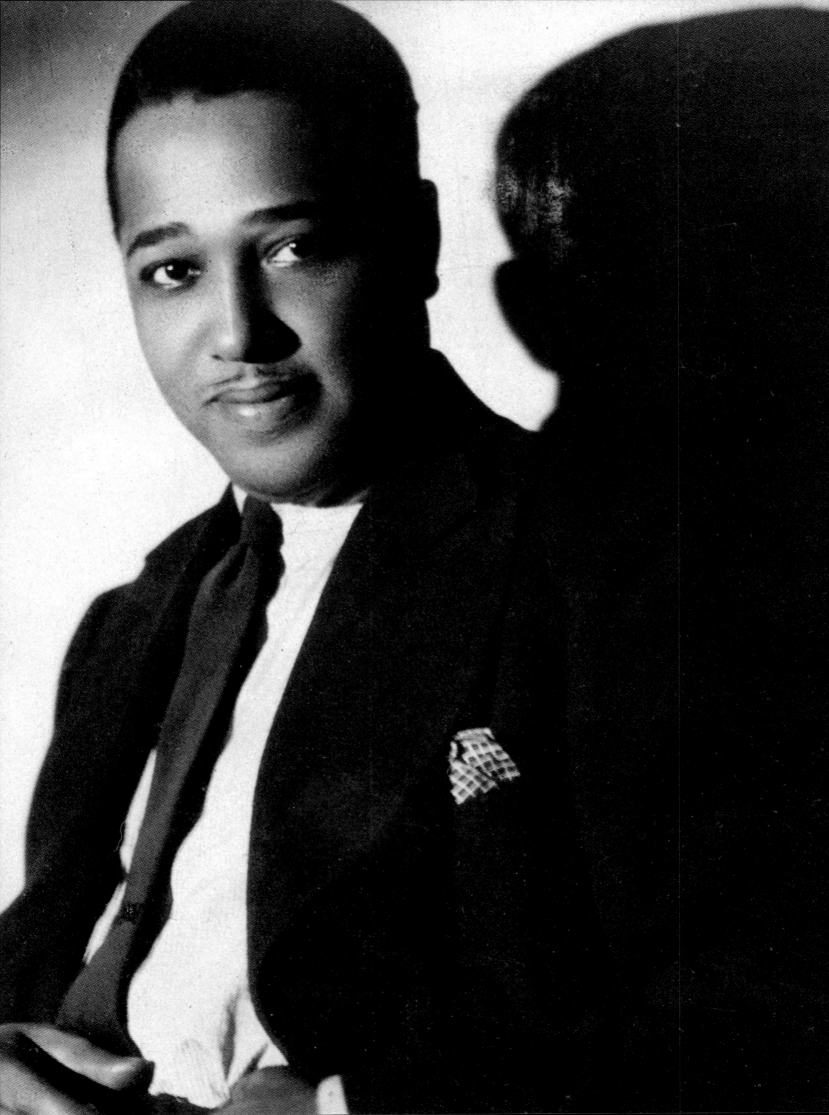

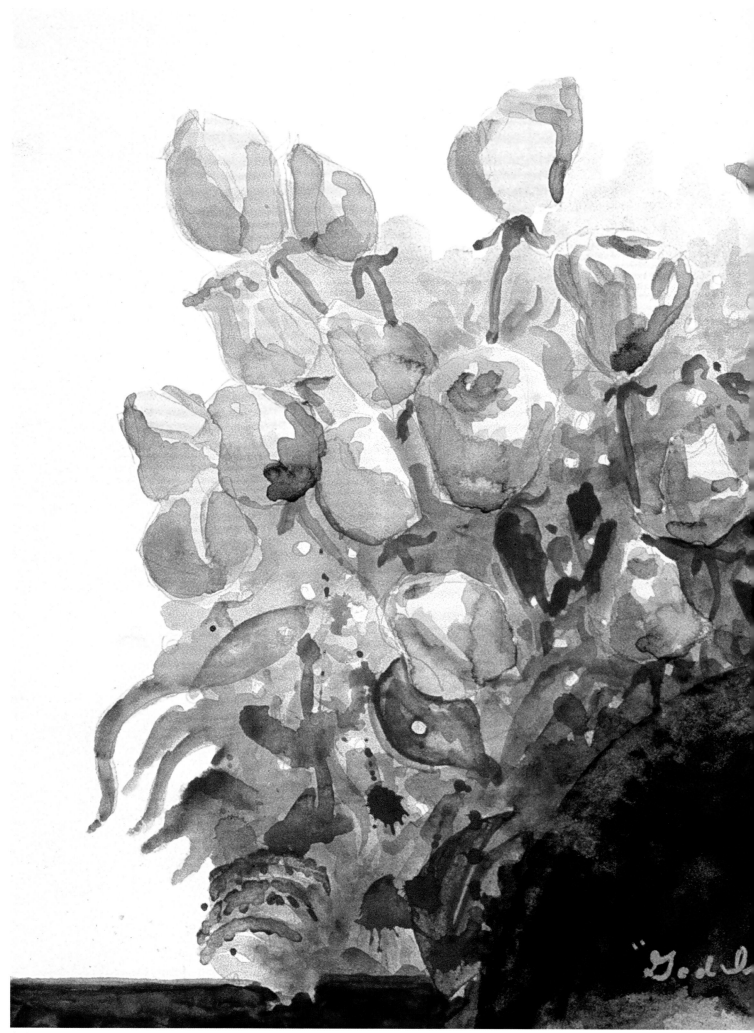

God Is Love, 14" x 20" watercolor by Anthony Benedetto, aka Tony Bennett © 1996 Benedetto/Bennett

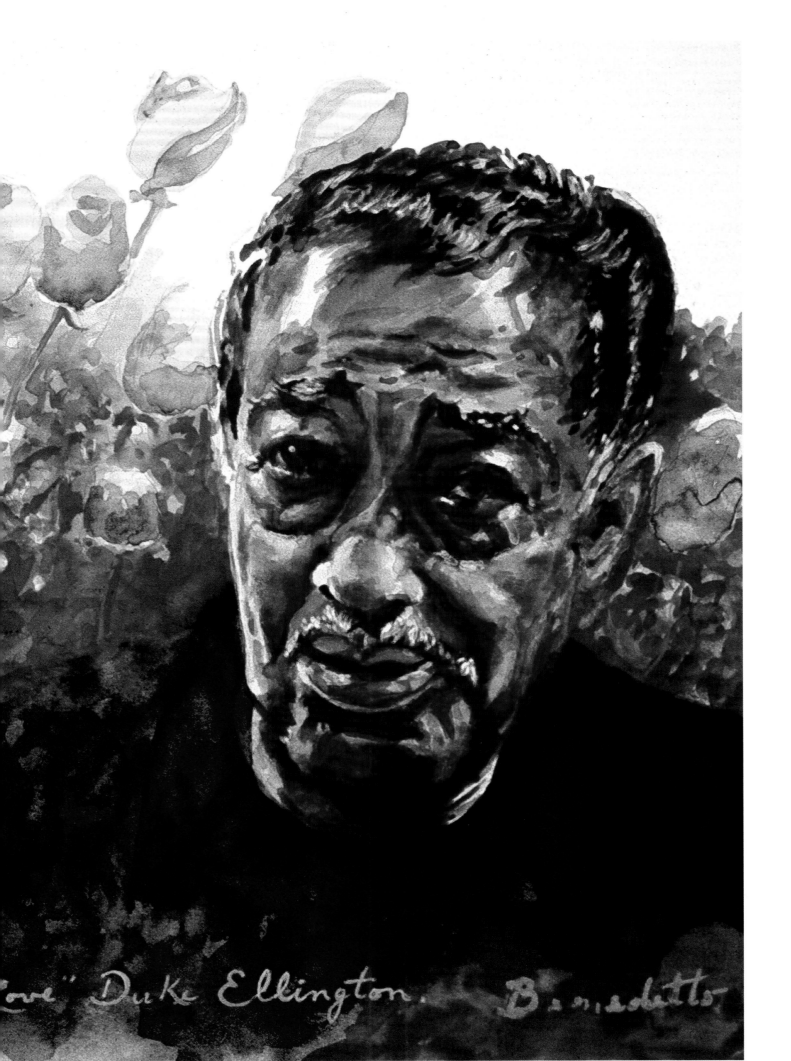

"Love" Duke Ellington Benedetto

See Forever)." Duke was doing his annual Sacred Concert at Saint John the Divine and had sent over the choir to cheer me up! That was just the kind of thing he would do all the time for his friends. He also encouraged me to take my painting seriously. He would see me sketching and said it was better to work in two art forms than just one. So, although I have been painting all my life, Duke inspired me to make a second career out of it. When I painted Duke's portrait, I called it *God Is Love* because Duke felt that all spirituality comes from love. I added pink roses in the background to mark Duke's habit of sending me a dozen roses every time he finished a new song. It was one of the greatest honors of my life to have my portrait of Duke hung in the National Portrait Gallery in Washington, D.C., and part of the permanent collection of the Smithsonian Institution.

Like Leonardo da Vinci, Albert Einstein, and Winston Churchill, there are certain individuals who come into this world and have a significant impact that carries on long after they are gone. Duke Ellington was one of those rare people, and both he and his music will live forever.

—*TONY BENNETT*

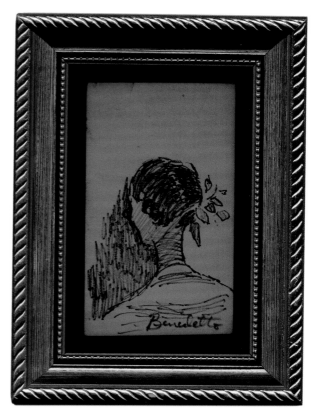

ABOVE: Portrait of Mercedes Ellington by Anthony Benedetto, aka Tony Bennett © 1996 Benedetto/Bennett. BELOW: Tony Bennett with Mercedes Ellington's mother, Ruth Batts, and Mary Murphy. NEXT SPREAD: Tony Bennett performs with the Ellington Orchestra.

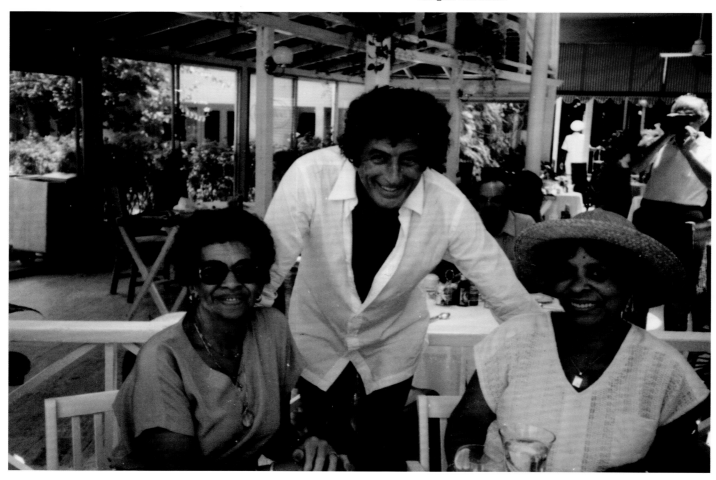

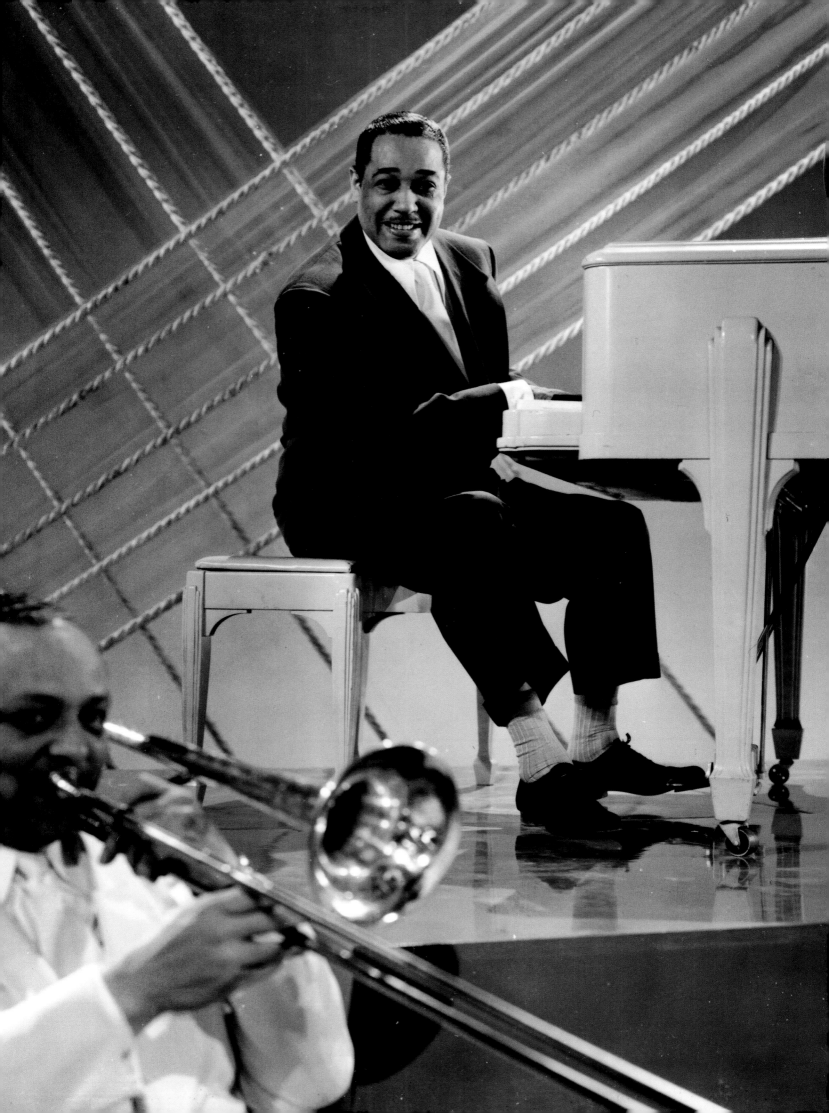

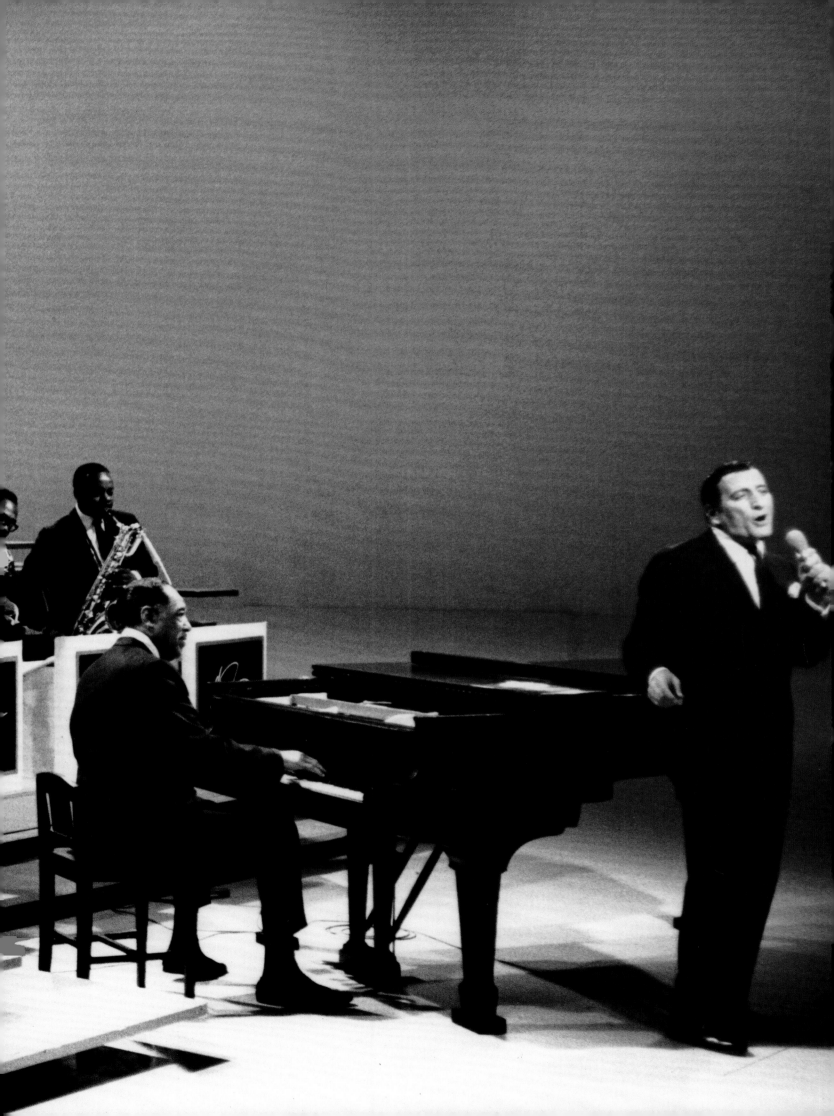

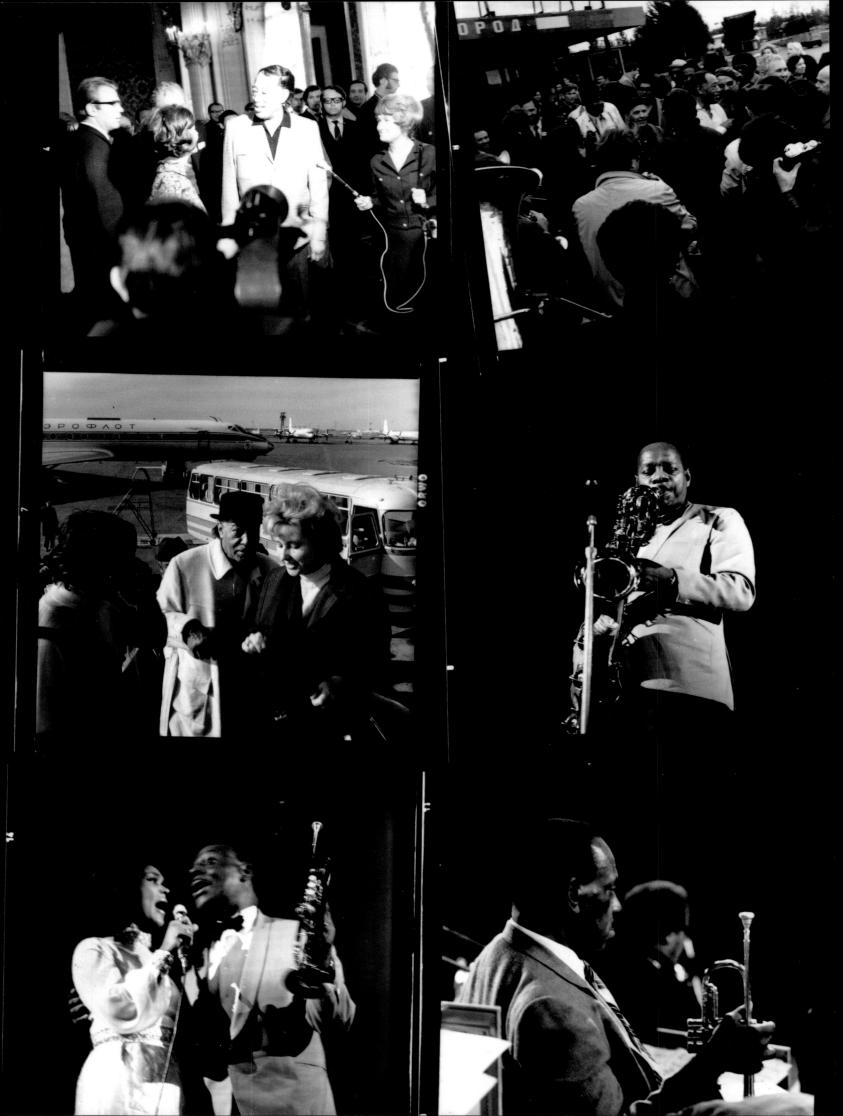

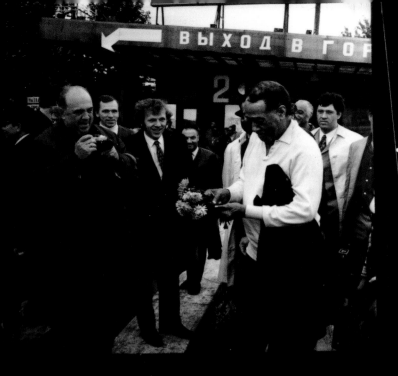

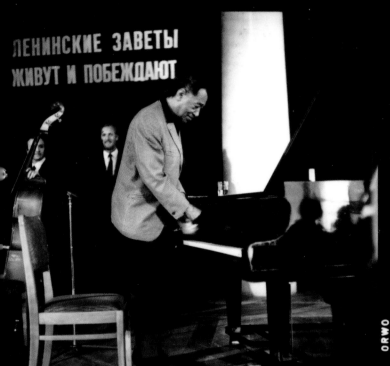

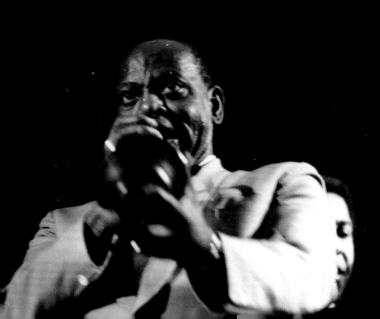

These images are all taken from a tour of Russia on which Ellington was invited in 1971. Some images show Ellington greeted at the airport and hosted at press conferences at a "House of Friendship" by Russian ambassadorial staff. Cootie Williams is shown playing trumpet.

MY GRANDFATHER
UNCLE EDWARD

There have been many books on Duke Ellington. Many have been fact filled—good on dates and compositions and accuracy of times and places—but there has been very little written about the man as I knew him. There was an attempt by my father, Mercer Ellington, who wrote *Duke Ellington in Person: An Intimate Memoir* with Stanley Dance, but it is a very slight volume. And, of course, there is Duke's own book *Music Is My Mistress*, which has become the canon, but it also has very little personal impact. Duke Ellington comes off as a very impersonal guy, when he wasn't. It is my hope that I can help finally correct that image and paint a broader portrait of the real man.

One of the things that separated Duke from the majority of people is that his priorities were different. Morning, noon, and night, music was his world. In those days, anyone who wanted to get ahead in the world of music, either by necessity or by desire, had to express himself in great volume, as did Duke, who wrote constantly. I visited him in the hospital on his deathbed, and there was an upright piano at the foot! The best thing I could think to bring him as a present—rather than a plant or something—was music paper, to encourage him. Music is what took him through good times and bad.

Duke Ellington was a man after all. He had his own foibles; he had his own taste in clothing, in food, in women, in music. This is the way he lived his life. He's an American icon. His music made a difference in the American music world. What America is, the huge land of the free, is what he hooked into; he hooked into writing music about freedom and its people and space.

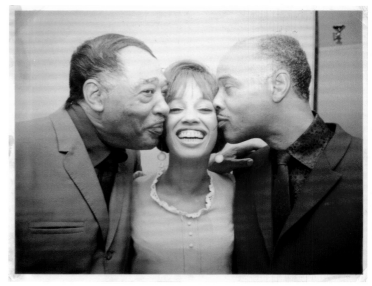

ABOVE: Mercedes with Duke and her grandfather, in Florida on tour with Jackie Gleason. BELOW: Duke at the piano in Florida.

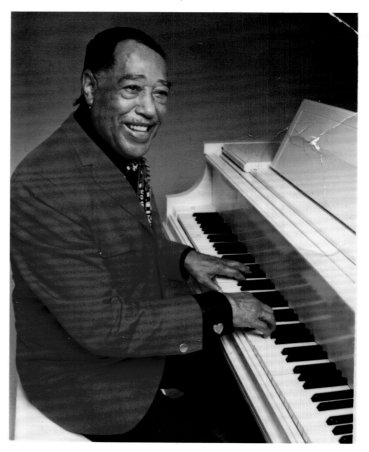

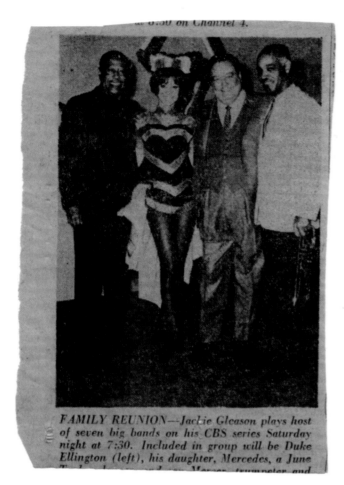

FAMILY REUNION—Jackie Gleason plays host of seven big bands on his CBS series Saturday night at 7:30. Included in group will be Duke Ellington (left), his daughter, Mercedes, a June...

Mercedes Ellington in costume for a show with Duke Ellington, Jackie Gleason, and Mercedes's grandfather.

I didn't have what you would call a normal family background. It is still difficult for me to work out what happened with my parents (Mercer, Duke's only son, and Ruth, whom Mercer never married) and why my maternal grandparents raised me (I called them "Pop" and "Momsey"). I was born in New York and had a very strict and disciplined upbringing. My grandmother was from the West Indies, and she was an orphan who had missed all those homey things. She had tried to provide them for my mother then tried to provide them for me. There were lots of obstacles; we weren't living in the lap of luxury. A lot of people think, "Oh well, she's Duke Ellington's granddaughter, she must have had a fabulous life, never wanting anything." Well, it was quite the opposite. We wanted everything. I had very little contact with my father's side of the family and he and the Duke were always on the road, touring together. There were times when I had to go downtown with my grandmother to collect my child support payments after a settlement had been reached. She made it a big adventure. She took me to Chinatown, where there was a big jail called

"the Tombs," and there was a song she would sing about the people there, "I Wish I Had Someone to Love Me (The Prisoner's Song)":

I wish I had someone to love me,

Someone to call me his own,

Someone to sleep with me nightly,

I weary of sleeping alone.

Meet me tonight in the moonlight,

Meet me tonight all alone,

I have a sad story to tell you

I'm telling it under the moon.

Tonight is our last night together,

Nearest and dearest must part,

The love that has bound us together

Is shredded and torn apart.

I wish I had ships on the ocean

Lined with silver and gold

Follow the ship that he sails in

A lad of nineteen years old.

I wish I had wings of a swallow,

Fly out over the sea

Fly to the arms of my true love

And bring him home safely to me.

She would also take me to the Board of Education to visit some of her friends, who would give me pencils and pads of paper, which would enthrall me for hours.

I was a kid when I first met Duke Ellington in person. Sometimes, my grandmother would take me to the Apollo when the Ellington band hit New York. They played three major venues: the Apollo, the Rainbow Room, and the jazz clubs on 52nd Street, like Basin Street West and Birdland. Whenever they played, she would make sure to take me

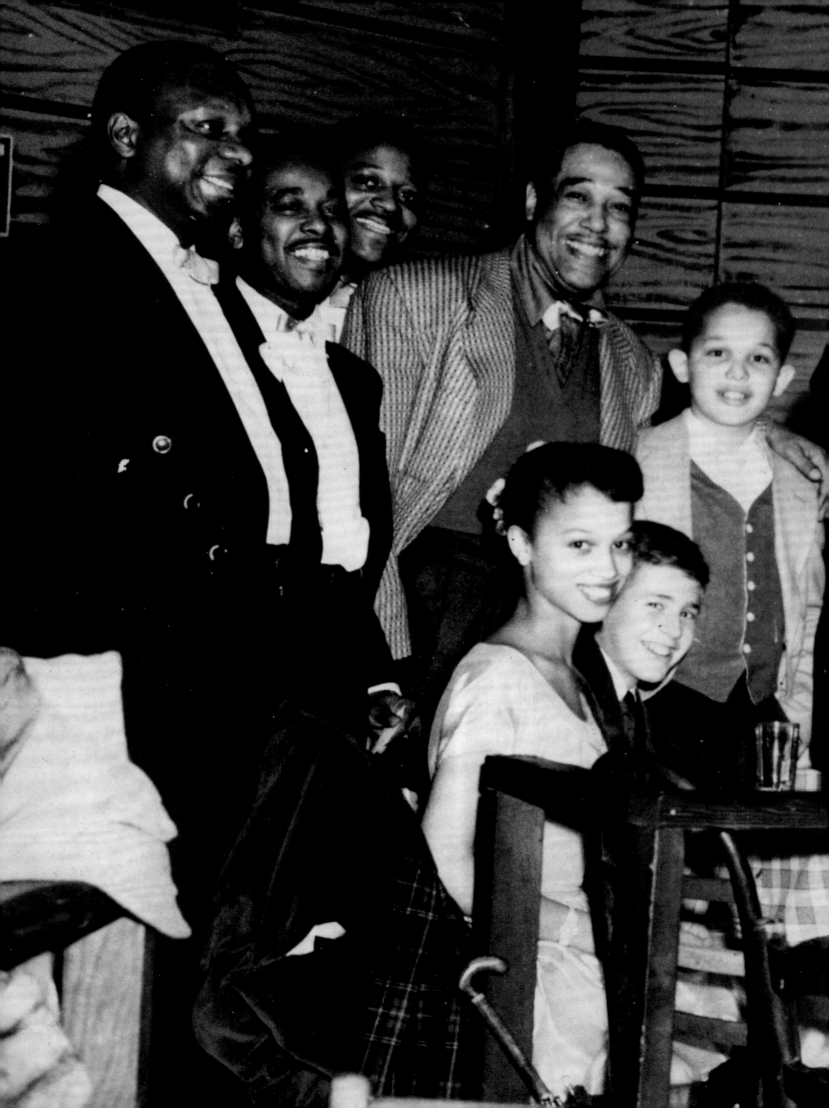

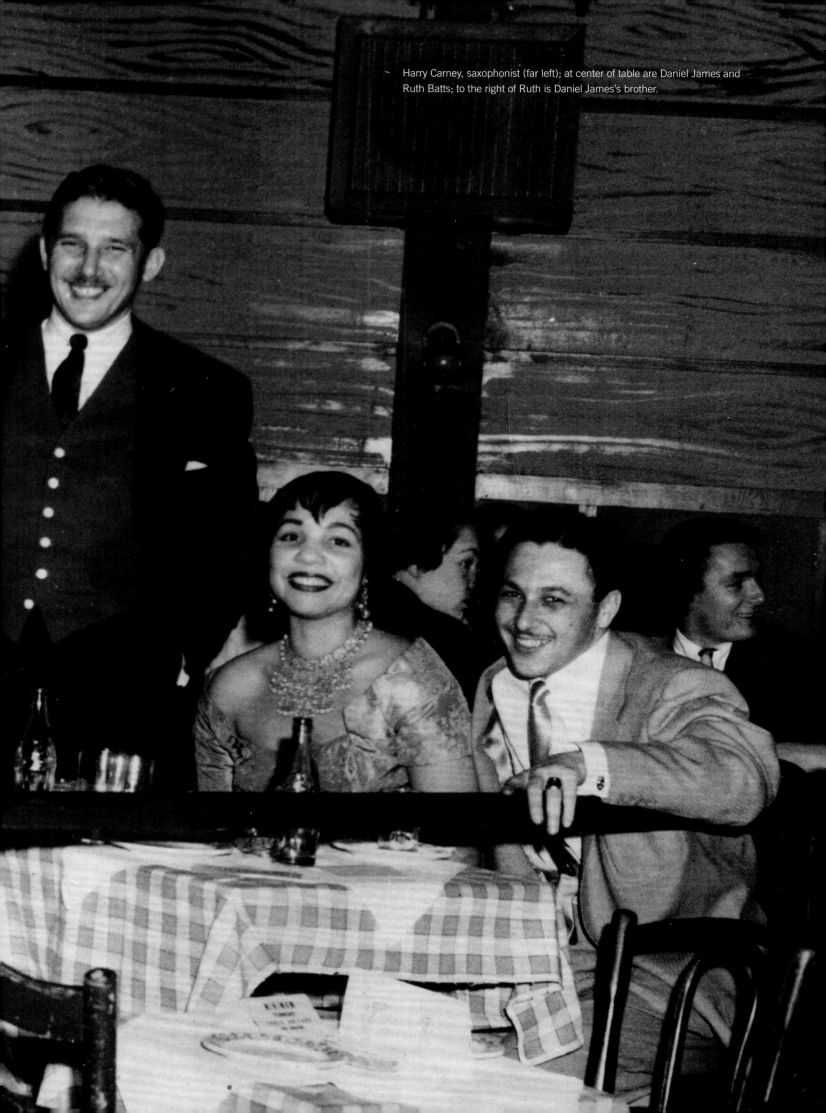

Harry Carney, saxophonist (far left); at center of table are Daniel James and Ruth Batts; to the right of Ruth is Daniel James's brother.

to see them, so that I would become acquainted with that side of the family and they would become acquainted with me. I remember her taking me to the Apollo, checking in backstage, then putting me in a seat (I guess it was a house seat). I sat there and watched the show. They played a movie and I was in heaven. I sat there until, after the last set, someone from the band or close to the band would come get me. We would go backstage, then on to Frank's Steak House on 125th Street, near the Apollo, to have dinner. Someone would eventually take me back to my grandmother's, about ten blocks uptown to "Sugar Hill" on Convent Avenue. I was seven or eight.

In the topsy-turvy world of a touring musician's life, my family would often find themselves celebrating Christmas in July—whenever the great man (the Duke) turned up in New York, that was Christmas. In our business, the holiday season is when people want entertainment, so the band, or "family" as I came to know them, would be away—they traveled practically fifty-two weeks of the year. So when the family (consisting of my father, grandfather, their band and all their families) did get together, it was a very warm meeting because it was so rare. Duke would always come with presents—once it was a typewriter, another time it was a set of LPs of the *Nutcracker Suite*. At one point, I wanted to know what to call him—he wasn't the grandfatherly type and certainly didn't look like one to me, either—so I talked to my father, and he said I should just ask him. Other people would call him "Maestro" and things like that. I asked him and he said, "Call me Uncle Edward." He did not want to acknowledge his age. If my father wanted to get his father mad, he'd call him "Pop."

Actually, I didn't even know what to call my father because I never really had a mother and father. I was born out of wedlock to a Catholic family in New York and sent to live with my grandmother. My mother moved to Philadelphia with a federal judge she had married. There are varying versions of the story, one of which being that Duke discouraged my father from marrying my mother because he was too young to settle down and they were busy touring. Another is that she was encouraged to abort me, but their Catholic faith stopped them. I am still trying to find the answers. It just felt normal to me. Musicians' lives are fragile; they are not the best at keeping their families together.

As a child, I got used to meeting famous artists—they were just people to me. I didn't think it unusual that the great

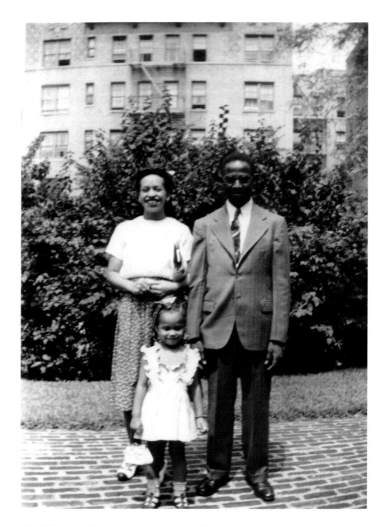

Ella Fitzgerald would occasionally babysit me in a hotel room. The fact that she was a phenomenal singer didn't come into it. She was a great person when she befriended me, and our relationship was very important to me because I didn't have many. She loved kids and wrote me letters, but I was very bad about keeping in touch. I remember spending whole days backstage at the Apollo Theater and meeting Pearl Bailey and Louie Bellson.

I went to Catholic schools, which are very disciplined worlds. My draw to the music world was dance, which is also very, very disciplined. After high school, I broke out. I went to Julliard, which was a very strange place to me, filled with music in the halls, people dancing down in front of the building. It was heaven. This was in the old building on 122nd Street. It was just amazing to me that such a place could exist.

There was a big argument after high school because I wanted to go straight to work, into auditioning for different companies, since a dancer's life is so short. But my father and grandfather were hell-bent on my getting a college education. The compromise was Julliard. It was a five-year

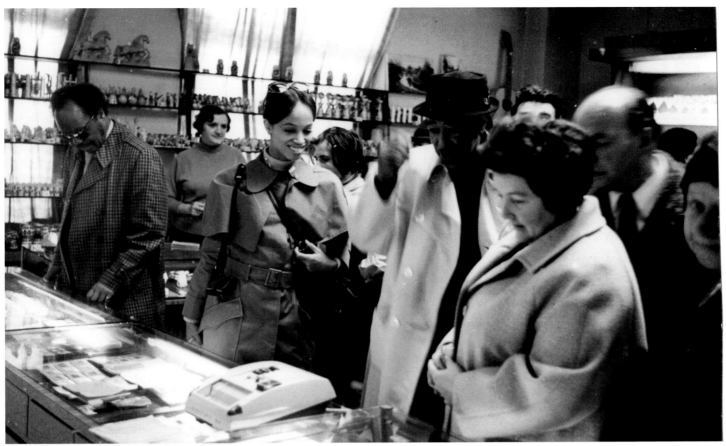

LEFT: Mercedes as a child with Ruth Batts (mother) and Dr. James A. Batts (stepfather). ABOVE: At a "commissary store" in Russia.
BELOW: With Mercer at Ruth's apartment on Riverside Drive.

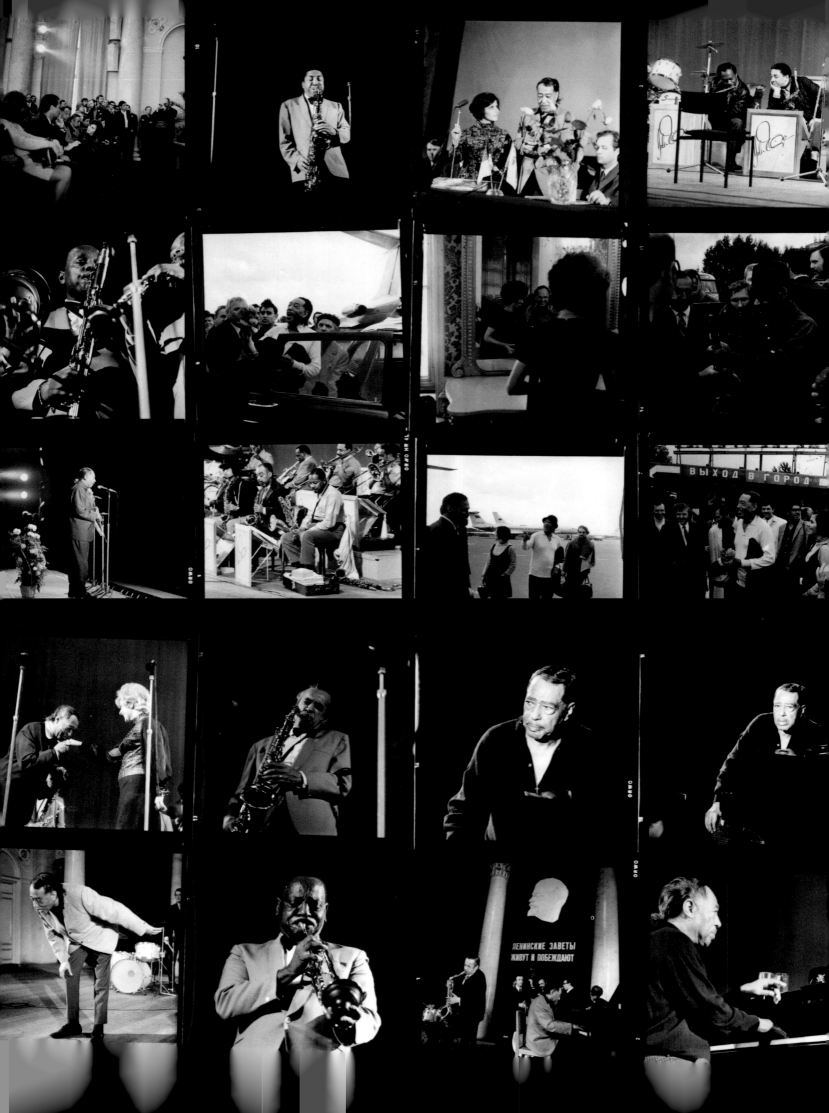

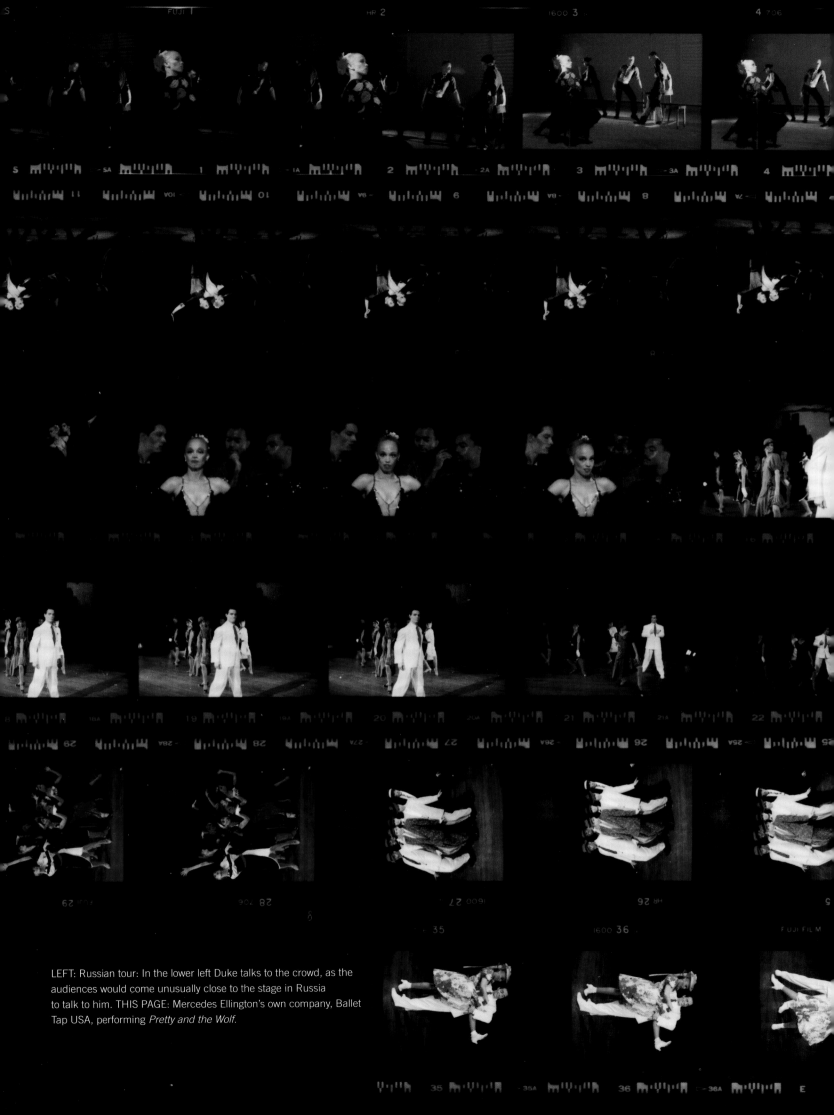

LEFT: Russian tour: In the lower left Duke talks to the crowd, as the audiences would come unusually close to the stage in Russia to talk to him. THIS PAGE: Mercedes Ellington's own company, Ballet Tap USA, performing *Pretty and the Wolf*.

course at the time, and I was going to be that much older in five years and too old to get into a ballet company, or any dance company, for that matter. Their idea was for me to have a much more stable base, to teach. But I wanted to perform; I wanted to be involved with choreography. The first jobs I had when I graduated were teaching jobs. At that time, public schools had daytime and after-school programs, so I taught dance for a while, and I did some workshops.

My first major dance job after Julliard was *West Side Story*. I auditioned with Jerome Robbins to do the movie version, but I was not able to get into that. He said that I was too young; yet, I had lots of friends who were in the movie, friends I had taken jazz classes with. Then it came time for the touring company. Somebody called and asked if I would be interested in going to Australia with *West Side Story*, and I jumped at the chance. That was one of my first bona fide jobs after Julliard: seven months in Australia, four months in Melbourne, and three months in Sydney. After that, I did three or four revivals at City Center. I did *Wonderful Town*, *Guys and Dolls*, and *Pal Joey* with Bob Fosse, which is how I came to know him and Gwen Verdon. Ralph Beaumont was reconstructing the choreography for other shows. I was doing a lot of summer companies and tent shows of *West Side Story*. You have to understand that at that time, for people of color, there weren't many venues; they were not hiring people of color on Broadway unless it was for something color specific. If it was a show about Africa, then you could audition. Me, I'm peculiar because I don't look "African." I did *West Side Story* for many, many years, all over: in Puerto Rico and Canada, and various and sundry summer camps.

I auditioned for *The Jackie Gleason Show* and it was a zoo. Everybody in the city and its environs came because it was a fabulous opportunity for a dancer—you were guaranteed thirty-two weeks a year of paid work for the season. It aired weekly, which also meant that you were guaranteed residuals when they played reruns during the summer. I auditioned a couple of times, but didn't get it. I worked for June Taylor out at Jones Beach, who choreographed *The Jackie Gleason Show*, and someone suggested I audition. I said, "Well, my tap is kind of weak," so I started taking tap classes.

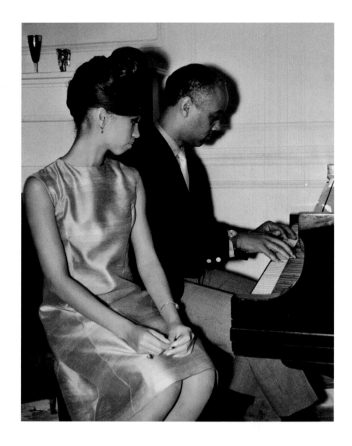

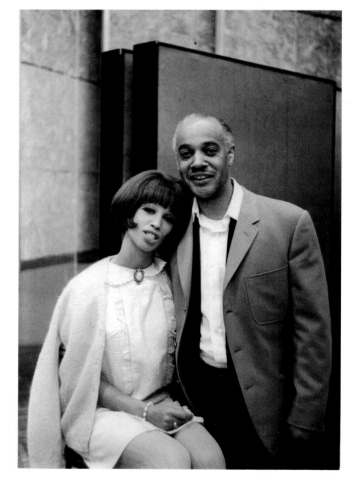

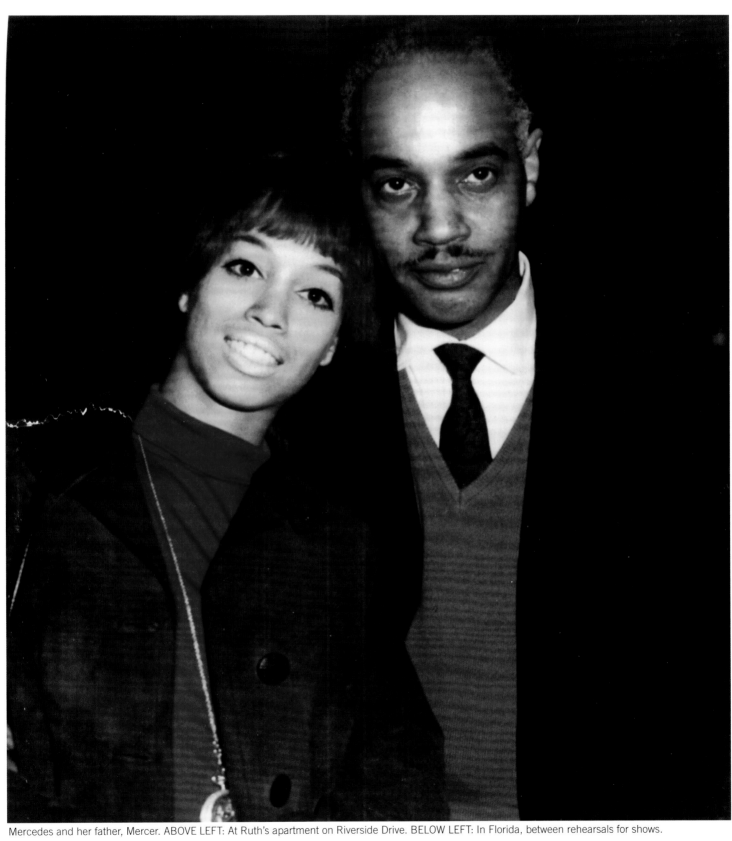

Mercedes and her father, Mercer. ABOVE LEFT: At Ruth's apartment on Riverside Drive. BELOW LEFT: In Florida, between rehearsals for shows.

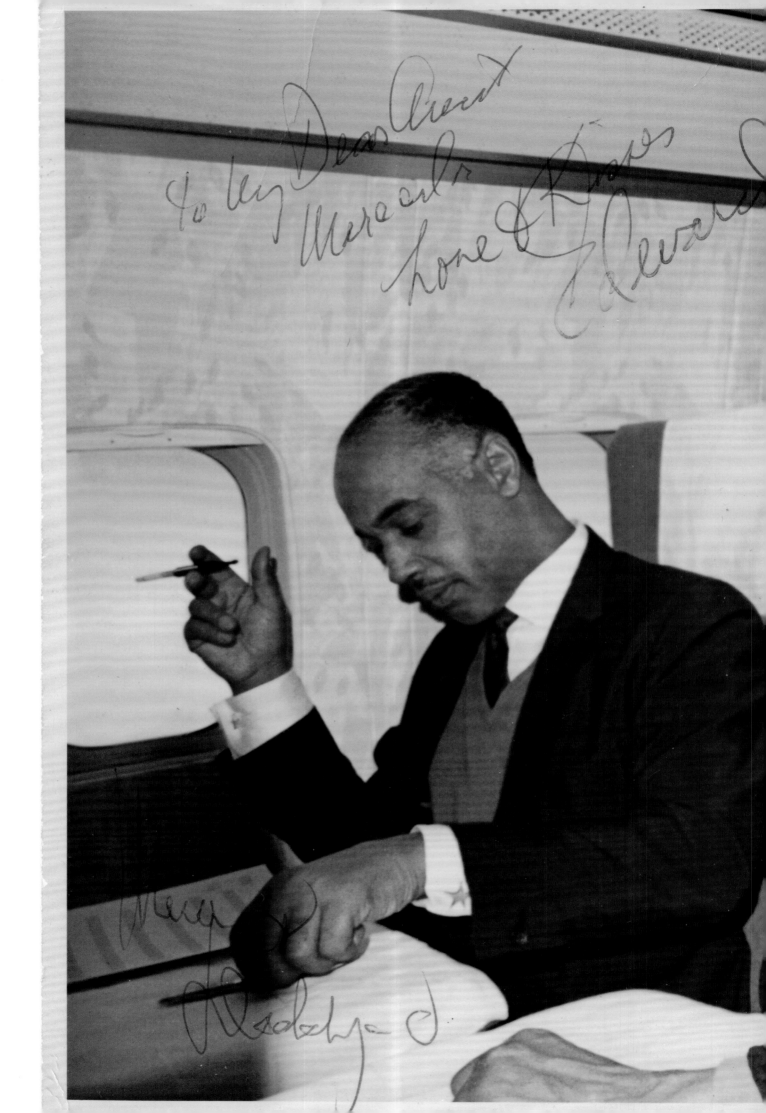

I auditioned for *No Strings* when Diahann Carroll and Richard Kiley were slated to go to Broadway. Typically, when we would go to an audition, as dancers of color, we would end up in a group in a corner, and were told to wait and see if they were going to be hiring any people of color. Not that that was kosher—it certainly was against all the rules regarding segregation—but it happened nonetheless. We were used to it. We would go anyway and use it as an excuse to catch up on the news, on gossip.

One morning, a friend called and asked, "Aren't you going to the callback for the June Taylor Dancers for *The Jackie Gleason Show*?" I said, "No, I go every year and it's the same story, I never make it." June had a studio on Broadway and 56th Street that I went to for jazz classes, so she knew me from that, too (not that she taught; she had teachers teaching). My friend said this year might be different since Sol Lerner, June's husband, had asked about me specifically. I agreed, even though I had missed the first audition and didn't know the combination. My friend said to meet her on the roof where she lived and she'd teach it to me. It was summer, August, so you can imagine how hot it was on that tar roof. We were there for a few hours, then I went to the audition.

It was at the Sheraton Hotel on 55th and 56th, where Gleason rehearsed his show when he was filming out of New York. The audition was also on the roof and it was long and grueling, involving various types of dance, ballet, modern, jazz, and tap. Suddenly, they began lining us up by height. They wanted to see how we looked next to each other: tall people in the middle, shorter ones on the ends. They instructed us to hold these positions until Mr. Gleason could approve their choices before making a final decision. Gleason charged into the room with a horde of photographers and people from the newspapers, who then made a few more adjustments as to where we were standing in the line, then they excused one or two people, and I was shocked to find that I was still in the room. I thought I'd have been long gone by then. Then June said simply, "Welcome, you are the new June Taylor Dancers."

Soon after I began on *Gleason*, he hosted a big band show. Count Basie came, along with the Dorsey Brothers and the Ellington band. My grandfather and I were on the same show together even though I didn't dance with the band.

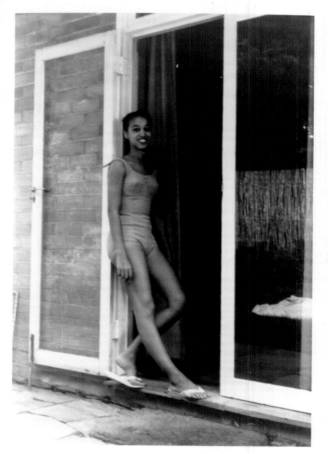

TOP: Mercedes's maternal grandmother Louise Silas. ABOVE: Mercedes at home.

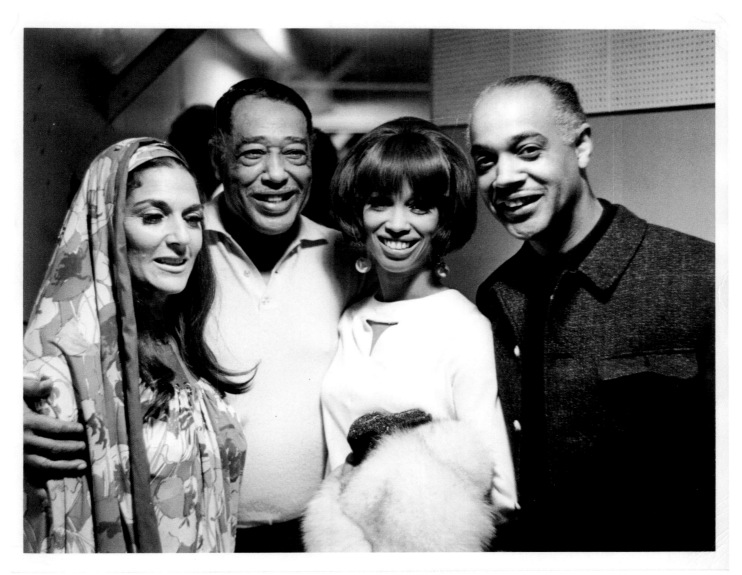

ABOVE: Duke with Mercedes, Mercer, and a fan.

Duke may have been a musical genius, but that didn't mean I always took his advice. "Go to Europe," he would tell me every day. He believed an African American dancer could only make it across the Atlantic, where there was less discrimination. But I wanted to make my mark in my country so I never listened to him. Some of my friends went and did have success, but I'll always be happy I stayed—if only to carry on my grandfather's legacy.

While I was on Broadway in *No, No, Nanette*, starring Ruby Keeler, Duke came with my great aunt to watch one of my first performances. They were late. I spied them coming in when we were performing "Tea for Two." It was so embarrassing—everyone stood up because of who he was. It was a sold-out show so they had to get extra seats—and the only reason they were able to get them was his huge celebrity. They didn't want to turn him away. I didn't know whether to be proud or to die on the stage.

My grandfather was not exactly the grandfatherly type. He was always on the road, not at home with a pipe and slippers. He carried a bible and thesaurus everywhere he went. He loved unusual words. Almost as much as he loved his women.

Around this time I traveled with my grandfather and his orchestra to Moscow, taking a two-week leave of absence from *No, No, Nanette*. It was a State Department tour. I just had to go because it was the home of the ballet, so I said to my grandfather, "I'm coming," and I made my own arrangements and got my own visa. When we arrived, there were fans running along the tarmac beside the plane with bouquets of flowers and police trying to hold them back. They had been listening to the music of Duke Ellington through Radio Free America. In those days, the Russian authorities were still playing that game with the wattage [censoring American radio], trying to block the music, and yet people

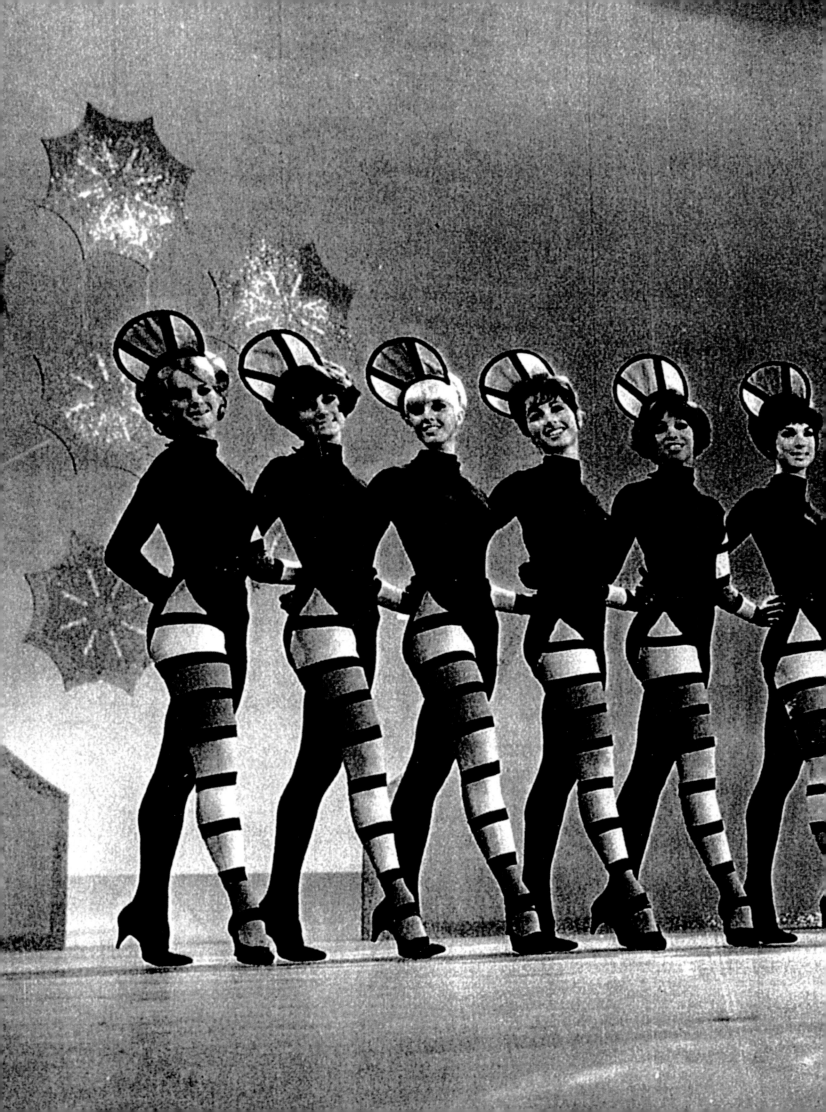

still knew all about Duke Ellington. There were plenty of Russian people who knew about the music and had secret recordings of the Ellington band. Duke received a great reception everywhere we went. He lived to work. When he traveled and toured, that's when he was in heaven.

Duke worked hard and it didn't matter where he performed, whether it was in school auditoriums or in big concert halls. He was a performer until the end.

He did not want to be designated as a jazz musician. People were always trying to nail him down into one mode or the other and he refused to be pinned down. He always said he composed "American music" because that opened up the scope of things. This just proves that the commonality among people is one of the things that Ellington wanted to accentuate. He was always on the path of acknowledging what was really happening in the world. Duke Ellington tore down racial barriers, playing to both African American and white audiences, a rarity during those racially divided times. The ideal of people being drawn together through music was his goal. He was constantly writing, every day.

As June Taylor Dancers, for our summer gigs, we sometimes played the house dancers for the Sahara Tahoe in Lake Tahoe, and one summer the Ellington band was playing across the street at Harrah's. Since they were so close, I used to go over to listen to their last set. We'd hang out—my grandfather, father, and I—and have Chinese food inside the casino. Because there are no windows in casinos, we'd lose track of time and, by the time we'd leave, the sun would be coming up.

After they finished their gig and I finished mine, I would get on the bus with them to Sacramento, to head all the way down to the Hollywood Bowl in Los Angeles. It was interesting; I had to sit in one of the "reject" seats, because each orchestra member had his own seat on the bus, which was like his personal apartment. Woe betide you if you sat in somebody else's seat.

After he passed, the next major Broadway experience I had was *Sophisticated Ladies*, a tribute to the music of Ellington, which sprang out of a relationship my father had with a man named Manheim Fox. There were originally five major producers of *Sophisticated Ladies*: Fox, Roger S. Berlind, Sondra Gilman, Burton L. Litwin, and Louise Westergaard. It was a big smash hit, which ran for a little more than two

years before there were smaller and sundry versions of it. I was not really involved in any of those companies—except years later, when I choreographed a couple of them.

Later, I did a show called *Sophisticated Ellington: Symphony and Swing*. It was billed as a "Pops Symphony Orchestra Evening with Perks." Michael Gibson wrote the arrangements and a man named David Levy wrote the script. I told the audience stories that were intermingled with pieces of music, compositions, some of which we would dance to—we had two vocalists and four dancers. We traveled around for a good many years with that production. It was produced by two gentlemen from the Indianapolis Symphony Orchestra: Ty Johnson and Tom Bennett. We had some very prestigious conductors: Erich Kunzel had known my grandfather and worked with him, as did Keith Lockhart. We played all over the states, including Hawaii. It was very successful.

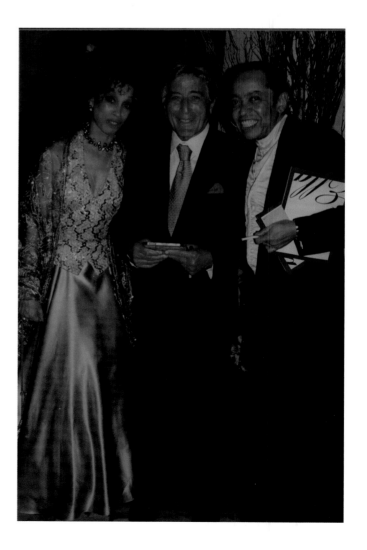

32

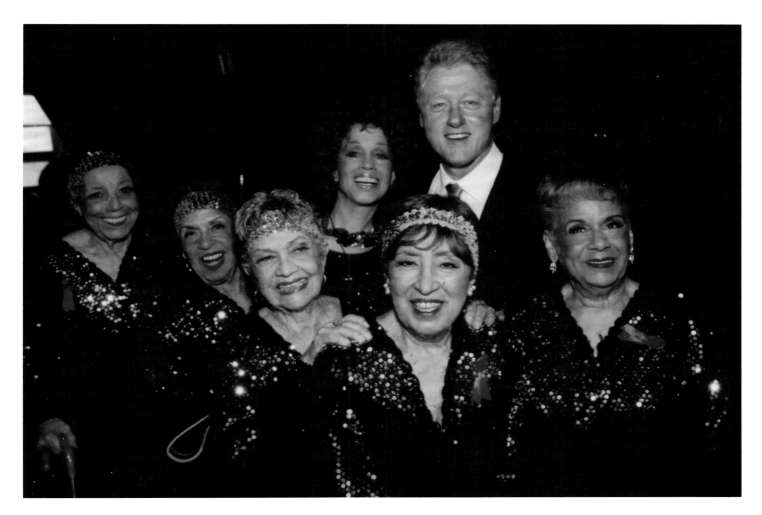

The music of Duke Ellington is of such a structure that it crosses generations and puts everybody on an even scale. Duke Ellington was very charming and very gracious, and he appreciated his career to such an extent that, when he was invited to play in different countries, he would compose a suite dedicated to that country. He loved to go places that he was not supposed to go to. When people used to tell him to stop writing, he would reply that as soon as you stop working, everything starts breaking down, the body starts falling apart. "Retire?" my grandfather would say when asked why he kept on working. "Retire to what?"

He gave us food for thought. He gave us, I believe, a way to speak—another way to communicate. He was always criticized for not being part of any particular political group or movement. But he said all he had to say through his music. All you had to do was listen. And I think that he made us listen. Even now, when I choreograph to his music, I learn new things about him and his work. He died with his boots on and that's what I'm planning on doing. You've got to keep working. He was a wonderful man.

— *Mercedes Ellington*

PREVIOUS SPREAD: Mercedes with the June Taylor Dancers performing in Florida, c. 1964. LEFT: Mercedes with Tony Bennett and Howard Porter. ABOVE: Mercedes Ellington with President Clinton and the Silver Belles at the Apollo. BELOW: Mercedes in *Sophisticated Ladies* at the Apollo, with Gregg Burge (left) and Hinton Battle (right).

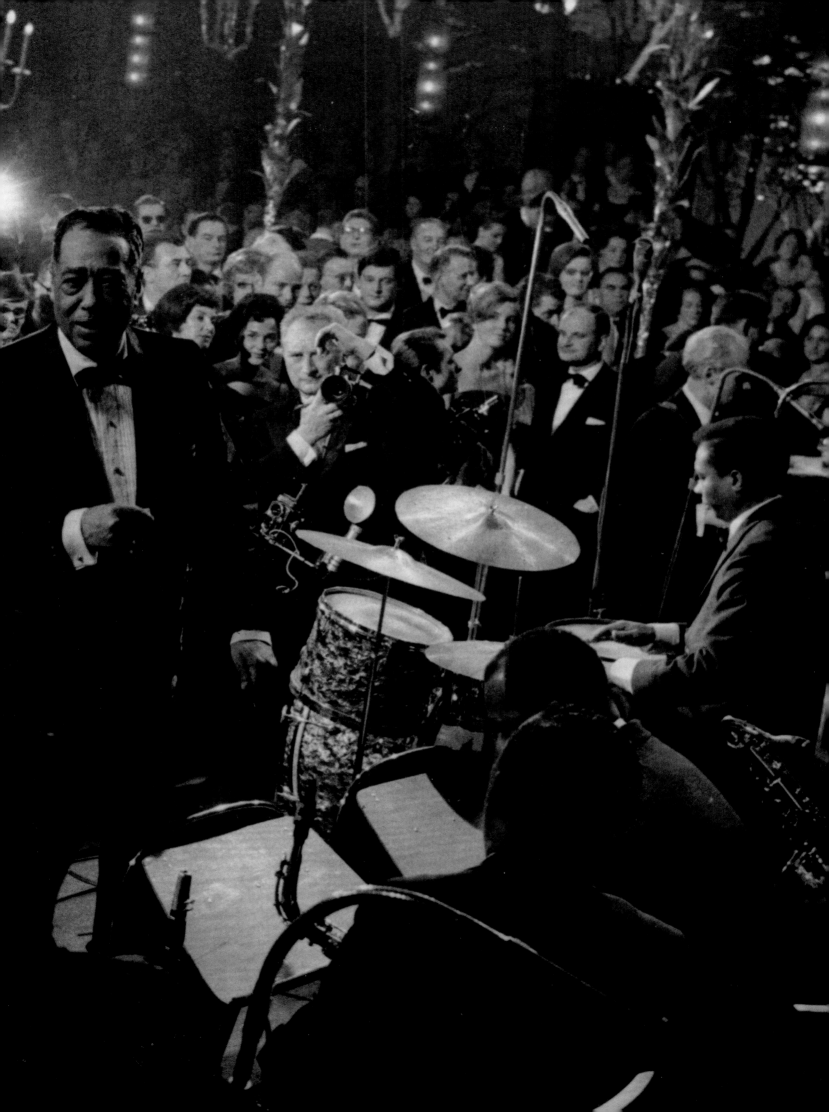

TIMELINE

1899 *April 29*: Edward Kennedy "Duke" Ellington is born in Washington, D.C., to James Edward Ellington and Daisy Kennedy Ellington, both amateur but accomplished pianists. James Edward is called "J.E." and "Uncle Ed" by his family, including by his son. **1906** Begins studying piano at age seven. His piano teacher is named Klingscale—her nickname, "Mrs. Clinkscales" sticks, and goes down in history as such. Young Edward shows talent in both the visual and musical arts and will eventually have to choose between the two disciplines. **1907** In jazz critic Barry Ulanov's biography, Ellington says that he was tagged "Duke" at age eight by a next-door neighbor who had a penchant for nicknaming people. Little Edward is always dressed well and carries himself like an aristocrat; hence, the "little duke." **1910** The Howard Theatre opens; it is a venue for African American performers and audiences. **1913** Attends Armstrong Manual Training School to study commercial art. Receives poor grades except in mechanical and freehand drawing, due to lack of interest in other courses. Visits pool halls and burlesque theaters even though underage. Hears pianist Harvey Brooks while vacationing in Asbury Park, New Jersey, with family. Though Ellington can't read music very well, he listens carefully. "Those ragtime pianists sounded so good to me! And they looked so good!" —Duke Ellington, *Music Is My Mistress*. Works as a soda jerk at the Poodle Dog Café on Georgia Avenue in Washington, D.C. Plays a number for the senior class dance and is a big hit. Is in demand at parties and dances. **1914** Hears and meets many of the top pianists in Washington, D.C., including Lester Dishman, who influences him greatly. "He [Lester Dishman] was terrific—really good. The piano jumped, the air shook." —Duke Ellington, *Music Is My Mistress*. **1915** Sister Ruth Dorothea Ellington is born on *July 2*. Washington, D.C., bandleader Doc Perry teaches him to read music and provides Duke with piano jobs. **1916** Enters a poster contest sponsored by the civil rights organization the National Association for the Advancement of Colored People (NAACP) and wins. Turns down the prize—a scholarship to study art at the Pratt Institute in Brooklyn, New York—to stay in D.C. and play music. Works painting signs and posters to make a living, partnering with Ewell Conway; plays music at night. When customers ask him to make a sign for a dance or party, he also offers to play the gig. **1917** Leaves high school just shy of graduation and earns a wide reputation as a piano player around Washington, D.C. **1917–18** Forms his own group: The Duke's Serenaders. Advertises in the telephone directory that he is seeking gigs. **1918** *July 2*: Marries high school sweetheart Edna Thompson in Washington, D.C., at age nineteen. Registers for the World War I draft but is never called. His personal motto is "No boxes." "It was just something about him. He didn't know it, but he had it then. When he walks into a strange room, the whole place lights up. That's how he likes people, and how he impresses them." —William Alexander "Sonny" Greer, drummer. "In those days, the fashion in D.C. was to have a tailor-made suit with some feature that no one else was wearing. One memorable evening, Ellington astonished everybody by strolling up to the corner attired in a shimmy back herringbone suit (this was shirred and pleated in black). To all of the style-conscious musicians, Duke was considered the epitome of elegance from then on." —Rex Stewart in *Boy Meets Horn*.

36

When Duke arrives at parties or gigs, friend Jerry Rhea flings open the door and says, "Get out of the way 'cause here comes Duke." **1919** *March 11*: Son Mercer Kennedy Ellington is born. Ellington is so successful at booking gigs, he's managing and sending out five bands at a time. Studies with local music teacher Henry Grant, who teaches him harmony and further influences Ellington's musical development. **1920** Earns $10,000 a year as a bandleader. Meets Sonny Greer, who becomes his drummer, and who works his first gig with Ellington on *March 19*. Learns James P. Johnson's difficult "Carolina Shout" stride piece by slowing down a piano roll and practicing until it's perfect. **1921** *August*: While making an appearance at the Lincoln Theater in Washington, D.C., songwriter/publisher Clarence Williams meets Ellington and assures the young musician he can be successful in New York City. *November 25*: James P. Johnson arrives in Washington, D.C., to play at the Convention Center. Ellington gets up on stage with Johnson and plays for him. He spends much of the night observing Johnson's piano style. **1923** *January*: Attends a performance at the Howard Theatre in D.C. of soprano saxophone master Sidney Bechet, his first encounter with New Orleans jazz. **"My first encounter with the New Orleans idiom came when I heard Sidney Bechet in my hometown. I have never forgotten the power and imagination with which he played."** —Duke Ellington, *Music Is My Mistress. March*: Travels to New York City with Sonny Greer and Otto Hardwick. Gains entrée into the inner circle of top Harlem pianists, including Willie "The Lion" Smith, who appreciates Ellington right from the start. Yet, despite staying with various friends and relatives, work is sparse. Sonny Greer hustles pool for ready cash. The group returns to D.C. after several weeks and hooks up with Wilbur Sweatman's band before rejoining Elmer Snowden. "Good-looking, well-mannered fellow; one of those guys you see him, you like him right away; warm, good-natured. I took a liking to him and he took a liking to me." —Willie Smith, *Beyond Category: The Life and Genius of Duke Ellington*. "'Course, all we need to have done was send home and they would have sent us some money anyway, but we preferred to do it this way so we could make an entrance. You know, 'Just back from New York for a little holiday,' something like that." —Duke Ellington, *Beyond Category: The Life and Genius of Duke Ellington*. June: With Elmer Snowden, Ellington, Greer, and Hardwick return to New York for good. As it had been in D.C., Snowden is the leader of the group, called The Washingtonians. Edna Ellington is shortly sent for and arrives with son, Mercer. *July:* Ada "Bricktop" Smith at the Exclusive Club. Ellington begins a successful career that eventually makes him a key figure in the Harlem Renaissance. At the time, New York has 786 dance halls, 238 of which are in Manhattan. Ellington reports that jazz is **"the music that somebody likes to look down on."** *July 26*: Makes his first cylinder recording a tune called "Home," as part of Elmer Snowden's five-piece Novelty Orchestra. In total, they recorded three test sides for Victor that have never been issued and are presumably lost. *August 25*: Makes first radio broadcast, on WDT, accompanying blues singer Trixie Smith. *September*: As part of Elmer Snowden and his Black Dot Orchestra, begins performing at the Hollywood Club on 49th Street and Broadway, an engagement that lasts forty-eight months, the longest of his career. *October 18*: Snowden's Novelty Orchestra records another session of "Home," as well as

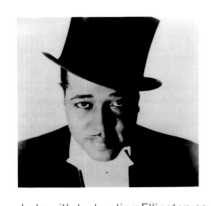

"M.T. Pocket Blues." Neither song was issued. *October 23*: "Blind Man's Bluff," Ellington's first copyright, is written with Jo Trent (arrangement by Geo. R. Holman), is published by Fred Fisher, and deposited for copyright on *October 24, 1923. December*: Late in the month, Ellington becomes the rehearsal pianist for Tin Pan Alley music publisher Fred Fisher Company. The alliance is short-lived and ends by February of the next year. **1924** *February*: Elmer Snowden leaves the band. Initially Sonny Greer, then Ellington, becomes its leader. *February 24*: Popular Music edition of the *New York Clipper* includes a band photo with text noting Ellington as leader. *June*: Ellington, Arthur Whetsol, Charlie Irvis, Sonny Greer, and Fred Guy join Local 802 of the local musicians' union. *November*: Makes his solo publishing and recording debut with "Choo Choo (I Got to Hurry Home)" released on the Blu-Disc label. **1925** With Jo Trent, Ellington contributes two songs—"Jig Walk" and "Jim Dandy"—to *Chocolate Kiddies*, an all-black revue that introduced European audiences to black American styles and performers. *January*: Records "How Come You Do Me Like You Do" for Blu-Disc with Florence Bristol singing vocals. *April 3*: A fire damages the Hollywood Club. The club is not insured and the loss totals about $10,000. The club reopens on May 1, but The Washingtonians, playing other gigs, don't return until June 10. Sometime in the spring, Ellington comes to the notice of Irving Mills, jazz publisher and musician. *March*: The Hollywood Club reopens as the Kentucky Club. Ellington writes "Parlor Social Stomp," "The Creeper," "East St. Louis Toodle-oo," and "Immigration Blues." *September*: Records for Pathé, "I'm Gonna Hang Around My Sugar" and "Trombone Blues." *December 15*: Another fire destroys the Kentucky Club. It reopens after several months. The Washingtonians work the Fox Theater circuit in the meantime. **1926** *June*: Joe "Tricky Sam" Nanton joins the band. *November 29*: Irving Mills arranges a session with Vocalion; the band records its signature song, "East St. Louis Toodle-Oo" and "Birmingham Breakdown." *December*: Two recording sessions with Okeh take place. "They Say I Do It" and "Drifting from You Blues" are recorded at the first session, and "The Creeper" and "Immigration Blues" are laid down at the second. **1927** Ellington records twelve sessions over the course of the year, under various band names, with labels including Victor, Brunswick, Columbia, and Okeh. Nineteen different songs are recorded in total. *June 16*: Harry Carney joins the band. Carney is originally a tenor and alto sax player who also plays the clarinet. Ellington uses him as a clarinetist before Carney switches to and permanently plays the baritone sax. *December 4*: First Cotton Club revue played by the Duke Ellington band opens, written by Jimmy McHugh and Dorothy Fields. It features fifteen numbers, with singing and dancing, plus encores. Ellington performs midnight and 2:00 a.m. shows, and between shows, provides dance music for patrons. His Cotton Club performances are also broadcast on WNBC radio stations across the country, helping to make Duke Ellington a household name. **"One of the hottest bands on the air is Duke Ellington's from the Cotton Club Monday midnights." —***Variety.* **"I am a man of the theater." —**Duke Ellington **1928** Over eighteen recording sessions total in the year, all very prolific. Five different takes of "The Mooche" are laid down. *January*: Creole clarinetist Barney Bigard joins the band. He has studied with the legendary Lorenzo Tio in his native New Orleans. *February*: Ellington broadens his national exposure by joining the WABC and the Columbia (WCBS) radio networks, with broadcasts relayed "Coast-to-Coast." *March 26*: Records "Black Beauty," an homage to Florence Mills, "The Queen

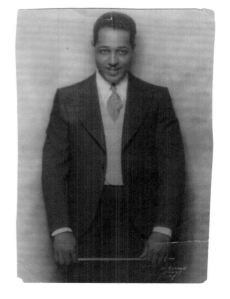

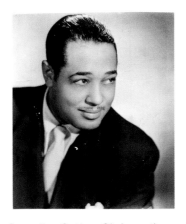

of Happiness," a singer-dancer who died tragically at age 32 on November 7, 1927. Mills was so popular that 100,000 people lined the streets from Harlem to the Bronx to her resting place at Woodlawn Cemetery. *May*: Johnny Hodges joins Ellington on alto sax. Bing Crosby visits Harlem to hear Ellington. Crosby started his career as a jazz vocalist. **1929** *January*: Ellington contracts with Victor Talking Machine Company for two years. Ellington can only record titles for Victor under his name, but may still record for labels using pseudonyms such as "The Whoopee Makers" on the Banner/Perfect labels; "The Jungle Band" on Brunswick; and "The Harlem Footwarmers" and "Ten Black Berries" on Okeh. Continues to broadcast from the Cotton Club on the national WABC network. *January 8*: Records for Brunswick as The Jungle Band. Ellington's band is the second jazz ensemble to record two sides of a ten-inch 78 rpm disc "Tiger Rag, Parts I and II," for a total of six minutes. For much of the Cotton Club period, Ellington's music is known as "Jungle Music." *February*: Trumpeter Cootie Williams joins the band, replacing Bubber Miley. *Summer*: Release of Ellington's first movie, a nineteen-minute "soundie," helmed by Dudley Murphy, for RKO. Titled *Black and Tan* and filmed in Astoria, Queens, it features an all-black cast and the orchestra playing "Black and Tan Fantasy" and "Black Beauty." The plot—complete with the typically insensitive Hollywood sterotypes of the day—involves "Duke" a hardworking, elegant bandleader and "Freddie" a dancer, played by Fredi Washington. This was Ellington's only foray as an actor in a role. In subsequent films he plays himself. *June*: Puerto Rican–born valve trombonist, composer, and copyist Juan Tizol joins the band. *June 20*: Broadway history is made when *Hot Chocolates*, the first all-black revue, opens featuring songs including "Ain't Misbehavin'" by Fats Waller and Andy Razaf. Runs for six months. *July 2*: Florenz Ziegfeld's *Show Girl*, a book musical (if a musical includes dialogue it is a "book" musical as opposed to a revue) written by William Anthony McGuire, with music by George Gershwin and lyrics by Ira Gershwin and Gus Kahn, opens and plays for 111 performances. Ellington plays the show, which stars Ruby Keeler, Jimmy Durante, and Eddie Foy, Jr. Twenty songs are staged in two acts, with the ballet *An American in Paris* opening act two. Some sources report that Ellington and the band are also playing their regular Cotton Club gig, with Duke making as much as $1,500 per night. *October 5*: Ellington's sixth Cotton Club revue opens, entitled *Blackberries*. *October 29*: The stock market crashes. Ellington, who has speculated heavily, loses his investment. **1930** *March 3 through April* (then intermittently thereafter for several months): Backs French singing star Maurice Chevalier at the Fulton Theatre. Ellington's band plays the fifty-minute first half of the show on stage, then moves to the pit to accompany Chevalier for the second half. "I didn't know the first thing about how to MC and the thought of it had me scared half to death. Then, there we were on stage and I opened my mouth and nothing came out."
—Duke Ellington, *Beyond Category, The Life and Genius of Duke Ellington*. *May*: Having left wife Edna in 1924 for dancer

Mildred Dixon, Ellington rents a three-bedroom apartment at 381 Edgecombe Avenue for himself and Dixon. He sends for his parents, who'd been raising Mercer, and for his sister, Ruth, now housing the entire family under one roof. *May 16:* The band leaves for their first tour of the United States. *August 1*: The band arrives in Los Angeles to begin filming *Check and Double Check* with Freeman Gosden and Charles Correll, white actors who star as Amos 'n' Andy in blackface. Ellington maintains his dignity despite Hollywood's continued use of deprecatory stereotypes. Ellington writes the score of the film, and is, according to the *Chicago Defender* paid $5,000 plus expenses. In fact, the contract is for $27,500 payable in weekly installments

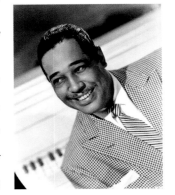

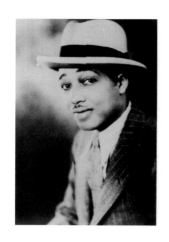

of $6,875 each Wednesday. *August 20 and 26*: Records for RCA-Victor "Ring Dem Bells," "Old Man Blues," and "Three Little Words." The same three tunes are recorded at each session. *September 14*: Returns to the Cotton Club and broadcasts exclusively on the WNBC-WEAF network stations. *September 28*: Opens *Brown Sugar: Sweet but Unrefined*, his seventh Cotton Club revue. *October 14 and 17*: Records two versions of "Dreamy Blues" (co-composed with Barney Bigard)—soon retitled "Mood Indigo"—over two sessions. The first version was rejected. *October 16*: Brings the Cotton Club revue downtown to the Roseland Ballroom. *October 31*: The band becomes the first black orchestra to play the Paramount Theater in Times Square, New York. *December 28*: About one-hundred performers led by Bill "Bojangles" Robinson entertain the prisoners in Sing Sing prison, north of New York City. The group includes the entire cast of *Brown Buddies*, which starred Bojangles, Ellington, and his band from the Cotton Club, and other entertainers from the Cotton Club and Small's Paradise Club. **1931** *January*: Begins an intense and active month of recording. *January 8*: Okeh /Harmony recording session with "I Can't Realize You Love Me," "I'm So in Love with You," "Rockin' in Rhythm," and "Mood Indigo." The group name varies from label to label. *January 10*: Plaza recording session as The Whoopee Makers, laying down "Them There Eyes," "Rockin' Chair," and "I'm So in Love with You." *January 12*: Brunswick session as The Jungle Band, recording "Rockin' Chair" and "Rockin' in Rhythm." Ten waxes were cut of "Rockin' Chair," and two of "Rockin' in Rhythm," but all were scrapped. The session was repeated again on *January 14*, with "Twelfth Street Rag" added. *January 16*: RCA-Victor session of Duke Ellington and his orchestra recording "The River and Me," "Keep a Song in Your Soul," "Sam and Delilah," and "Rockin' in Rhythm." *January 20*: Brunswick session as The Jungle Band, recording "The Peanut Vendor," "Is That Religion?" and "Creole Rhapsody," which covered two full 78 sides. *February 4*: Plays last show at the Cotton Club and leaves the next day for an extended road tour, lasting through *January 1932*. Cab Calloway takes over as the Cotton Club's house band. *February 13*: Ivie Anderson joins Ellington's band. Plays a week at each of these Chicago theaters: the Oriental, the Regal, the Uptown, and the Paradise. Returns to the Oriental before moving on to Detroit and points West, returning to Chicago on *May 15* for a week. Sometime during the first Chicago dates, an Ellington imposter duping well-to-do married women forces the musician to speak to the press to set the record straight. In St. Louis a white elevator operator at the Melbourne Hotel refuses to take the band to the sixteenth floor for a broadcast date at WIL Radio. The band is on the road continuously, crisscrossing all points between Chicago and Philadelphia. In Camden, New Jersey, the band records for RCA Victor: on *June 11*, parts one and two of "Creole Rhapsody"; on *June 16*, "Limehouse Blues" and "Echoes of the Jungle"; and on June 17, "It's Glory" and "The Mystery Song." *September 26*: The band arrives at the Howard Theatre in Ellington's hometown of Washington, D.C. While in Washington, plays a benefit for the "Scottsboro Boys," nine black teenage boys wrongly convicted of rape in Alabama without benefit of adequate council. Scheduled to meet with President Hoover at the White House, a first for an

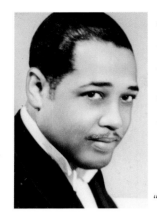

African American, but the meeting is canceled. By now, Ellington receives two hundred fan letters a day. His father answers them. Grosses between $5,000 and $6,000 per week. *August*: Broadcasts twenty-eight times a week over the Chicago local radio station WGN. *December*: Still on the road, Christmas and New Year's Eve are spent at the Fisher Theater in Detroit. **1932** *February 1*: Returns to the Cotton Club for several engagements, but not as the house band. *February 2*: ARC recording session as *Duke Ellington and His Famous Orchestra*. The band lays down "Moon over Dixie," "It Don't Mean a Thing (If It Ain't Got That Swing)" and "Lazy Rhapsody" (on some rare labels, otherwise "Suwanee Rhapsody"). *February 3*: RCA-Victor session of "Duke Ellington and His Orchestra" recording two takes of a medley consisting of "Mood Indigo," "Hot and Bothered," and "Creole Love Call." This was Ellington's first 33⅓ rmp record, lasting seven minutes and forty seconds, and is one of the earliest known stereo recordings. *February 4*: ARC recording session of Duke Ellington and His Famous Orchestra laying down "Blue Tune" and "Baby When You Ain't There." *February 9*: RCA-Victor recording session of "Duke Ellington and His Orchestra" and a medley: "East St. Louis Toodle-Oo / Lot O' Fingers / Black and Tan Fantasy," "Dinah" and "Bugle Call Rag." Ellington's second 33⅓ rpm record, playing time seven minutes and thirty-four seconds. *February 11*: ARC session with Bing Crosby with Duke Ellington and His Famous Orchestra recording "St. Louis Blues," "Creole Love Call," and "Rose Room" (which later became "In a Mellow Tone"). *February 12*: Duke Ellington's train, the Pullman coach "McLaughlin," departs Grand Central Terminal for San Francisco. The band stays on the West Coast through the beginning of April. The band is on the road, touring the Northeast and Midwest through the rest of the year. **1933** *January 31*: Received the New York School of Music annual award for best composition, for "Creole Rhapsody." Paul Whiteman features the song in his concert at Carnegie Hall. *March*: Ellington performs for nightly broadcasts on WMCA and WNBC, for midnight broadcasts on Tuesdays and Fridays on WJZ and WNBC, and for a midnight broadcast on Thursdays on WEAF. *March 4*: Makes Paramount Pictorial 837, *The World at Large*, a ten-minute film featuring Baron Lee and His Blue Rhythm Orchestra, Cab Calloway and his orchestra, and Duke Ellington and his orchestra. *March 9*: Taking over for Cab Calloway, Ellington returns for a residency at the Cotton Club, which ends on *May 31*. Ray Bolger, Eddy Duchin, Bert Lahr, and George Raft are in the opening night audience. *April*: Forty-five radio stations across the nation are now broadcasting Ellington. *April 16*: Opening night of the new revue, the *22nd Cotton Club Parade*, with book and score by Ted Koehler and Harold Arlen. Ethel Waters performs "Stormy Weather."

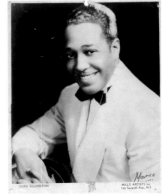

Roscoe "Fatty" Arbuckle, Milton Berle, Eddie Cantor, Jimmy Durante, Ethel Merman, Sophie Tucker, and Johnny Weissmuller, among others, are in the audience. *May 16*: Records "Sophisticated Lady," which becomes a big hit. *May 23*: Films the nine-minute Paramount short film *Bundle of Blues*, with the film soundtrack recorded by Duke Ellington and His Famous Orchestra. *June 2*: Departs for Europe on the SS *Olympic*. *June 9*: Docks at 12:30 p.m. at Southampton, England, to be met by British bandleader Jack Hylton, who sponsored the British leg of the tour, and by journalist Spike Hughes. The reception in England is very positive. The

fans love Ellington and know most of the band members by name. Ellington discovers that he is considered a significant composer in London. Continues on a fifty-five-day tour of Great Britain, Holland, and France to mostly rave reviews. Plays three dates at the London Palladium and broadcasts over the BBC. *August 2*: Departs Southampton on the SS *Majestic* for New York City. Arriving back in the U.S., the band immediately sets off on a tour of the States. New Year's Eve is spent in Kansas City, Missouri. Constant touring now becomes a way of life. Featured in the August issue of *Fortune* magazine in an article entitled "Introducing Duke Ellington." The article notes that Ellington, "grosses $250,000 a year with 'Mood Indigo' and the 'Cotton [Club] Stomp.'" *December 4*: Records "Daybreak Express" in Chicago. Makes two short films, a newsreel and A Bundle of Blues, both filmed in New York. Writes "Jive Stomp," "Merry-Go-Round" (aka "Cotton Club Shim-Sham"), "Ev'ry Tub," "The Monkey," "Drop Me Off at Harlem," "Dragon's Blues," and "Harlem." **1934** *January 10*: Records "Solitude," another huge hit. Ellington appears in two Paramount feature films in Los Angeles: *Murder at the Vanities*, filmed in *February*; and *Belle of the Nineties*, filmed in *March*. *November 29*: Double bassist and tuba player, Billy Taylor, joins the band. The double bass has, by this time, taken over the timekeeping function in modern jazz bands. *December*: Records the soundtrack for *Symphony in Black: A Rhapsody of Negro Life*, with filming completed the following *March* which costars Billie Holiday. *December 27*: Coronetist Rex Stewart joins the Duke Ellington Orchestra. (His band went under several names, i.e., Duke Ellington and his Famous Orchestra, The Cotton Club Orchestra, and so on). **1935** *March 5*: Records as the "Duke Ellington Sextet" with two takes each of "Tough Truckin," and "Indigo Echoes." *April 30*: Records "In a Sentimental Mood." *May 25*: Daisy Ellington passes away after a year's illness. For the last eight weeks, she's been in in a private hospital in Detroit, where Ellington is playing—with husband, James, and daughter, Ruth, in constant attendance. Duke and Mercer are present when she dies. *May 26*: Daisy Ellington's body is taken to Washington, D.C., for burial. Ellington is completely devastated by his mother's death and honors her with three thousand flowers. He writes "Reminiscing in Tempo" around this time, and also becomes a heavy drinker. **"After my mother passed, there was really nothing, and my sparkling parade was probably at an end."** —Duke Ellington, *Music Is My Mistress*. **1936** *January and February*: Records "Echoes of Harlem," featuring trumpeter Cootie Williams and "Clarinet Lament" for Barney Bigard in two different sessions. Ellington begins writing to the strengths of the men in his band, and will feature them as soloists from then on. *May 8*: Begins a residency at the Joseph Urban Room in the Congress Hotel, Chicago, which ends on *June 5*. *November 10 through 18*: Plays the Chez Maurice and is the first black band to play an extended engagement at a downtown Dallas nightclub. *December*: Begins two years of recording more than sixty songs for two new labels owned by Irving Mills: Master and Variety. Most are successful. **1937** Gypsy guitarist Django Reinhardt— an ardent admirer of and destined to work with Ellington briefly in 1946—records

"Solitude" (with Ellington), "Runnin' Wild" and "Swing" (without Ellington) in France. *February 2*: Begins a week of work for Republic Studios in North Hollywood, making the film *The Hit Parade*. *March 5*: Ellington arrives back in New York City. *March 17*: Returns to the Cotton Club, now relocated to Broadway and 48th Street. The new revue is called the *Cotton Club Express Show*. The show features singers Ethel Waters and George Dewey Washington, and dancers Bessie Dudley and the Nicholas Brothers. The residency lasts until *June 15. May 15*: Records the hugely popular "Caravan," composed by Juan Tizol and arranged by Ellington, on the Master label. Starting with Irving Mills's presumptive presence in the music publishing, the authorship of some of Ellington's work becomes

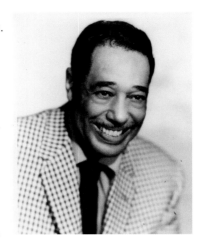

murky. It's an issue future scholars will tackle and straighten out. *June*: Ellington and the band return to the road again. *September 20*: On a stopover in New York, records "Diminuendo and Crescendo in Blue." *October 28*: Ellington's father, J. E. Ellington, dies at Sloane Presbyterian Hospital in New York. The family takes the body to Washington, D.C., on October 30, for burial. "The memory of things gone is important to a jazz musician. Things like old folks singing in the moonlight in the backyard on a hot night or something someone said long ago."—Duke Ellington, *The Duke Ellington Reader. December*: Named to the newly formed Negro Actors Guild of America. **1938** *March 3*: ARC/Brunswick (Master) recording session includes another hit standard, "I Let a Song Go Out of My Heart." ARC is American Record Corporation, which owned Brunswick. *March 9*: Begins a residency at the Cotton Club, which ends on *June 9. Cotton Club Parade*, for the first time, is a musical review whose score is written entirely by Ellington. Meets Cotton Club greeter Beatrice Ellis, nicknamed Evie. Ellington moves into her St. Nicholas Place apartment and never again returns to Edgecombe Avenue. The family and Mildred Dixon each find their own living quarters. Ellington's relationship with Ellis will last until his death, despite his wandering eye. *July*: Ellington is sidelined for several weeks for hernia surgery. *August 9*: Duke Ellington and His Famous Orchestra record "Prelude to a Kiss" for ARC/Brunswick (Master). *December*: Duke Ellington meets Billy Strayhorn in Pittsburgh, who shows him the precociously written "Lush Life." Ellington is impressed and encourages Strayhorn to come to New York to be his lyricist. **1939** *January*: Strayhorn arrives in New York. *February 11*: Plays the NAACP Annual Ball in New York City to a crowd of twelve hundred people in the 369th Regiment Armory. *March*: Strayhorn officially joins the Ellington organization and spends the first month in Ellington's apartment while the band returns to Europe. *March 23*: Leaves New York on the SS *Champlain* with thirteen musicians and Ivie Anderson, one of the singers in his band. Lands in Le Havre, France, seven days later and begins a thirty-four-day, twenty-eight-concert tour of Europe. Plays two concerts to packed houses at the new National Théâtre de Chaillot. Booked in Denmark and Sweden but not Germany—for political reasons, nor England—because of a dispute with the British Ministry of Labour. *May 10*: Returns home on the SS *Île de France*. Met in New York by five hundred fans, among them the prizefighter Joe Louis. *May*: Severs ties with Irving Mills after examining the books in Mills's office. Because Mills attached his name to Ellington's work, and took a 50 percent commission on it, the relationship had long come under criticism in the black press. From his pulpit at the Abyssinian Baptist Church in Harlem, the Reverend Adam

Clayton Powell, Jr., branded Ellington a "musical sharecropper."*June 20*: Attends funeral for Chick Webb in Baltimore, Maryland. *October*: Innovative bassist Jimmie Blanton joins the band toward the end of the month. Blanton is a musical genius and transforms the way future bass players will use their instruments. **1940** Stops drinking heavily. Mercer Ellington, who mostly works independently from his father, agrees to compose for him (an arrangement that lasts through 1941). *January*: Bassist Billy Taylor leaves the band and tenor saxophonist Ben Webster joins, ushering in a period of activity that historians will refer to as "The Blanton Webster Band." "Singing Cowboy" Herb Jeffries is also hired as a vocalist. *March 6*: Duke Ellington and His Famous Orchestra record "Ko-Ko" and "Jack the Bear," both featuring the innovative bass work of Jimmy Blanton. The session is under a new RCA-Victor contract; the Master-Brunswick-Columbia-Variety-Vocalion-Okeh alliance under Irving Mills has ended. *March 15*: Records a new version of Cootie's solo tune as "Concerto for Cootie," which later becomes better known as "Do Nothing Till You Hear from Me." *May 4*: Records "Cottontail," which features tenor saxophonist Ben Webster, based on the chords of George and Ira Gershwin's "I Got Rhythm." Also records "Never No Lament," better known as "Don't Get Around Much Anymore." *June 10*: Citing poor business, New York's Cotton Club shuts its doors. *July 22*: Records "Harlem Airshaft." *July 24*: Records two takes of "Sepia Panorama." *October 1*: Alone in the studio with bassist Jimmie Blanton, the duo record "Pitter Panther Patter," "Body and Soul, " "Sophisticated Lady," and "Mr. J.B. Blues." *November 2*: With Ellington's blessing, Cootie Williams leaves the band for Benny Goodman's organization. *November 7*: Ray Nance takes Cootie's place on the trumpet. Nance also plays violin and sings. *November 7*: The historic concert at Fargo, North Dakota, takes place at a dance in the Crystal Ballroom. The concert is recorded live by two young men, Jack Towers and Richard Burris, who'd gotten permission to record it for private use only. Eventually the concert is remastered and issued commercially in 1978, earning a Grammy Award. *December 28*: Records "Flamingo," with Herb Jeffries on vocals. It becomes a huge hit. **1941** *February 15*: Records, for the first time ever, what has become the band's theme song, "Take The A Train" (which had replaced the prior signature tune, "East St. Louis Toodle-Oo"). "Blue Serg" and "Jumpin' Punkins" by Mercer Ellington are also recorded. *June 5*: Records "Bakiff," featuring Ray Nance on violin. *June 26*: Records the great standard "I Got It Bad and That Ain't Good," with Ivie Anderson on vocals. *July 2*: Tickets for *Jump for Joy* go on sale as the band records the tune "Jump for Joy." *July 3*: Records as Johnny Hodges and His Orchestra, "Things Ain't What They Used to Be," composed by Mercer Ellington. *July 10*: After five days of rehearsals, *Jump for Joy: A celebration of the American Negro* in dance, sketch, and song with music by Ellington and lyrics by Ellington and Sid Kuller, Paul Francis Webster, and others, opens at the Mayan Theatre in Los Angeles. Features performances by Dorothy Dandridge, Herb Jeffries, Ivie Anderson, and Big Joe Turner—the blues shouter from Kansas City, Missouri. Portrays African Americans in a non-stereotypic light. Closes *September 27* after 101 performances. *November 2*: Jimmie Blanton, very ill with tuberculosis,

leaves the band. *November–December*: RCM videos Duke Ellington Soundies, made for the Mills Panorama Machine juke box, recorded at Fine Arts Studio. Titles include "Cottontail," "Flamingo," "I Got It Bad And That Ain't Good," "Bli-Blip" and "C-Jam Blues." *December 12*: Plays a free concert for the military at Portland, Oregon, air base; America is now at war, following the December 6 attack on Pearl Harbor. *December*: Hired by Orson Welles to write music for the feature film *It's All True* (partially shot but never released). Ellington is paid a $12,500, but due to the chaos on Welles's end winds up writing only twenty-eight bars of a trumpet solo (which Welles never heard). **1942** *January 21*: Records "C-Jam Blues," "Moon Mist," "Sentimental Lady," and "Perdido." *July*: Barney Bigard leaves the band. *July 28*: Records "Sherman Shuffle" and two other military-oriented tunes, "A Slip of the Lip," and "Hayfoot Strawfoot." *July 30*: Jimmie Blanton dies at the age of twenty-three. *August 13*: Ivie Anderson, who has long suffered from asthma leaves the band, and retires from singing. *September 28 and 29*: Prerecording for MGM film *Cabin in the Sky*. *September 30 through October 12*: Films the ballroom scene for *Cabin in the Sky*, directed by Vincente Minnelli and starring Louis Armstrong, Lena Horne, and Ethel Waters. The film features Ellington's song "Goin' Up" and Mercer Ellington's "Things Ain't What They Used to Be." *October 8*: Prerecords and films the famous "Take the A Train" segment of the Columbia film *Reveille with Beverly*. Betty Roché sings the lyric to the iconic tune. *December*: Wins Best Swing Band category in *Downbeat* magazine readers' poll. **1943** *January 23*: Debuts at Carnegie Hall, with feature stories in *Time*, *Newsweek*, and the *New York Times*. Eleanor Roosevelt and Leopold Stokowski attend. Presented plaque signed by thirty-two eminent musicians including Stokowski, Aaron Copeland, Jerome Kern, Earl Hines, Count Basie, Paul Robeson, Benny Goodman, and Kurt Weill. Highlight of the three-hour concert is "Black, Brown and Beige: A Tone Parallel to the History of the Negro in America." Performs the same concert on *January 28* at Symphony Hall, during a blizzard in Boston, with three thousand in attendance and twelve hundred turned away. At this point Ellington has made more than seven hundred recordings and sold twenty million records. "I couldn't work without a deadline. If I retired to some luxurious home by the sea, you know what I'd write? Nuthin!"—Duke Ellington, *Beyond Category: The Life and Genius of Duke Ellington*. Ellington's "Don't Get Around Much Anymore" becomes a hit song for the Ink Spots. Ellington receives a $22,500 royalty check from RCA Victor. *April 1*: Begins a six-month engagement (which ends on *September 23*) at the Hurricane Club in New York, earning at least $3,000 weekly. Broadcasts six nights per week. *June 24*: *The New Yorker* magazine runs a three-part profile on Ellington titled "The Hot Bach—I" (parts II and III would run in subsequent weeks). *August 7*: Is featured in an article in the *Saturday Evening Post*, "The Duke of Hot." *August 8*: Ben Webster's last performance with the band. He leaves to form his own quartet and plays the Three Deuces in New York. *December 11*: Premieres "New World A-Comin'," a fifteen-minute piano concerto inspired by Roi Ottley's book of the same name. **1944** *January:* Refuses to play a whites-only United Service Organization's show at the Naval Station Great Lakes near Chicago. "I'm Beginning to See the Light" and "Do Nothin' Till You Hear from Me" are hits. Ellington

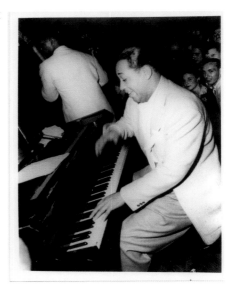

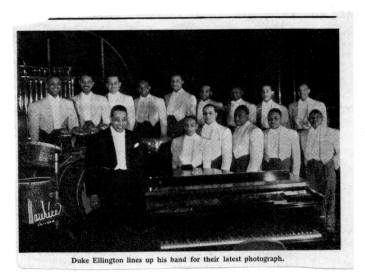
Duke Ellington lines up his band for their latest photograph.

has a yearly income of $405,000 with expenses of $394,000, leaving a net profit of $11,000. "Ellington wants life and music to always be in a state of becoming."—Clark Terry, *Beyond Category: The Life and Genius of Duke Ellington. April*: Juan Tizol leaves the Ellington organization. *May*: Tenor saxophonist Al Sears joins the band. *July 12*: At the Roxy Theater in New York, Ellington is in an elevator that loses control and plummets two stories before coming to a jarring stop. The crash breaks a light fixture, which cuts Ellington's hand. Three stiches are required. Ellington still plays the show, but Billy Strayhorn covers piano. *September*: Trumpeter Cat Anderson joins Ellington's orchestra. *December 19*: Records a three-hour concert at Carnegie Hall. *December*: Again wins the *Downbeat* readers' poll as best swing band. **1945** Twelve recording sessions over the course of the year, with *July 24* recording of the first suite, the "Perfume Suite." Wins the *Esquire* magazine gold "Esky" award for arranger and bandleader as well as the *Metronome* magazine poll. Makes twenty-five Treasury broadcasts on the WABC radio network, designed to sell treasury bonds for the war effort. *November*: Bassist Oscar Pettiford joins the band. *December*: Rex Stewart leaves the band. **1946** *January 15*: Publication of the first Ellington biography: Barry Ulanov's *Duke Ellington*. Ellington again wins an *Esquire* magazine gold "Esky" award. *February*: Ellington is given the libretto of John Latouche's updated version of John Gay's 1728 *The Beggar's Opera. April*: Russell Procope joins the Ellington organization on reeds, principally on clarinet and alto sax. *July*: Joe "Tricky Sam" Nanton, who has been in poor health, is found dead in his bed. *October 21*: Rehearsals begin in New York for Latouche's *Beggar's Holiday*, originally titled, "*Twilight Alley*," for which Ellington has written the score. *October 30*: Gypsy guitarist Django Reinhardt arrives from France. He joins the Ellington organization for a tour that begins on *November 4* and ends on *November 24* in Carnegie Hall. *November 10*: the first known public performance of "The Deep South Suite," at the Civic Opera House, Chicago. *December 26*: After weeks of out-of-town tryouts, *Beggar's Holiday* opens at the Broadway Theater. It is forced to close after 111 performances because of nightly picketers who object to the interracial relationship depicted in the piece. *December*: Again wins the *Downbeat* magazine readers' poll, in the swing band and sweet band categories. **1947** *January*: Wins *Esquire* magazine gold "Esky" award for the third time. *August*: Returns to Columbia Records. *October 18*: American Federation of Musicians president James C. Petrillo announces a recording ban effective *December 31*. Record companies furiously record as much as possible; Columbia runs two or three sessions a day, around the clock. The Ellington band is kept busy. *October 31*: Release of Paramount *Puppetoon, Date with Duke*, produced and directed by George Pal. This short featured Ellington playing the "Perfume Suite" on piano with several characters produced by stop-motion animation. *November 11*: Ellington's band records Billy Strayhorn's "Progressive Gavotte." *December 24*: Records the "Liberian Suite," which has been commissioned by the Liberian government. *December 30*: Records "The Clothed Woman." **1948** *April 2*: Ellington collapses on the train between

Washington, D.C., and New York. Upon arrival, he's taken to the hospital and undergoes an operation for a cyst on his kidney. Strayhorn covers for Ellington while he recovers. *June 18*: Sails on the RMS *Media* for a tour of England, France, Belgium, and Switzerland—the first time since 1939. Sails home on the *Queen Elizabeth*, arriving in New York on *August 4. November 11*: Ben Webster rejoins the band for a brief stint, leaving in *May 1949. November 13*: The extended work, "Tattooed Bride," debuts at Carnegie Hall, a daring work with advanced harmonic language. *December*: Once again wins the *Downbeat* readers' poll. **1949** *January*: Guitarist Fred Guy leaves the band and is never replaced. *February 16*: Records the soundtrack for Universal's fifteen-minute short film *Symphony in Swing. September*: Columbia recording session, the first since the recording bans imposed on *December 31, 1947. October 2*: Makes his first television appearance on CBS show *This Is Show Business* performing "a specialty with the show's Henry Sylvern orchestra." Thereafter, Ellington will be no stranger to this burgeoning medium. *December 26*: Ivie Anderson dies at age forty-five. **1950** Tempo Music (Publishing) and Mercer Records are established, owned and controlled by Ellington. *March*: Prerecords and films another Universal Studios short, *Salute to Duke Ellington. March 29*: Sails on the *Île de France* for a two-and-a-half month tour of Europe. *August*: Paul Gonsalves joins the band on tenor sax. *December 18*: Records his first LP, *Masterpieces*, for Columbia. **1951** *January 28*: Cancels a performance at the Mosque Auditorium in Richmond, Virginia, because the NAACP protests audience segregation. *February 15*: Is part of an eighty-minute floor show at the Thunderbird Hotel, the first ever in Las Vegas to feature an all-black cast. *March 27*: Juan Tizol, valve trombonist, rejoins the band, bringing alto saxophonist Willie Smith and drummer Louis Bellson with him from the Harry James band; this change of personnel becomes known as the "Great James Robbery." *June 10*: Ellington becomes substitute host for two months on Benny Goodman's WNEW radio broadcasts, Sunday afternoons. *November 11*: Flugelhorn and trumpeter Clark Terry joins the band. *September 29*: Meets President Truman at the White House and presents him with a manuscript copy of "Harlem." *December 7*: Records "Harlem," which had been commissioned for the NBC orchestra by Arturo Toscanini. *December 11*: Records the "Controversial Suite." **1952** Due to a decrease in popularity of swing and big-band music, the band finds itself scheduling more and more one-nighters, with travel by bus and car. *March 25*: Duke Ellington and his orchestra perform a concert in Seattle, Washington's Civic Auditorium, which is issued as the *Seattle Concert* by RCA Records. *June*: Finishes *Ellington Uptown*, recorded in several sessions over 1951 and 1952. *October 25*: No stranger to television appearances, Ellington is booked on *The Steve Allen Show* on the NBC network, Ed Sullivan's rival in the choice 8:00 p.m. time slot for Sunday evening. Sullivan broadcast his show on the CBS television network. *November 4*: *Downbeat* magazine devotes an entire issue to Ellington, on the twenty-fifth anniversary of his Cotton Club engagements. Arthur Fiedler, Milton Berle, Frank Sinatra, and Cole Porter pay tribute. Strayhorn writes an article, coining the phrase **"the Ellington effect."** *November 14*: Two concerts at Carnegie Hall celebrate the twenty-fifth anniversary of Duke Ellington in show business. Billie Holiday, Charlie Parker, Dizzy Gillespie, Stan Getz, and

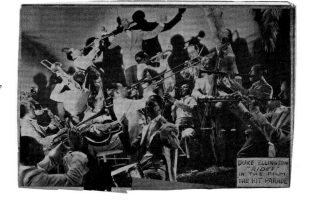

Ahmad Jamal are some who appear with Ellington. **1953** *February 26*: Drummer Louis Bellson leaves the band to manage his wife, Pearl Bailey. *April 6*: Having left Columbia, Ellington begins the first of many recording sessions for Capitol Records, and lays down tracks for "Satin Doll." *August 26*: Ellington wins the first *Downbeat* critics' poll as Best Band. *November*: Juan Tizol returns to the Harry James Orchestra. **1954** *May*: *Jet* magazine runs a story claiming that Ellington, fearing air travel, refused to accept fall bookings in Europe because they included flights between one-night stands. *October 15*: Norman Granz's *Modern Jazz Concert* debuts in Phiadelphia, with Ellington as MC of the entire show. **1955** *July*: Bebopper, composer, and progressive pianist Thelonious Monk

records an homage for his first album for Riverside Records, *Thelonious Monk Plays Duke Ellington*. Monk is the second-most-recorded jazz composer after Duke Ellington. *July 9*: Drummer Sam Woodyard joins the Ellington band. **1956** *January 23*: Columbia recording session at the 30th Street Studio for the album *Blue Rose*. Rosemary Clooney's vocals are recorded separately at a later date. *February 7 and 8*: Bethlehem recording session in Chicago at Universal Studios for the albums *Historically Speaking* and *Duke Ellington Presents*, including Strayhorn's "UMMG," which stood for Upper Manhattan Medical Group (where Ellington's physician, Dr. Arthur Logan, had his practice). *July 7:* Performs at the Newport Jazz Festival, a triumphant concert deemed a comeback. The climax of the performance is "Diminuendo and Crescendo in Blue" with Paul Gonsalves playing a tenor sax solo for twenty-seven straight choruses. The audience goes wild, demanding the band continue to play. As a result, Ellington gets a new contract with Columbia and the concert recording becomes a best-selling Duke Ellington album. *August*: *Downbeat* voters put Ellington in the magazine's Hall of Fame. *August 20*: *Time* magazine places Ellington on its cover, running a seven-page feature, making much of the Newport appearance. Ellington had been bumped off the *November 8, 1954 Time* cover for Dave Brubeck. Brubeck felt badly but Ellington was gracious. *October*: Begins recording *A Drum Is a Woman*. **1957** *March 20*: Records four piano improvisations for Columbia. "Such Sweet Thunder," also known as the "Shakespeare Suite," at New York's Town Hall. "I'm so damned fickle. I never could stick with what I was doing—always wanted to try something new." —*Duke Ellington, Beyond Category: The Life and Genius of Duke Ellington*. *May 8*: Appears in "A Drum Is a Woman," a special episode for the *United States Steel Hour*, on CBS TV. *August*: *Downbeat* readers give Ellington top honors for composing and jazz and as personality of the year. *September 2*: For Verve, records "Portrait of Ella Fitzgerald," which becomes part of the Ella Ftizgerald Duke Ellington songbooks. **1958** Strayhorn and Johnny Mercer add lyrics to 1953's "Satin Doll" for the album *The Cosmic Scene* and it is a hit once again. *January 4*: Plays a one-week club date with Tony Bennett in Miami Beach, Florida. *April 2*: Recording session for the album "The Cosmic Scene." *April 6*: Ellington performs at Carnegie Hall with Ella Fitzgerald. *October and November*: European tour. In England, plays the Leeds Triennial Musical Festival, which is attended by the Duke of Edinburgh. At a later social gathering, Ellington is introduced to Queen Elizabeth and Prince Philip and the Princess Royal. The queen apologizes for missing the performance but assures him that the prince thoroughly enjoyed it. As a result of this meeting, he writes "The Queen's Suite" in her honor

Duke with Ella Fitzgerald

and presses a single copy, which he sends to Buckingham Palace. It is never released to the public during his lifetime. *December*: Wins the *Downbeat* critics' poll as the Best Big Band and the readers' poll for composing. **1959** *April 29*: Celebrates his sixtieth birthday with son Mercer and celebrities Billy Daniels, Jimmy Durante, Sophie Tucker, and Ted Lewis at the Riviera in Las Vegas, where the band is performing. *May 4*: The Second Annual Grammy Awards are held; Ellington wins three of them. *May 29*: Begins recording sessions of the film score for Otto Preminger's *Anatomy of a Murder*. Has a cameo appearance in the film, and plays the piano off-screen with Jimmy Stewart's character. Ellington's score is criticized by some and appreciated by others who recognize its innovations. *June 28*: Makes the first of eleven appearances on *The Ed Sullivan Show*. *August*: Ellington wins Best Big Band and Best Arranger in *Downbeat* critics' poll. *September*: Awarded the Spingarn Medal by the NAACP for outstanding achievement by an African American. *October 21*: Clark Terry leaves the band. *October*: Returns to Europe for nearly fifty days of concerts in Austria, Belgium, Denmark, England, Germany, Holland, Italy, Norway, Sweden, and Switzerland. **1960** Leonard Feather in *The Encyclopedia of Jazz* lists Duke Ellington, Louis Armstrong, Charlie Parker, Lester Young, and Count Basie—in this order—as top jazz figures. *November*: Begins work on composing the film score for *Paris Blues*, starring Paul Newman and Sidney Poitier. *December*: In Paris, writes and records a score for a revival of *Turcaret*, a 1709 comedy by Alain-René Lesage. **1961** *January*: Finishes work in Paris and returns to the Unites States. *April 3*: Louis Armstrong and Duke Ellington record together for Roulette Records. *May 2 and 3*: Records the soundtrack for *Paris Blues* at Reeves Sound Studios, New York. *July 6*: The orchestras of Duke Ellington and Count Basie record the LP *First Time! The Count Meets the Duke*. *November 11*: *Paris Blues* premieres in New York City. **1962** *April 9*: The thirty-fourth Academy Awards is held in Los Angeles. Ellington is nominated for *Paris Blues* for Best Scoring of a Musical Picture. He loses to *West Side Story*. *May 8*: Ellington undergoes a gall bladder operation. *August*: Meets Dr. Martin Luther King, Jr., during rehearsals for *My People in Chicago*. *August 18*: Records with Coleman Hawkins *Duke Ellington Meets Coleman Hawkins*. *September 17*: Duke Ellington, bassist Charles Mingus (whom he'd previously fired some years ago after only a few weeks on the job), and drummer Max Roach record "Money Jungle." *September 26*: Ellington and John Coltrane record together *Duke Ellington Meets John Coltrane*. *November*: Signs with Frank Sinatra's Reprise Records label. **1963** *January*: Departs for

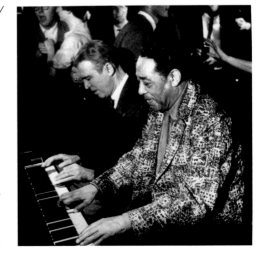

Europe and returns on *March 14*. Departs for a month in Europe on *May 26*. *July 29*: *Timon of Athens* premieres at the Stratford (Canada) Shakespeare Festival, with incidental music written by Ellington. Departs for Damascus, Syria on *September 6* for a U.S. State Department–sponsored tour. While they are in Turkey, John F. Kennedy is assassinated and the tour is cancelled. The band arrives in the U.S. on *November 29*. **1964** *January 4*: First concert as a solo pianist at the Museum of Modern Art in New York. *February*: Again tours Western Europe, through the end of March, with television broadcasts from London, Milan, and Paris. *June 19*: Arrives in Tokyo, and tours one month in Japan for the first time. **1965** *January 3*: Receives *Musician of the Year* award from the Jazz At

Home Club in New York. *January 11*: Mercer Ellington joins the band as trumpet player and road manager. *February*: Month-long tour in Western Europe. *April*: Nominated for, but ultimately denied, a Pulitzer Prize. (He will win it posthumously in 1999 on the centenary of his birth.) **"Fate is being kind to me. Fate doesn't want me to be too famous too young."** —Duke Ellington, *Music Is My Mistress*. *May 18*: Plays "In the Beginning God" at the Monterey Jazz Festival, a liturgical work originally commissioned for the opening of Grace Cathedral in San Francisco in 1964. *June*: Performs at the White House Festival of the Arts. *September*: Films two documentaries for broadcast on National Educational Television: *Duke Ellington: Love You Madly* wins an Emmy Award. *September 16*: The first Concert of Sacred Music is

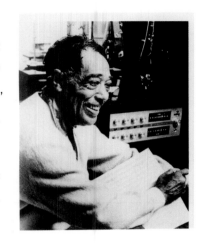

presented in Grace Cathedral, San Francisco. This Concert of Sacred Music is presented again on December 26 at the Fifth Avenue Presbyterian Church in New York and subsequently many times thereafter. **1966** *January 23*: Departs for a five-week tour of Europe. Performs the Concert of Sacred Music at the Coventry Cathedral in England on *February 21*. *March 15*: "In the Beginning God" wins a Grammy Award for best original jazz composition. *April 1*: Travels to Africa to perform in the First World Festival of Negro Arts in Dakar, Senegal, where he and his band premiere "La Plus Belle Africaine." *May 12*: Departs for a second tour of Japan, returning on *May 27*. *July*: Spends the last week of *July* playing at the Juan-les-Pins/Antibes Jazz Festival. Performs a number of concerts with Ella Fitzgerald. *December 19 to 21*: Records "The Far East Suite" for RCA in New York. **1967** *January 13*: Arrives in Paris, touring Western Europe through *March 10*. *May 31*: In the early hours of the morning, Billy Strayhorn, who'd been battling esophageal cancer for three years, dies. He wrote his final tune, "Blood Count," during a hospital stay in *March*. *August 28*: The first of several recording sessions for "And His Mother Called Him Bill," Ellington's tribute to Billy Strayhorn. The last track on the album is "Lotus Blossom," a meditative, personal piano solo caught as the band was packing up to leave. **"Billy Strayhorn was my right arm, my left arm, all the eyes in the back of my head, my brainwaves in his head, and his in mine."**—Duke Ellington, *Music Is My Mistress*. *December 11 to 13*: Reprise recording sessions with Frank Sinatra. **1968** *January 19*: The second Concert of Sacred Music is debuted at the Cathedral Church of Saint John the Divine in New York. *May 18*: Commemorative stamp of Ellington issued by the West African Republic of Togo. *September*: Spends the last week of the month playing dates in Mexico for the first time. *November*: Appointed by President Johnson to the National Council on the Arts. *November 5*: Records the "Latin American Suite." *November 6*: Records the "Degas Suite." **1969** *April 29*: President Richard Nixon hosts an event in honor of Ellington's seventieth birthday, awarding the artist the Presidential Medal of Freedom (the highest honor that can be awarded to a civilian) at the White House. **"There is no place I would rather be tonight, except in my mother's arms."** —Duke Ellington at the White House, *Duke Ellington's America*. *October 27*: Departs for a tour of Europe, returning on *December 1*. **1970** January 10: Leaves for a one-month tour of Japan, the Far East, Australia, and New Zealand. *April 27*: Duke Ellington records the "New Orleans Suite" for Atlantic. *May 11*: Records on solo piano "The River," a ballet suite commissioned by the Alvin Ailey Dance Company. *May 11*: Johnny Hodges dies suddenly of a heart attack while at his dentist's office. *June 28*: Departs for European tour, returning on *August 2*.

1971 Commemorative stamp of Ellington issued by the Republic of Chad. *March 12*: Ellington is made a member of the Swedish Academy of Music, the first non-classical member to be so inducted. *March 16*: Ellington receives a Grammy award for Best Big Band Album of the Year for *Duke Ellington's 70th Birthday Concert*. *June 14*: Receives an honorary doctorate from the University of Wisconsin, one of many that accrue in his later years. *September 11*: Begins extensive tour of Europe and five weeks in the Soviet Union, sponsored by the U.S. State Department. Is joined briefly by granddaughter Mercedes, and also son, Mercer. Follows with a tour of Central and South America, where the orchestra plays Argentina, Brazil, Chile, Columbia, Ecuador, Mexico, Nicaragua, Panama, Puerto Rico, Uruguay, and Venezuela, returning to New York on *December 13*. **1972** *January 5*: Tours Far East and Southeast Asia: Australia, Ceylon, Hong Kong, India, Indonesia, Japan, New Zealand, the Philippines, Singapore, and Taiwan, returning to the U.S. on *February 14*. *July 17*: The band is in residency at the University of Wisconsin–Madison for one week. The governor of Wisconsin proclaims it "Duke Ellington Week." *October 5*: Ellington records the "UWIS" suite. **1973** *January 1*: Ellington publishes memoir *Music Is My Mistress*, which he wrote in longhand while on tour; his collaborator on the project is friend and jazz writer/historian Stanley Dance. *February 11*: CBS television airs "Duke Ellington: We Love You Madly," produced by Bud Yorkin and Quincy Jones, a ninety-minute special tribute starring more than one dozen top artists and a fifty-two-piece orchestra that, led by Jones, performs Ellington's music. Ellington appears at the piano surrounded by a quartet composed of Aretha Franklin, Peggy Lee, Sarah Vaughan, and Roberta Flack, who sing to him his song "Love You Madly." *February 11 to 19*: Ellington is hospitalized with a viral infection. He does not rejoin the band until the end of *February*. *May*: Ellington is awarded three more honorary doctorates in music, bringing the total to at least nineteen. *September 6*: Ellington's last time in a recording studio, laying down tracks with vocalist Theresa Brewer. *September 20*: Ben Webster dies in Denmark, where he'd been living. *October 23 to December 4*: Tours Europe and Ethiopia and Zambia. *October 24*: The third Concert of Sacred Music debuts in Westminster Cathedral, London. *November 25*: Ellington's close friend and personal physician, Dr. Arthur Logan, dies mysteriously in New York from a fall from a viaduct. The news is kept from Ellington for four days. When he's told he is extremely distraught, saying, "I'll never get over

this. I won't last six months." **1974** *January*: Due to poor health, several dates in Florida are cancelled or postponed. It becomes clear that Ellington is failing rapidly. *March 22*: Ellington's last appearance on stage, in Sturgis, Michigan. *March 23*: Ellington arrives home in New York and two days later checks into the Harkness Pavilion of Columbia-Presbyterian Hospital. Ellington had been diagnosed with lung cancer in 1972, but kept the diagnosis between himself and his physicians. He was a smoker. A piano and an electric piano are installed in Ellington's room. He continues to work until the last, principally on the "street opera" "Queenie Pie," which is unfinished. In *May* he continues the practice of sending out a self-designed Christmas card to his friends. *April 29*: Spends his seventy-fifth birthday in the hospital. *May 14*: Paul Gonsalves dies in London; the news is kept from Ellington. Four days later, Ellington trombonist Tyree Glenn dies. (Their wakes overlap Ellington's and, for a short period of time,

all three were being viewed in the same funeral home.) *May 24*: Edward Kennedy "Duke" Ellington dies in New York City at 3:10 a.m. *May*: CBS TV immediately airs a special tribute. Sixty-five thousand people turn out to view his body in the Walter Cooke Funeral Home. Ten thousand attend his funeral at the Cathedral Church of Saint John the Divine. Police turn away 2,500, who listen to loudspeakers outside. On *May 27*, he is brought to his final resting place in Woodlawn Cemetery in the Bronx, New York. *October 8*: Ellington's lifelong friend and ever-faithful baritone saxophonist Harry Carney dies. —*When there is uncertainty about when exactly something was recorded first, the copyright date and/or the earliest published date is listed.*

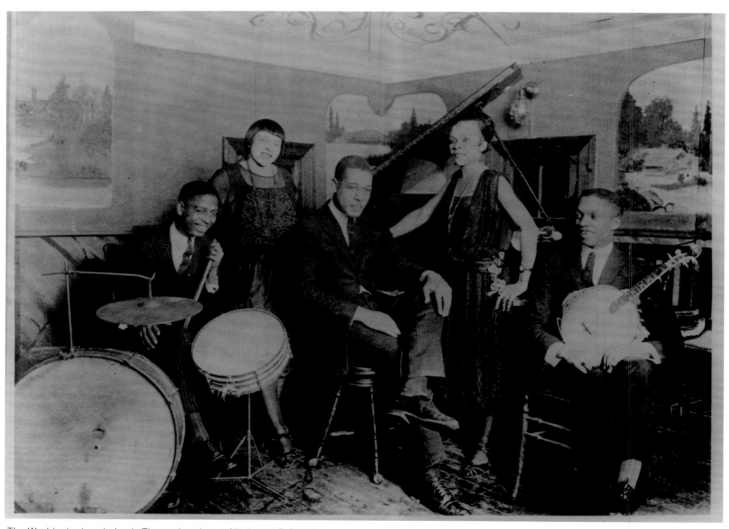

The Washingtonians in Louis Thomas's cabaret, Ninth and R Street, Washington, D.C. Left to right: Sonny Greer, Bertha Ricks, Duke Ellington, Mrs. Conway, Sterling Conway.

Duke with Ed Sullivan.

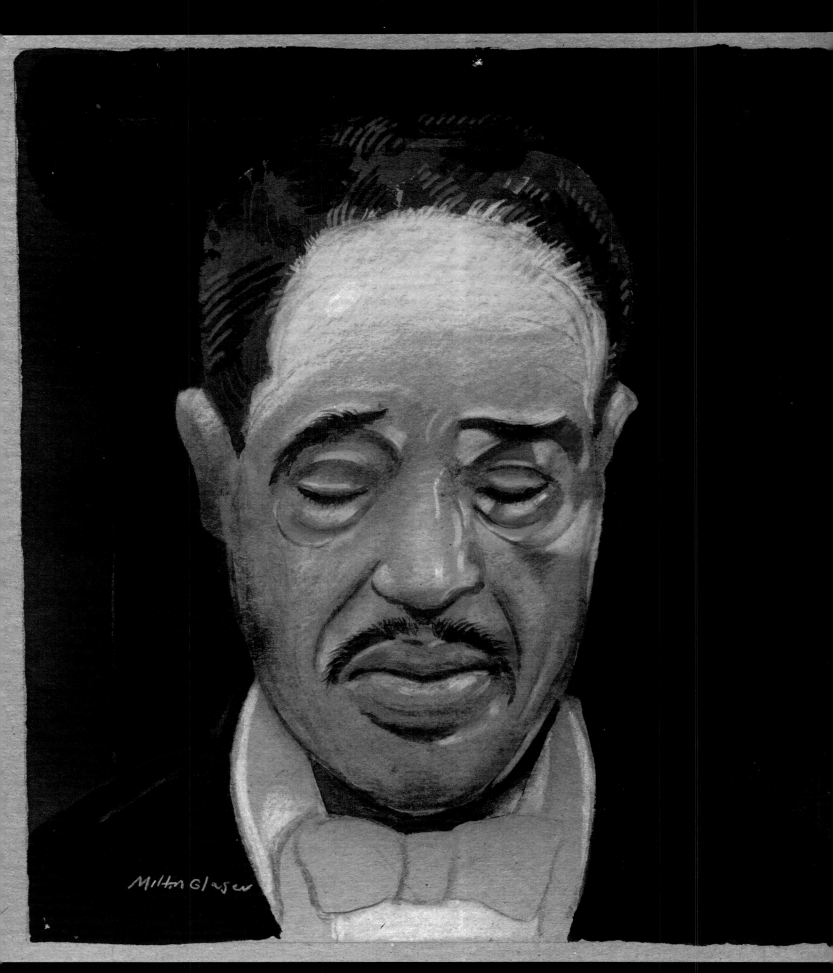

Illustration by Milton Glaser

THE PURPLE PEOPLE AND THE GREEN PEOPLE

—DUKE ELLINGTON

The Purple people lived in the fat *green* valley.

The Green people, their neighbors, lived in the *purple* mountains—

rich grape country.

The Purple people had cattle and all kinds of vegetables—

they *lived* on the fat of the land.

The Green people had sheep and wine—

they *lived* on the fat of the land.

But as usual downstairs looked better to the upstairs people and

upstairs looked better to the downstairs people.

So to improve their living standards, they both declared war—

on each other.

They fought battle after battle after battle . . .

until they both had won.

The Purple people won the purple mountains and

the Green people won the green valley.

But neither side was satisfied:

Because of the confusion, the Green people with the green scenery and

the Purple people with the purple background, they couldn't tell

the houses from the trees or the people from the animals.

They both felt they had won a profitless, empty victory.

So back to war they went.

And finally, at the end of the war, which they both lost,

they all were dead.

There was blood everywhere!

But there was no purple blood,

and there was no green blood.

All the blood was red.

BEYOND
CATEGORY

D uke Ellington was "beyond category," to use one of Duke's favorite phrases. He may not have known it, but he was a mentor to me. He encouraged me when I was still an unknown in San Francisco. He even offered to get me a job at the Hickory House in New York, "because," he said, "you have to go to New York if you want to be recognized."

As far back as his early 78s, Duke has been an inspiration to me. Through his early works, such as "Black and Tan Fantasy," which extended jazz into a larger form, he pioneered and smoothed the way for my generation's experimentation in merging classical music and jazz.

A memorable moment in my career came in 1954 when my group toured with the Duke Ellington Orchestra and I learned so much by observing how he led the band and conducted himself onstage. He was a night owl like me, and so in the middle of the night, we two were frequently the only ones awake on the train. Duke liked to sit in the very last car and over the wheels, so that he could feel the steady clickety-clack rhythm as they passed over the railroad ties. Sometimes, he and I would both be writing music; sometimes we would sit and talk. Those intimate conversations are some of the most treasured moments of my life. Not long after that tour I wrote a piece, an homage to Ellington. I called it "The Duke" and recorded it on my first solo album *Brubeck Plays Brubeck*. Later, Miles Davis and other jazz artists recorded that piece in honor of Duke.

I was thrilled to be there when Duke received the Medal of Freedom from President Nixon in 1969. It must have meant so much to him to be honored as a special guest in the very same room in the White House that his father had worked as a butler. That was a joyful, unforgettable night.

When I received Duke's early Christmas card in May 1974, I knew the end must be near. This was Duke's unique way of saying good-bye to his many friends and telling them, once more, that he loved them madly. The news of his passing came a few days after receiving the out-of-season card. Although forewarned, it was still a blow. I felt that I had lost an important part of my life.

Of course, the music Duke created is still with us, and still inspires. In my six decades of playing jazz piano, there has seldom been a nightclub set or a concert that didn't include at least one Ellington tune. For years "Take the A Train" was my usual encore. It was always greeted with instant recognition and delight, because all of us love Duke "madly."

—Dave Brubeck, pianist, composer, named a Duke Ellington Fellow at Yale University in 1977

Illustration by Mark Ulriksen

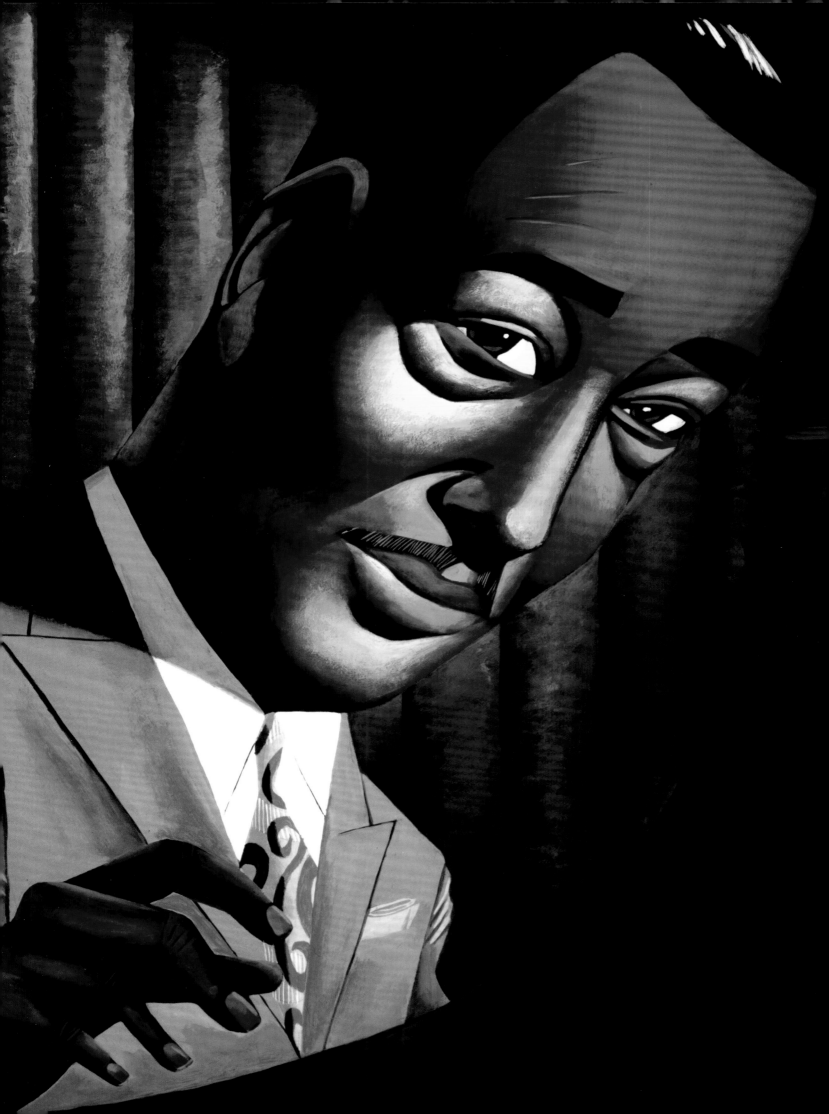

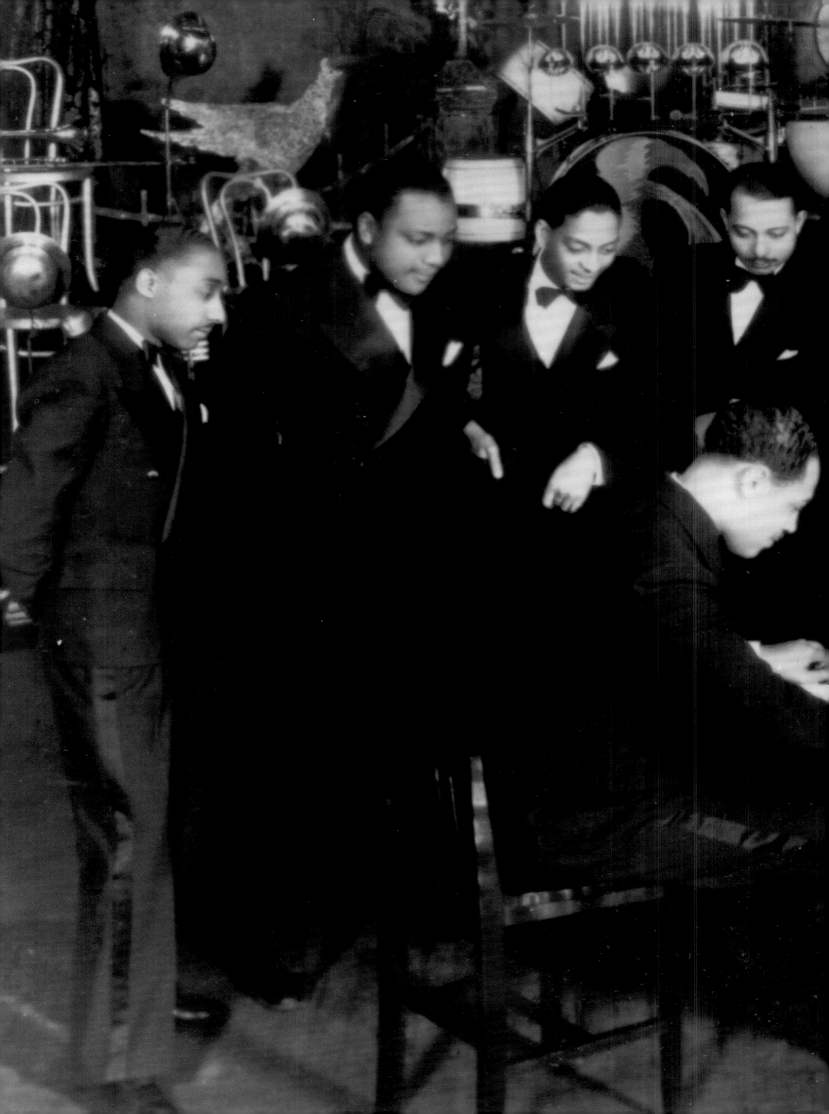

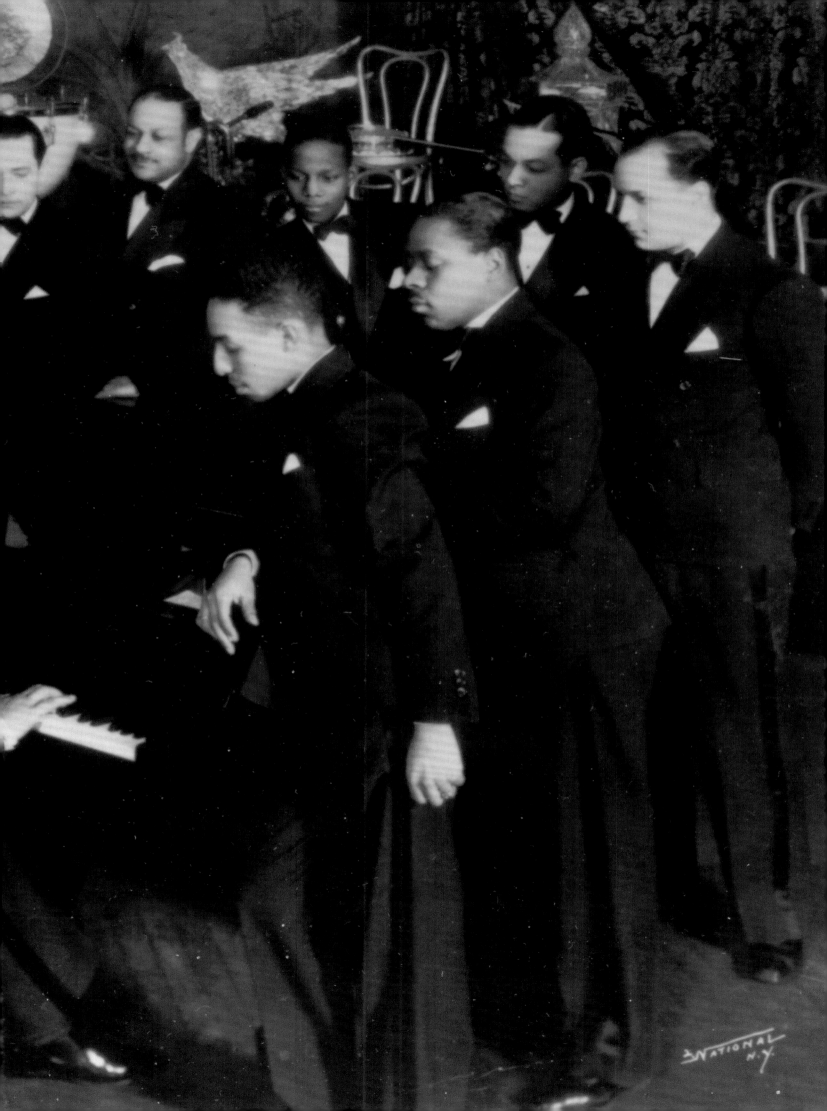

DUKE UNDERSTOOD US

Edward Kennedy Ellington embodied the timeless spirit of humanity through the blues and swing. He made music personified.

He was timeless yet contemporary. He knew what to play when, and where, and how. Most importantly, he knew why. It was just who he was . . .

Duke understood people.

He not only knew what people liked to hear, but also what they needed to hear. With the deepest integrity, he provided them with both.

Duke understood people.

Upon first meeting, he'd instantly assess you as if he had known you in a past life. He'd then charm you to a smile and make you forget your sadness, even if only for that brief moment. He always left you with something special, evidenced in the way that people who knew the Duke speak of him with such great admiration to this day.

Duke understood his people.

All great leaders must have an acute emotional radar in order to effectively lead and accommodate their team. He led a band of rebels and true originals and they all loved him. He was surrounded by people who either worked for him, with him, or just strongly believed in him and they all loved him, too. The genius of his beloved "Swee' Pea" [Billy Strayhorn] felt at home in the Ellington camp for nearly three decades. That's no accident.

Duke understood a variety of people.

He was relatable to queens, kings, and other royalty (after all, he was the Duke). He talked smack with the down-home fellas. He was a ladies' man and could flirt like no other. All women loved him and he them. He was a thinker. Intellectuals study his musings to this day.

Duke understood me.

Who he is to me is a mentor. An inspiration. A guiding light on my quest to become a great artist. He is someone who raises my consciousness, pushes my artistic imagination to its limits, and challenges me to achieve the highest potential of my God-given talent. Though I never met him, he is many things to me. But most importantly . . .

Duke understood us.

Above all, the Duke was a humanitarian of the highest order. The work he left with us on this planet enriches humanity and affirms for all of us that it is okay to be who we are.

Duke understood the people and that's why we the people still love the Duke.

— *Jonathan Batiste*

Illustration by Harry Pincus, courtesy Lincoln Center for the Performing Arts.

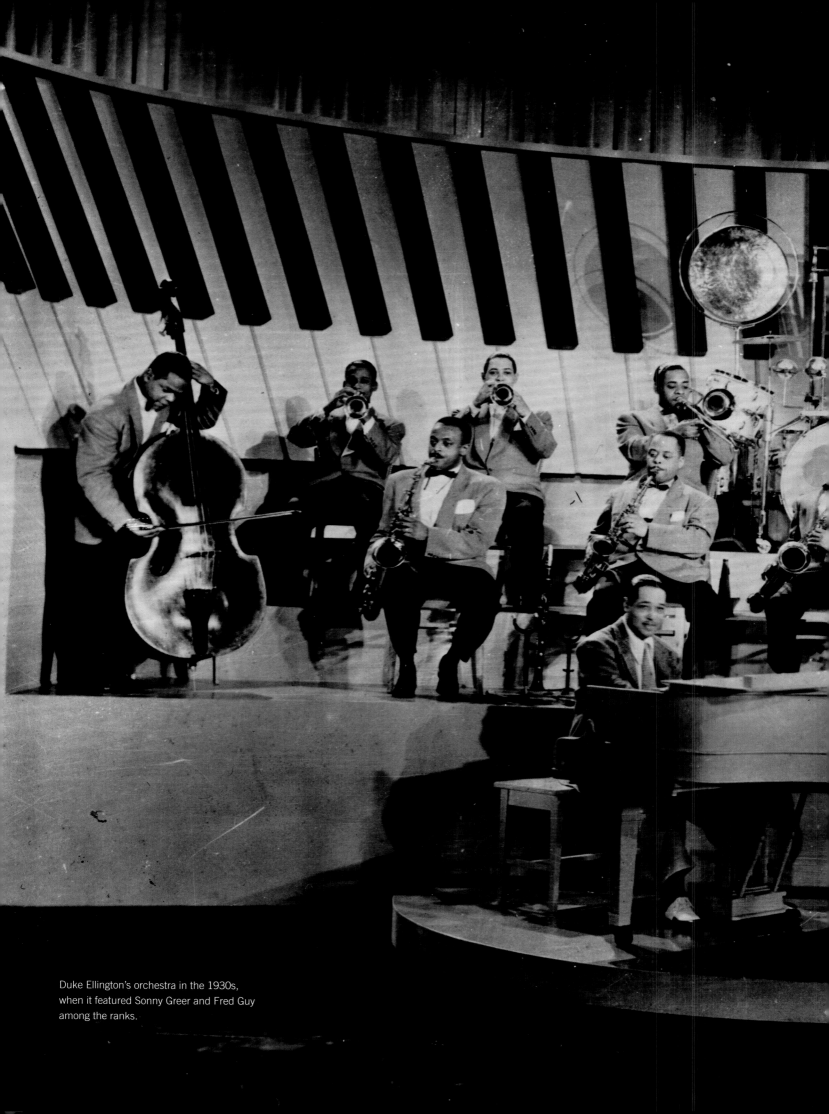

Duke Ellington's orchestra in the 1930s,
when it featured Sonny Greer and Fred Guy
among the ranks.

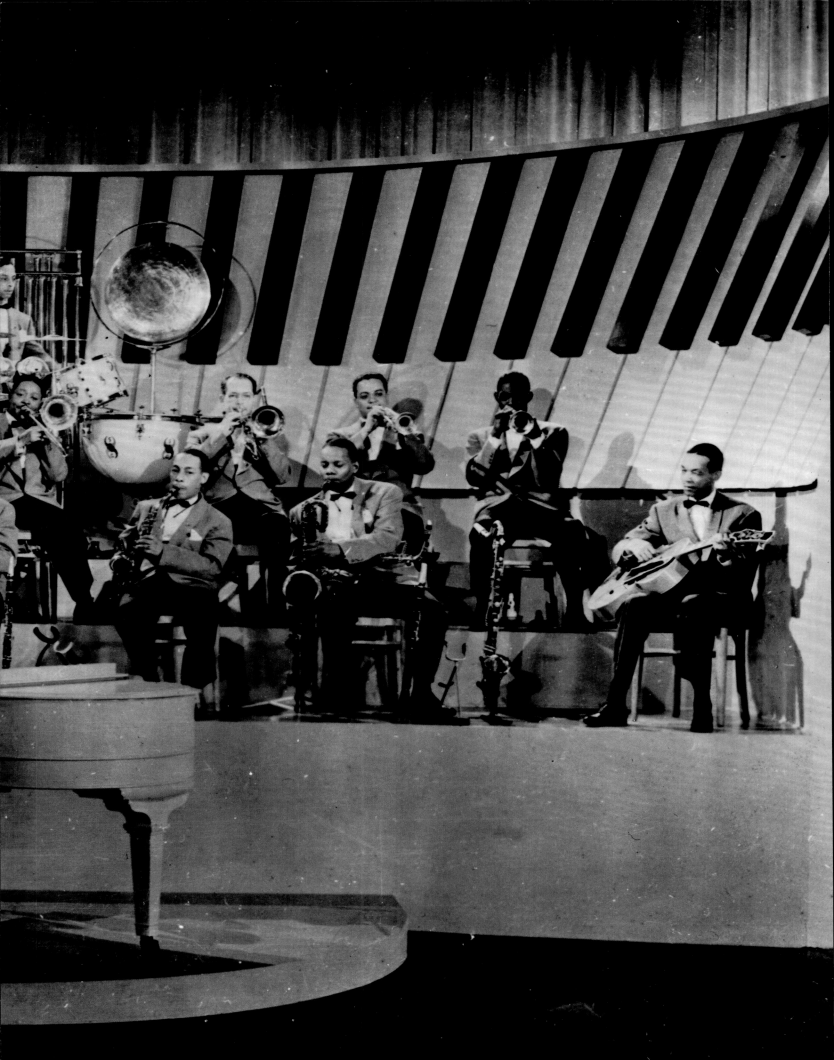

MAESTRO

" I'm honored to meet you." This or something close to it was my standard response upon meeting the several world-renowned composers whose life and work I had the privilege to explore for public television: Darius Milhaud, Carlos Chávez, along with Roger Sessions and Aaron Copland (who appeared as part of the Chávez film). However, in each instance, I added one important word in my greeting: Maestro. It was no different when Ralph J. Gleason introduced me to Edward Kennedy Ellington. I was soon to learn that customs were a little different at the Ducal court. To my astonishment, Duke, with his hands on my shoulders, whispered into my ear, "This is the way it is done: a light kiss on the left cheek, then on the right, and step back. Ciao." Obviously, I was a barbarian who needed an introduction to Continental manners.

The meeting took place in Ellington's Fairmont Tower suite in San Francisco. My film crew and I were to spend the next two and a half weeks following Duke Ellington and his orchestra wherever they performed: Basin Street West, the Monterey Jazz Festival, a recording studio, and the premiere performance of *A Concert of Sacred Music* at Grace Cathedral. And, of course, we recorded all words exchanged between the Duke and Ralph J. Gleason, an eminent essayist and jazz critic for the *San Francisco Chronicle*. Ralph was a longtime champion of Ellington as one the greats of American music, an elite that included Charles Ives, Aaron Copland, and very few others. At the end of our two and a half weeks with Duke, any doubts I may have had about his importance as an artist had vanished. I became a true believer.

I was familiar with the Ellington sound from recordings, but I was not prepared to hear the orchestra close up and in a confined space like Basin Street West.

Illustration by Joe Ciardiello

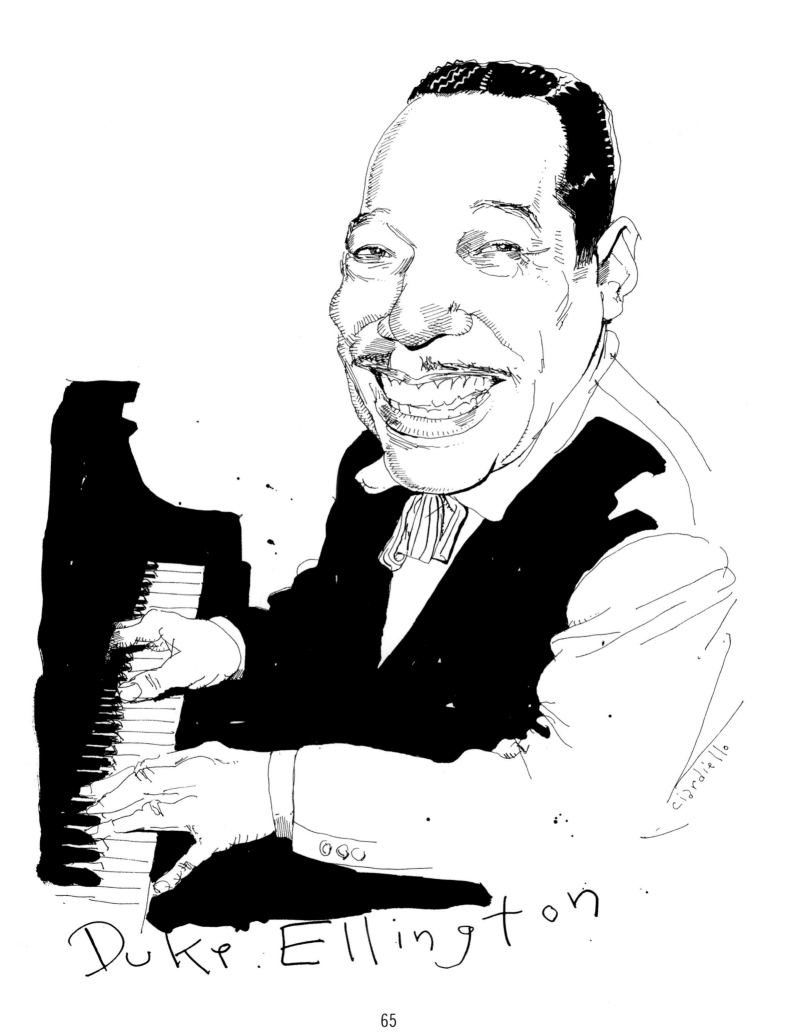

Duke Ellington

At the first crescendo (I was so startled that I can't recall the composition), I felt that I had slammed into a wall of sound. We were to record the orchestra in the bandstand at Monterey, the cavernous Grace Cathedral, the sound-balanced environment of a recording studio, and, on our first night of filming, a shoe box of a nightclub. The Ellington sound was pure in each location.

In conversation with Gleason, Duke recited a litany of compositions, commenting on the circumstance, location, and time to complete each: "'Solitude'—I wrote the whole thing in twenty minutes in Chicago, standing up." In a cramped dressing room at Basin Street West, Duke, in a bathrobe with a towel over his eyes, asked Gleason what he would like to hear in the next set. "Anything you want to play I want to hear," was the reply.

Editing offers the greatest challenge in documentary filmmaking. I don't mean, however, to dismiss creative camerawork or sound recording. For example, we discovered that Ralph J. Gleason's reading of his commentary sounded stilted when compared to the same comments in casual conversation. We, therefore, recorded several hours of conversation between Ralph and me, excerpting what we wanted to use, cutting around the sound of Ralph munching on an apple, and assembling the commentary from fragments of conversation. As mentioned earlier, every recorded word was transcribed. We were amused to read a young transcriber's entry: "My mother used to tell me, 'You're a blast.'" What Duke actually said was, "My mother used to tell me 'You're blessed.'" So much for generational difference.

After several time-consuming false starts we finally had a one-hour documentary and a one-hour record of *A Concert of Sacred Music* ready to show Duke. The next challenge was when and where. Duke and his orchestra were constantly on the road. There was only one West Coast engagement before an extended tour elsewhere in the U.S. Also, the screening had to take place where Duke and his orchestra were performing. We settled on a date and time. We were to show both films in Duke's casino-hotel after work. Under no circumstances was anyone to be invited.

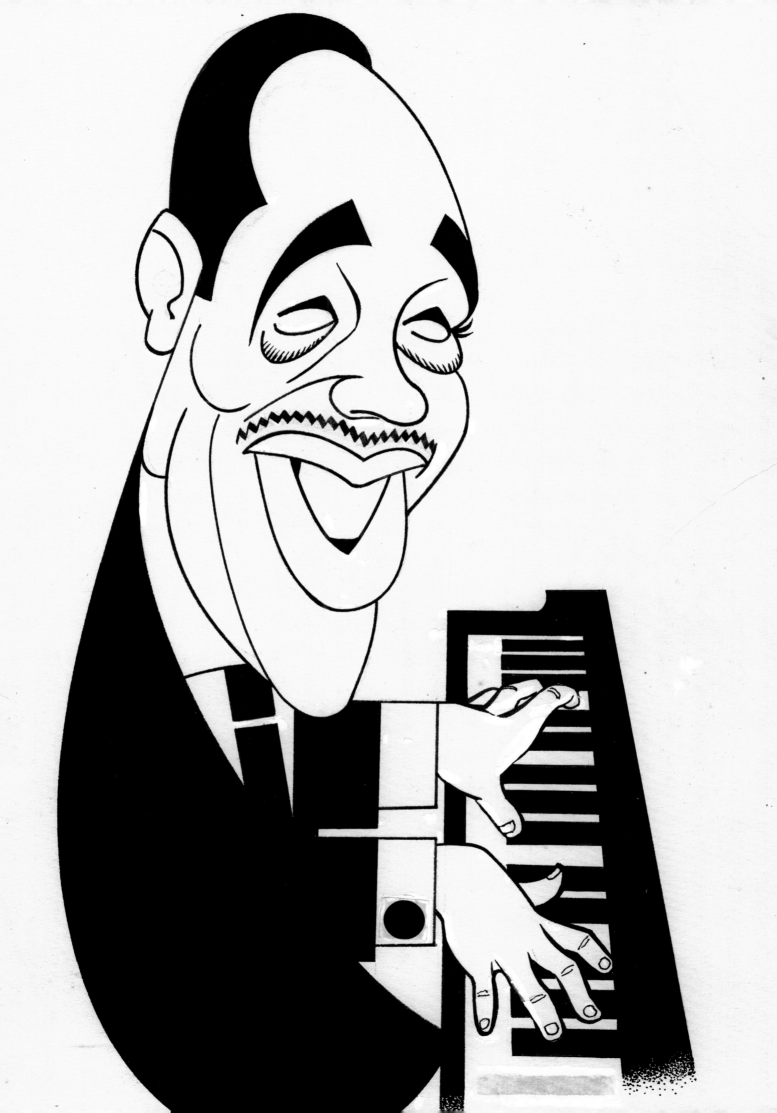

When the assigned day (perhaps I should say night) arrived, cinematographer and editor Phil Greene and I drove to Lake Tahoe's north shore, heading for one of the casinos. It struck me as a painful irony: the orchestra was not booked as a headline act, but instead as the band in one of the cocktail lounges adjoining the gambling floor. Duke and the members of the orchestra seemed indifferent to the circumstance, ignoring people talking over the music and the persistent sound of slot machines. I was reminded of Ralph J. Gleason's remark about the orchestra as Duke's "traveling workshop." I began to understand how, for the maestro, the creative process never took a day off. Duke, in deflecting a question about the economics of maintaining the orchestra, put it this way: "They get the money and I get the kicks!"

We had arranged earlier to set up the cumbersome double-system projector in Duke's hotel suite and as the screening time approached we became more and more nervous. How would the maestro react? The final set of the evening concluded, the lounge was almost empty. All business, the orchestra had disappeared. It was well past 3:00 a.m. when Phil turned on the projector. The first hour went by quickly. Except for a nod that we took to be a nod of approval, Duke made no comment and he remained silent as Phil changed reels for *A Concert of Sacred Music*. During this screening Duke made notes, accompanied by an occasional grunt of disapproval. We wondered, "Was the film that bad?" We learned later from Ralph that Maestro Ellington actually liked the documentary and that his reaction to the concert was to elements of the performance and not to the filmmaking. "OK for a first rehearsal" was the comment reported by Ralph.

On Highway 80 driving back to San Francisco that same morning, both Phil and I were fatigued but, underneath it all, exhilarated. We could now "lock up" each film and deliver the two to NET for broadcast. As Phil drove and I dozed off, scene after scene, sound after sound began to appear. There were moments when the traffic seemed in pulse with "Things Ain't What They Used to Be." Comments drifted in and out, Duke talking about the strong points of some of the soloists: "When Johnny Hodges makes that smeary sound." Memorable images dissolved one into another: Johnny Hodges playing "Jeep's Blues" at Basin Street West and, all the while, his eyes checking out the fairer members of the audience. Later, at Grace Cathedral, that same dispassionate gaze examines the vaulted ceiling. Looking back some forty-eight years, I am forced to confront the dismal fact that Edward Kennedy Ellington and the members of the Duke Ellington Orchestra have left the stage. The show is closed, but not the music, a body of work that has earned Duke Ellington a secure place in the pantheon of great composers of the twentieth century. Ciao, Maestro.

—*Richard O. Moore, poet and documentary filmmaker*

DUKE ELLINGTON

THE PRIVATE COLLECTION

VOLUME NINE
STUDIO SESSIONS
NEW YORK
1968

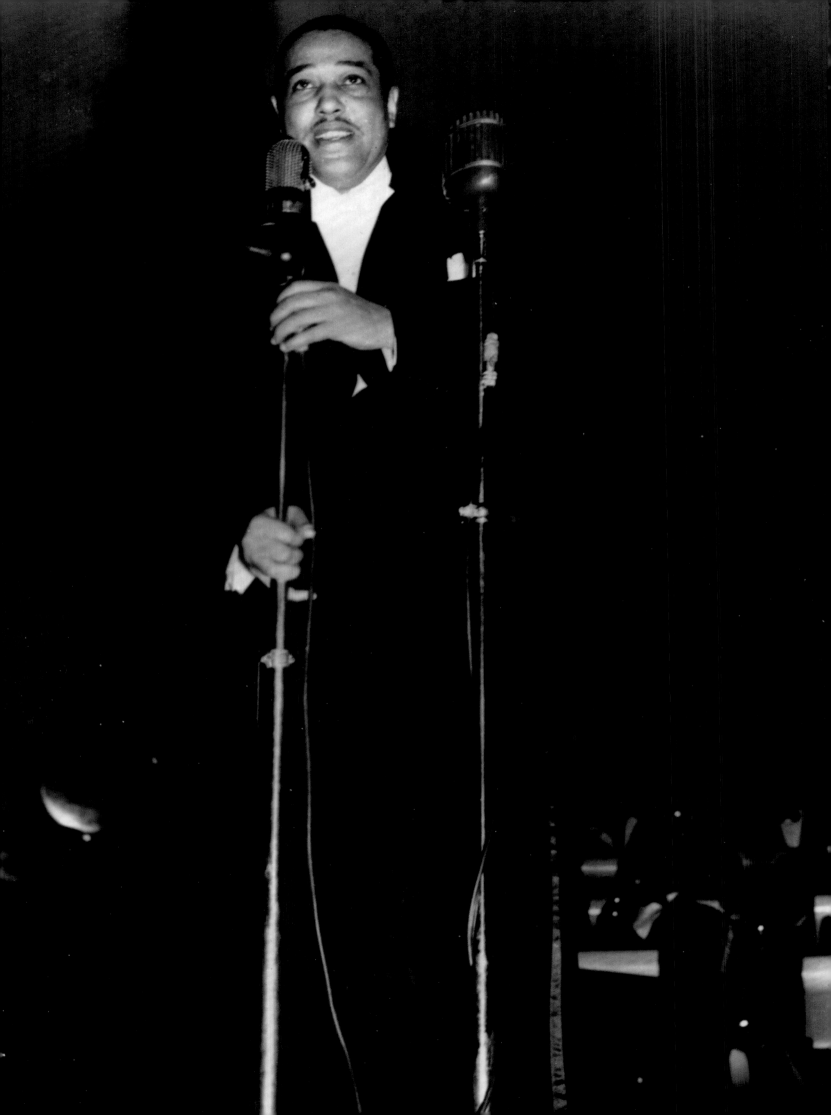

A FIRST MEETING OF THE "DUKE OF ELLINGTON"

As a young child, I met the "Duke of Ellington"—as I referred to him—through my dad (Aaron Bell, an Ellington bassist). For me, he was one of my dad's friends. Certainly, I was familiar with his music and often heard him talked about while listening to conversations my parents had with their friends. I remember how the ladies would go on about how handsome he was and the jazz artists would talk about his musicianship, especially my dad. Even then, I knew he was very important! The day we first met, when he took my tiny little girl's hand in his, then looked at me—displaying his absolutely brilliant smile—I felt as though I knew what some of my mom's friends were talking about. What a charmer! Over the years, and now as a jazz producer and promoter, I have grown to understand, appreciate, and concur with what everyone has said about his masterful talents as a composer, band leader, pianist, and advocate for music. Today, at the end of a Jazzmobile concert, we continue a longtime tradition started by our (retired) production director and a former manager of the original Birdland, Johnnie Garry. We say, " . . . in closing, we end the evening in the words of Duke Ellington, 'We Love You Madly!'"

— *Robin Bell-Stevens,*
Director, Jazzmobile, Incorporated

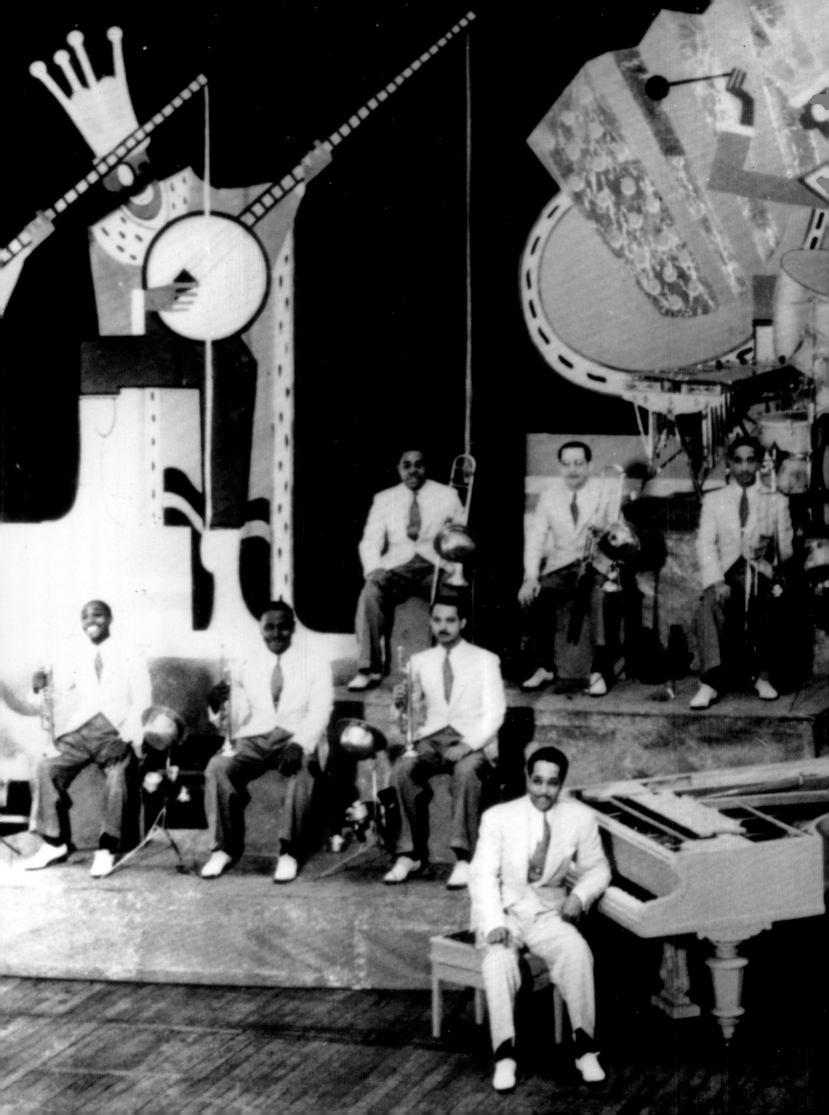

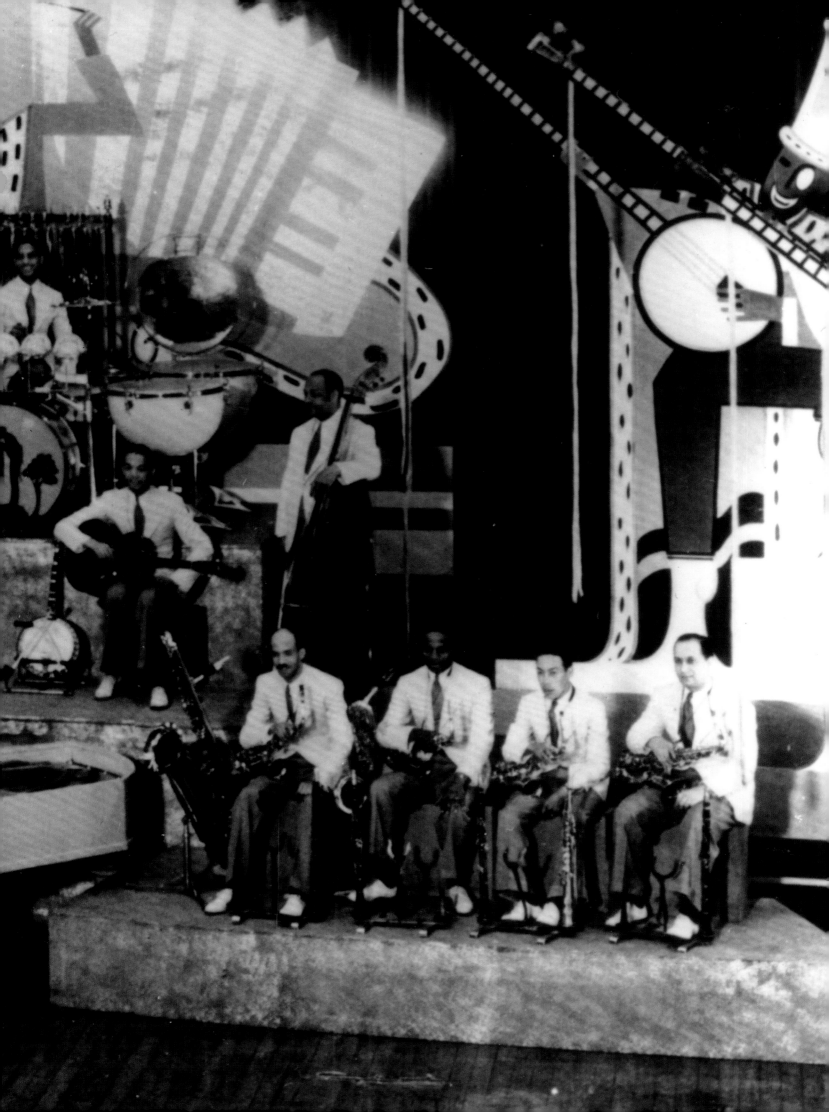

 Duke has been an influence since I was thirteen years old. In 1973, I coproduced, with Bud Yorkin and Norman Lear, a television tribute to him, Duke Ellington . . . *We Love You Madly*, the very first ever filmed in the Shubert Theatre in Century City. We had the most incredible cast: Duke, Count Basie, Chicago, Joe Williams, Sammy Davis Jr., Billy Eckstine, Ray Charles. We had Sarah Vaughan, Roberta Flack, Aretha Franklin, Peggy Lee, James Cleveland. Like Duke Ellington, those are the nights you never forget, ever. Afterward Duke gave me one of my prize possessions, a photo of himself on which he wrote, "To my friend, the great one who has de-categorized the American art—Quincy and his beautiful family. Good luck. Duke 2/73." Duke hated categories and so did I. Duke Ellington is the master and my master!

—*Quincy Jones*

Illustration by Harry Pincus, courtesy
Lincoln Center for the Performing Arts.

THE ELLINGTON MAGIC

Ellington was my first jazz love. Though I was born in Europe—I'm a child of the Swing Era—that music had universal appeal. It started with records (I loved my windup phonograph) and radio, then, just shy of my ninth birthday, seeing Fats Waller in concert in Copenhagen. Even so, it was only in my mid-teens that I became serious about the music and a serious record collector. There was a great store with secondhand records where I spent my meager weekly intake from an after-school job. The discs were stored in bins in no particular order and there was no guidance from employees. My first one by Duke happened to be a pretty famous coupling, "Solitude" and "In a Sentimental Mood," but the next, which was an original U.S. import, a blue label Okeh of "Black and Tan Fantasy," struck me as more exotic, with that unique plungered voice of Tricky Sam Nanton. Thus my acquisitions came in no particular order, chronological or otherwise, and a week's take might yield, say, "Misty Mornin'" and "The Blues with a Feeling" from 1928, and "Dusk" and "Blue Goose" from 1940. This served to underline the infinite sonic and emotional variety of Ellingtonia. By the time I left for the U.S. in the spring of 1947, my Ducal stash had grown to about fifty two-sided 78s.

From then on, while the record collection continued to grow (as it still does), live encounters became the main events. The first was at Harlem's famed Apollo Theater, where the relationship between performer and audience was so special; I'll never forget the collective sigh that emerged from the ladies in response to Johnny Hodges's first note, or the sight of Sonny Greer's fabulous percussive equipment. The band in its prime was a collection of individuals that only Ellington was able to keep together. As I became a professional observer (though I never stopped being an Ellington or Armstrong fan), I had the privilege of attending many recording sessions, which gave me an insight into Ellington's methods, and the reason why even the existence of scores often fail to reveal what actually was performed. For one small example, once when a passage for the reed section failed to fully satisfy the composer's ears, he called on trumpeter Willie Cook (an expert reader). "Willie," he said, "put in your Harmon and double Norris's part." (The "Harmon" is a mute and "Norris" was the alto saxophonist Norris Turney.) What ensued pleased the maestro and was recorded but, of course, the score does not reflect such a subtle change.

There were two especially memorable sessions. First came the long overdue joining of the two greatest figures in jazz (to me, unarguably), Louis and Duke. It was a spur-of-the-moment affair, masterminded by producer Bob Thiele. When he discovered that both artists were in New York and uncommitted, he placed Duke in the Armstrong All Stars' piano chair. The second of the two consecutive sessions, which took place in the early afternoon (the previous had ended well past midnight), was the one I was at, and the way the two protagonists collaborated was a joy to behold. All the tunes were from the Ellington treasure chest, and Louis surprised Duke with a special set of lyrics he'd created for "Drop Me Off at Harlem." The way they joined forces on "I'm Just a Lucky So and So," essentially a duet, was special, then Duke pulled out the sheet music to "Azalea," a song with his own lyrics (that he said were inspired by a passage in Louis's first autobiography, *Swing That Music*), which he had never been able to record in a satisfactory manner. As was his way, Louis soon declared himself ready to try the new piece, and to Duke's delight, even the very first attempt nailed the essence of that sweet, romantic song (which, among other poetic conceits, rhymes the title with "assail ya").

The other special occurrence was an outgrowth of the first: Since Thiele, recording for Roulette, had not cleared the use of Ellington with his label, Columbia, the

latter asked for the services of the Count Basie Orchestra in return, and thus the memorable encounter between the two greatest bands in jazzdom came about. This took place in Columbia's acoustically marvelous 30th Street Studio, which, foolishly sold to a real estate developer, could do sonic justice to a thirty-two-piece orchestra. What was clear from the start, after the ingenious disposition of the joint forces by the engineers, was that Basie deferred to Duke (and the discretely present Billy Strayhorn) in all musical questions. When Duke suggested that Basie play the introductory piano role on "Take the A Train," Basie suggested Strayhorn instead, and that was what happened. The collegial spirit was palpable, and transferred to the unsuspecting neighborhood bar upon which almost all hands descended for the break. All returned on time and in good shape, and the session was a warm and wonderful experience over which Duke presided like a benevolent general.

Duke would always refer to himself as "the piano player" in the band, and he was indeed remarkable in that role. One always wanted to hear more of him, however, and that urge was satisfied, in my experience, three times, all of which were in New York City. There was the Museum of Modern Art recital in 1962, with Aaron Bell and Sam Woodyard; another at Columbia University, with Woodyard and Peck Morrison, at which Strayhorn and Willie "The Lion" Smith guested, in 1964; and one eight years later, at the Whitney Museum of American Art, with Joe Benjamin and Rufus Jones.

At all three of these events, there were times when Duke would play unaccompanied, to everyone's delight. Not many of us who witnessed that 1972 concert at the Whitney knew that, aside from having presided over a performance of his Sacred Concert the night before, he and the band had only just returned the day before from a seven-week tour of the U.S., which had begun immediately after a thirty-six-day odyssey that took them from Japan to Taiwan to the Philippines to Hong Kong to Thailand to Burma to India to Ceylon to Singapore to Malaysia to

Indonesia, once again to Singapore, then to Australia and New Zealand and finally Hawaii! Nine U.S. one-nighters after the recital, Duke would celebrate his seventy-third birthday one day late, at Newark Symphony Hall, greeted by three thousand schoolchildren.

Needless to say, if you knew Duke Ellington, the piano recital at the Whitney was a wonderful experience, filled with the fabled Ellington charm, and remarkable in how he got his hands to work so well in coaxing that commanding sound from the piano. We left the museum that night elated—as was always the case after having been in the presence of Duke Ellington, that magician of wit, warmth, and wisdom. To have been in his presence was a very special blessing.

— *Dan Morgenstern, Jazz critic, author, and former director of the Institute of Jazz Studies at Rutgers University*

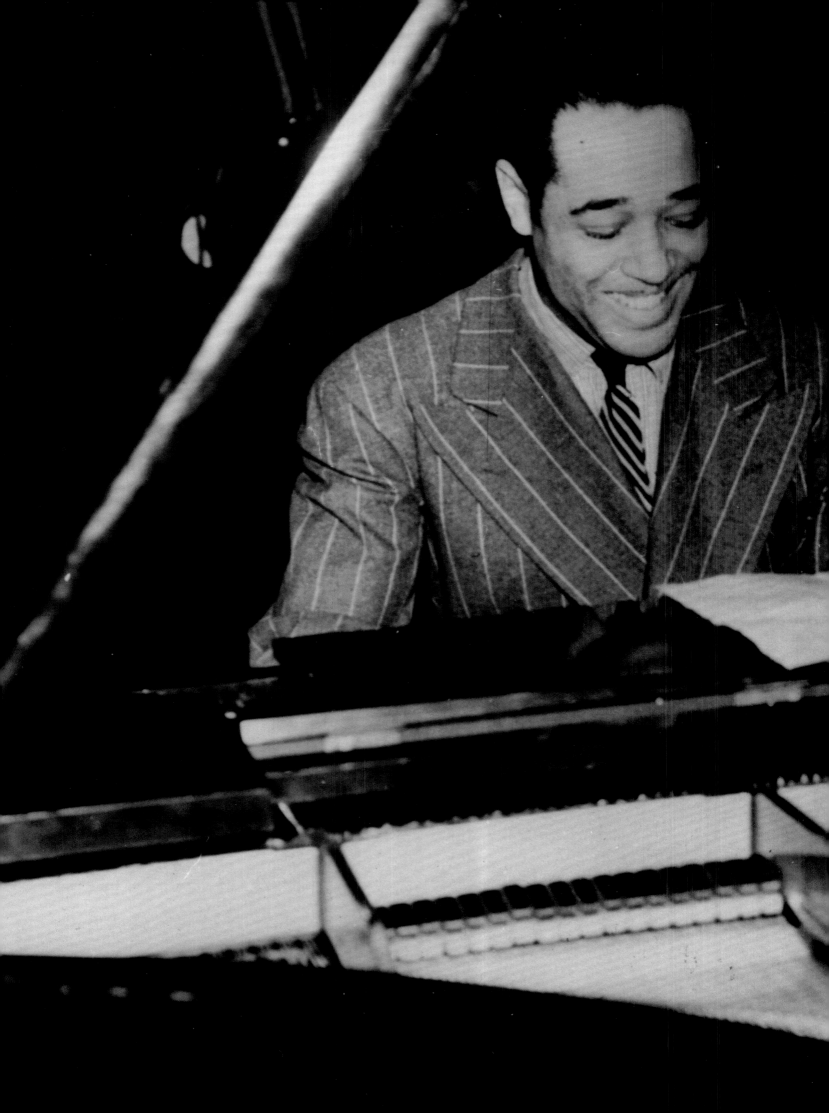

"My biggest kick in music -playing or writing- is when I have a problem. Without a problem to solve, how much interest do you take in anything?"

— Duke Ellington

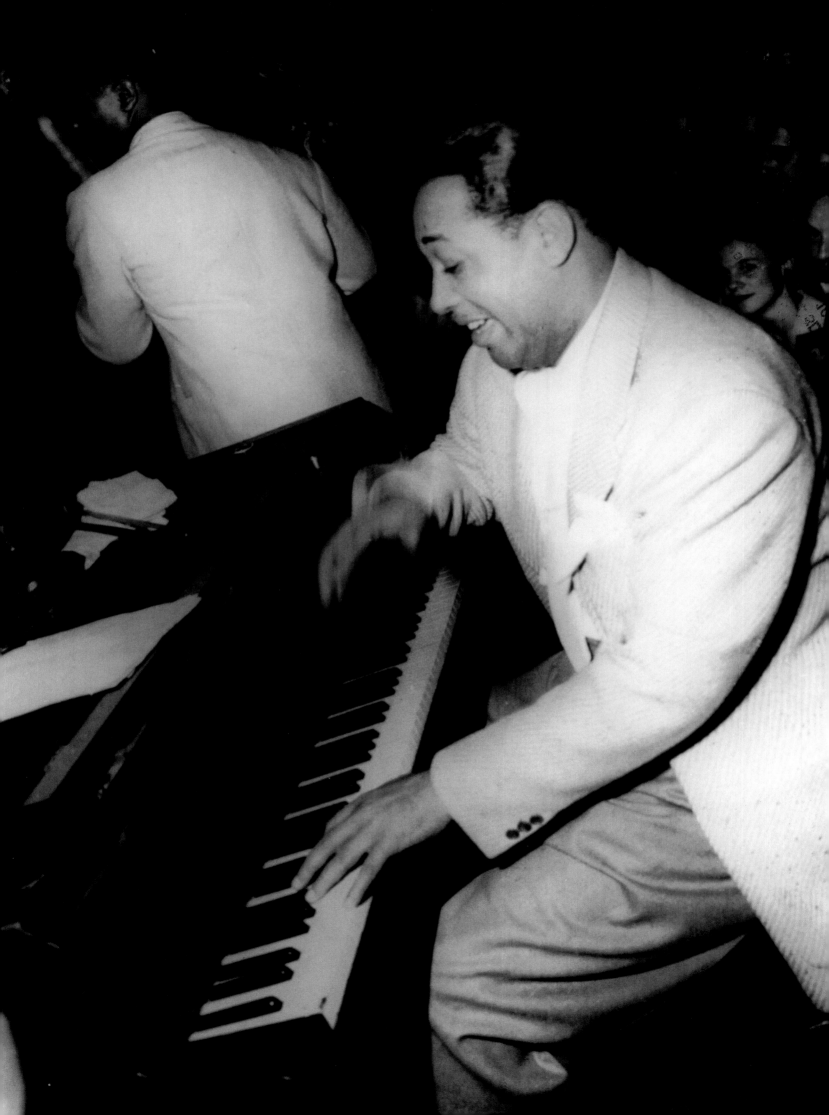

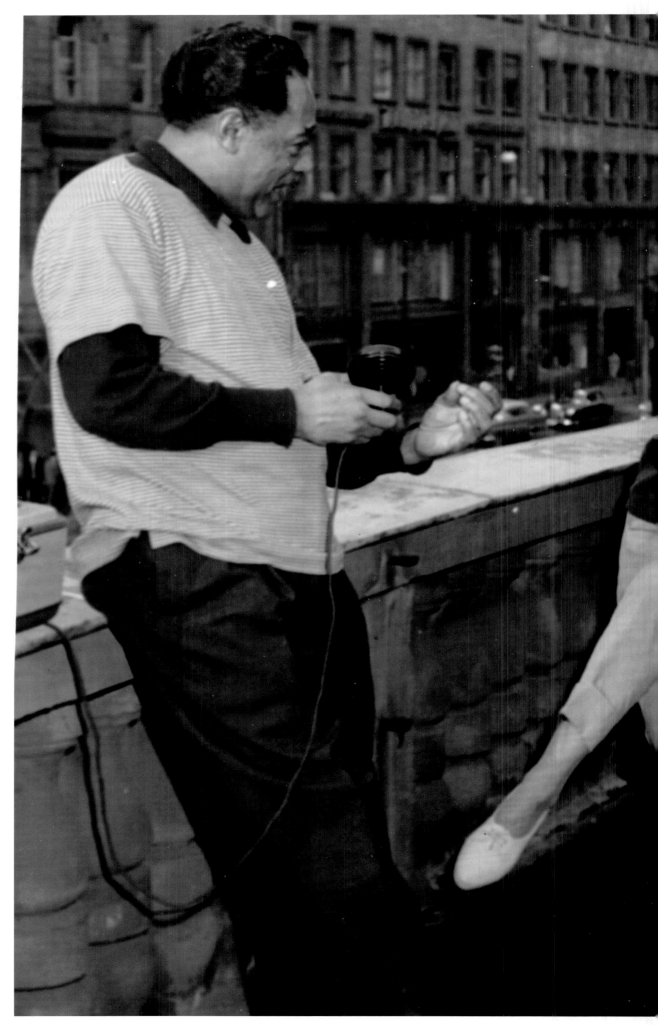

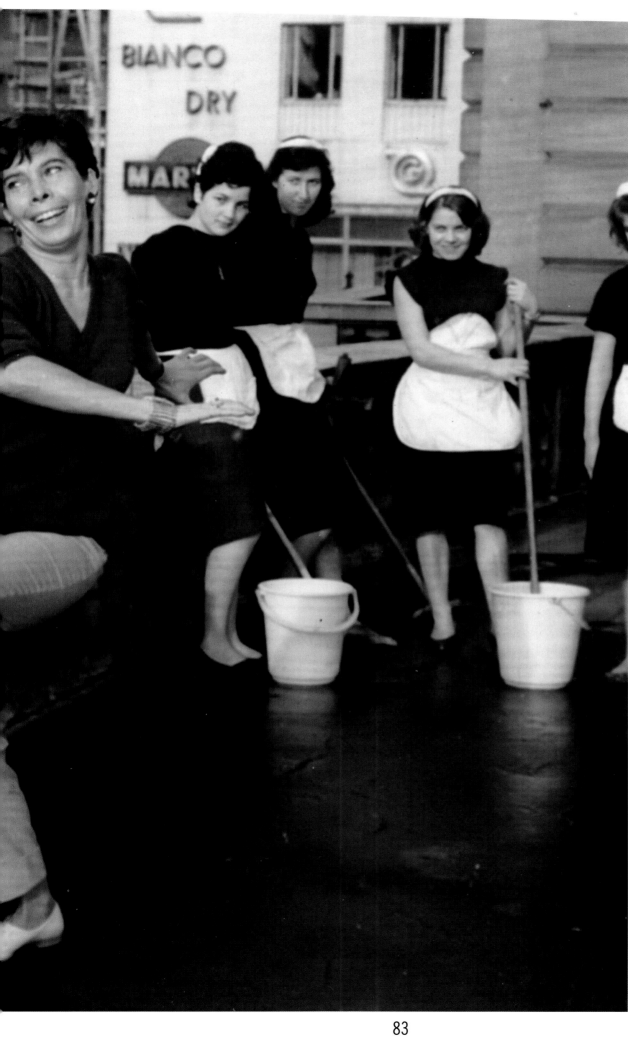

Duke on the rooftop of
a theater in the garment
district in midtown
Manhattan, with dancers.

"Duke Ellington and Louis Armstrong were the greatest jazz musicians of all time."
- Bing Crosby

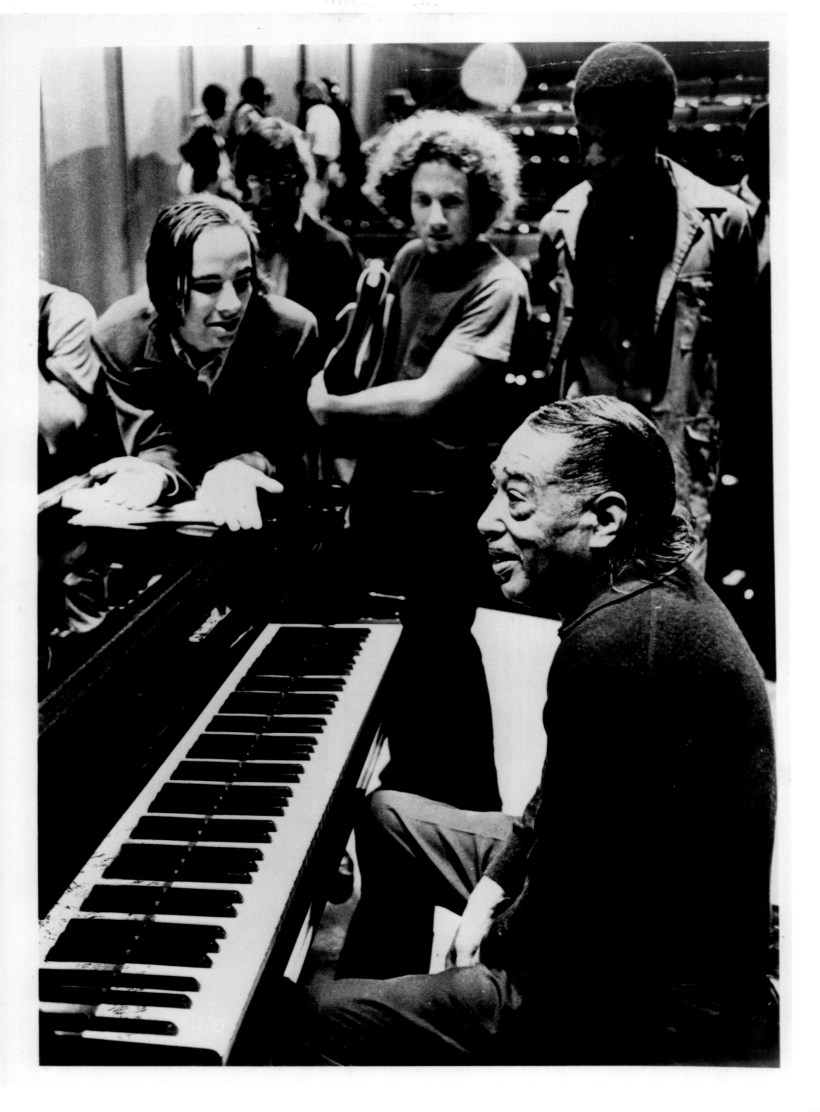

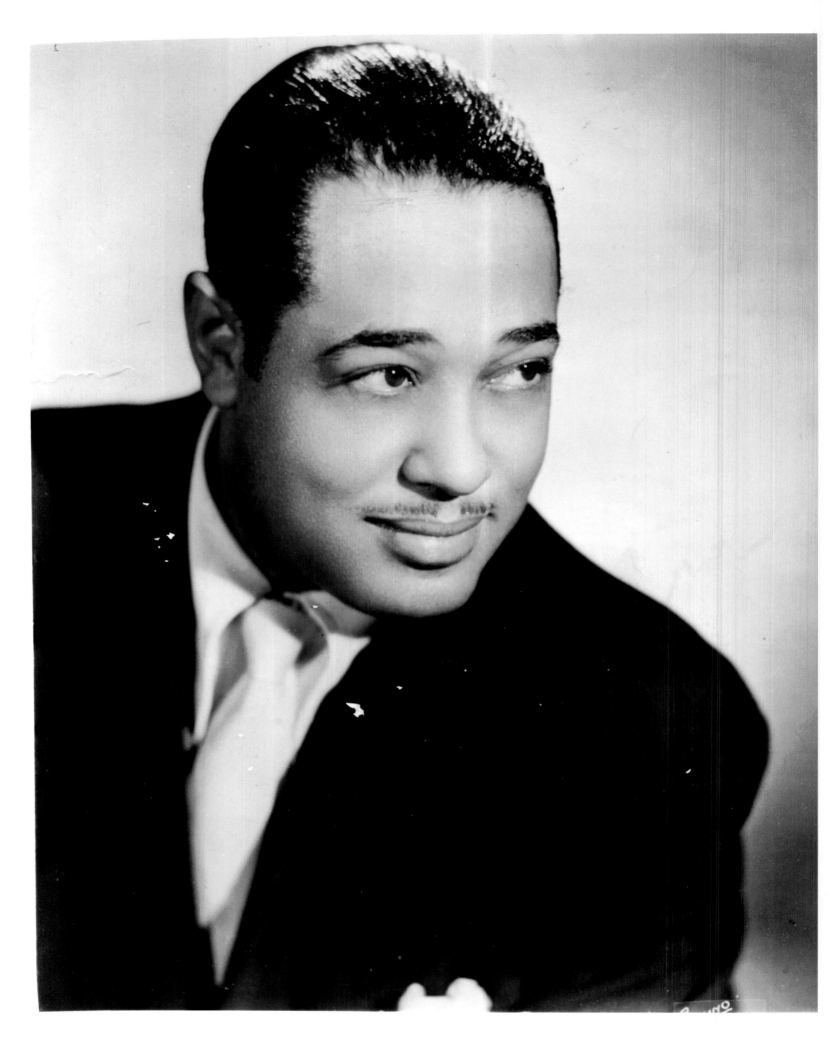

86

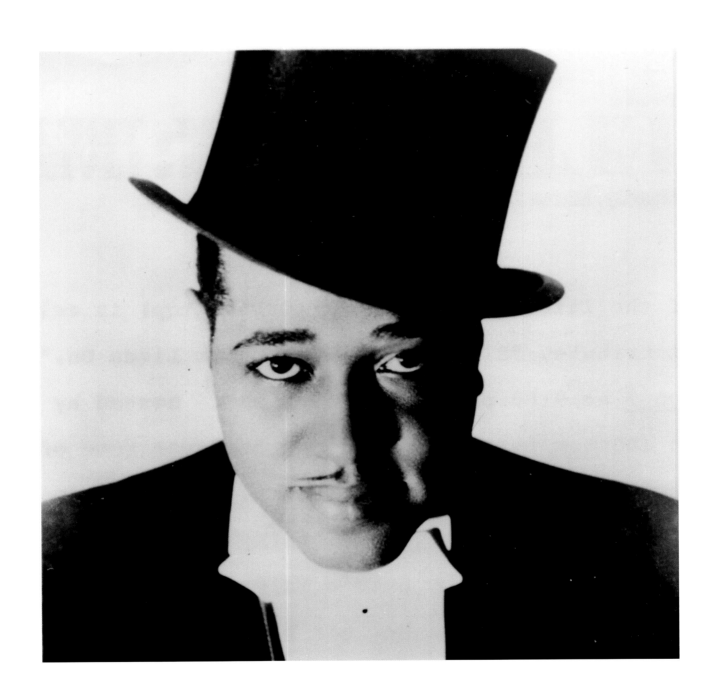

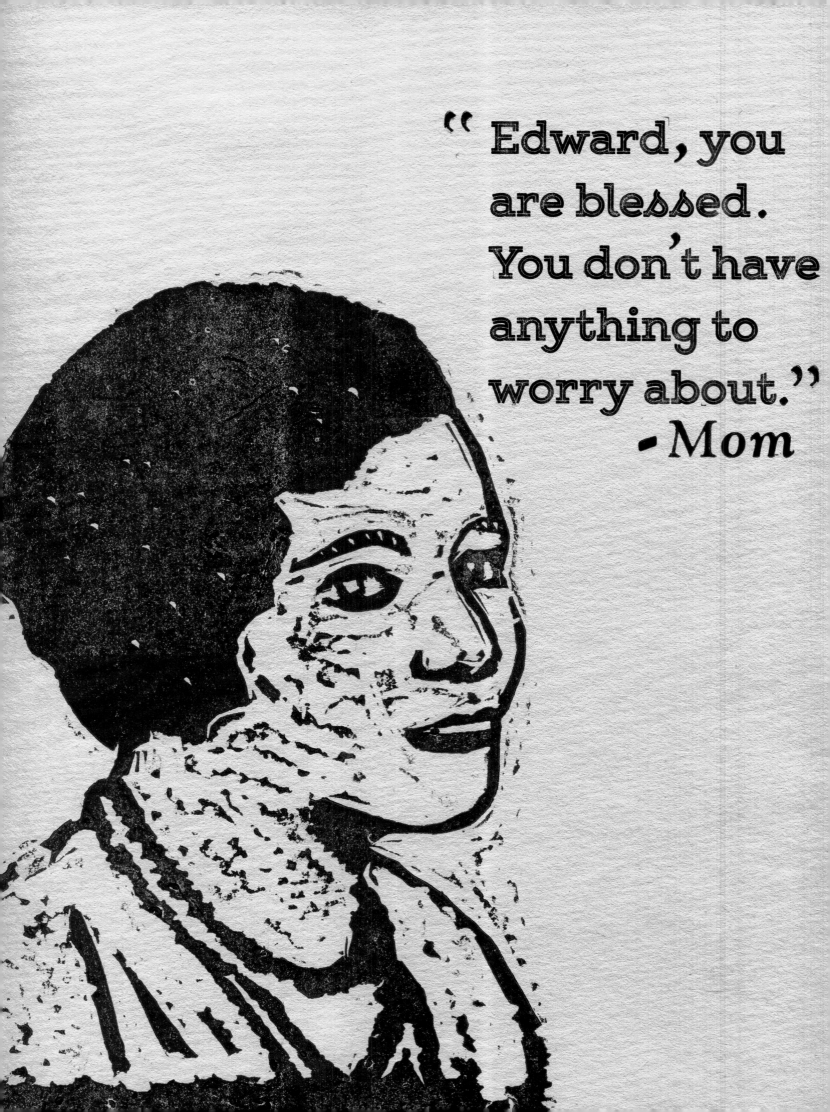

" Edward, you are blessed. You don't have anything to worry about."
- Mom

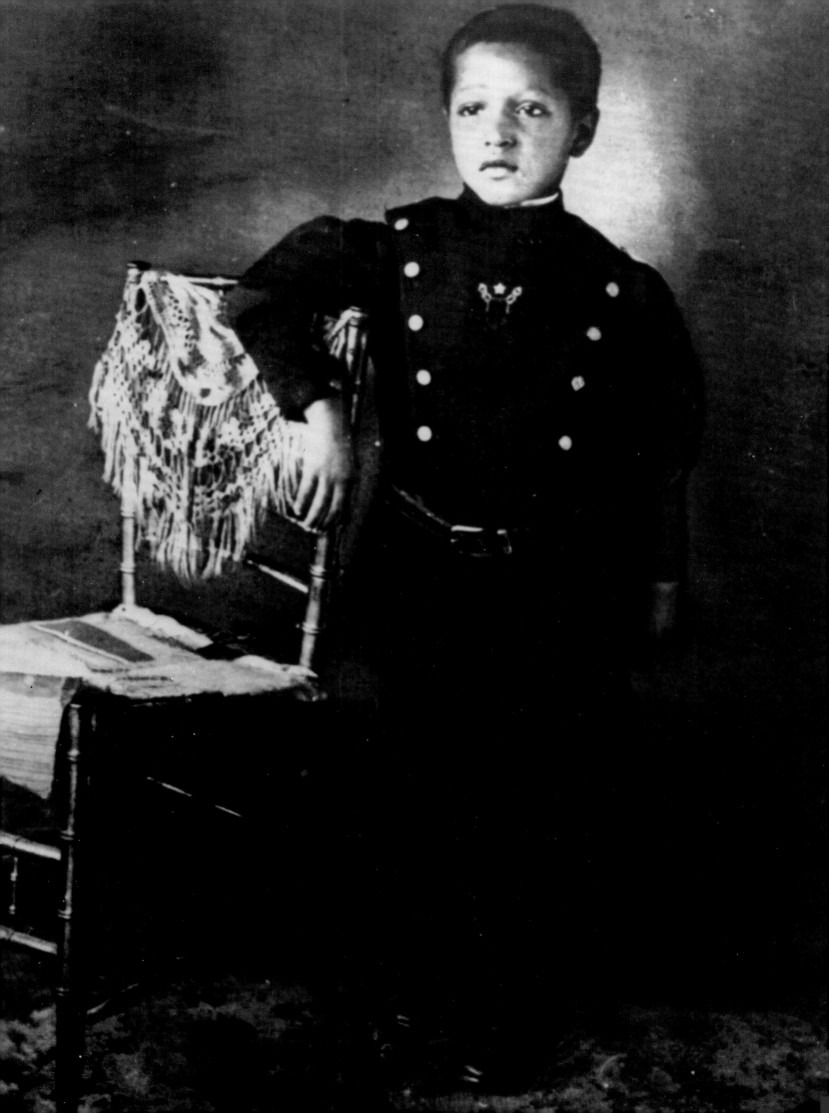

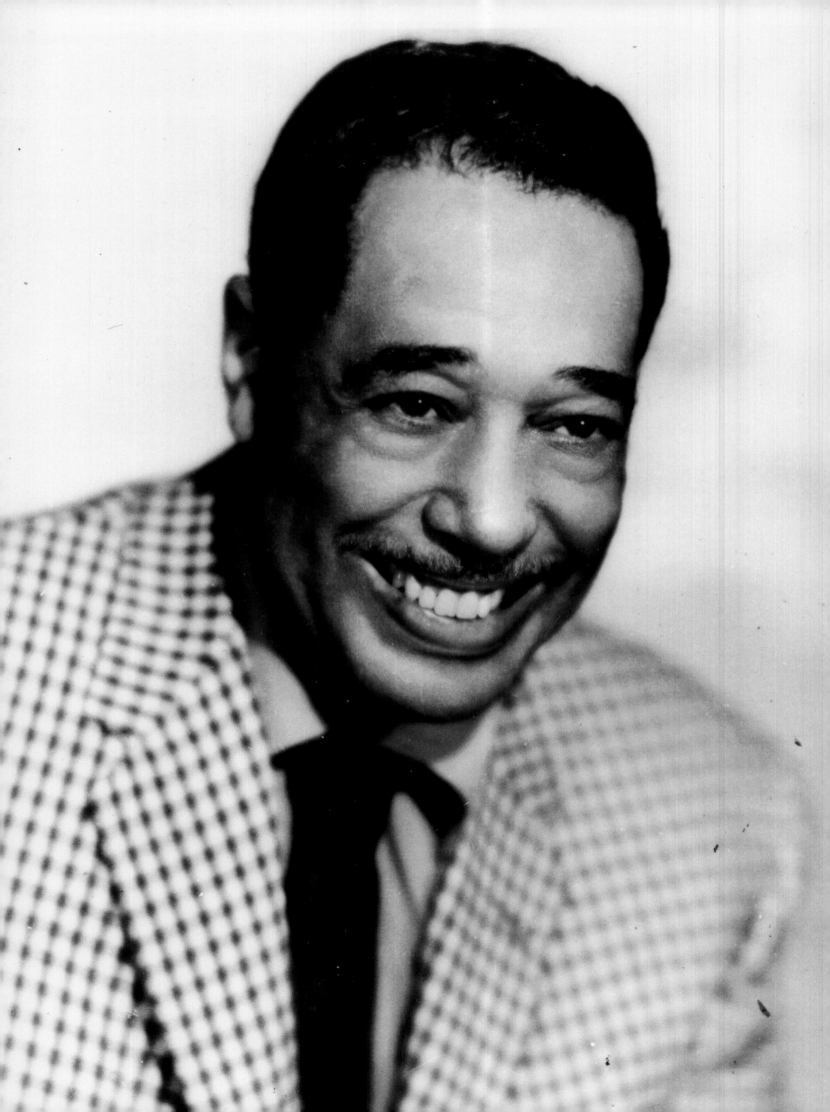

"Fate is being kind to me. Fate doesn't want me to be too famous too young."

— DUKE ELLINGTON

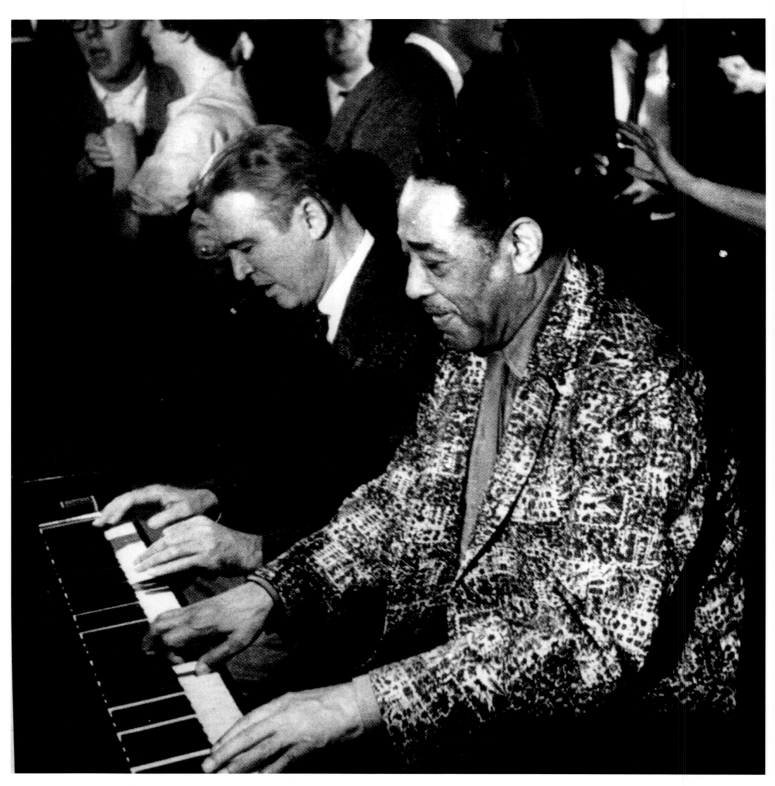

With James Stewart on the set of *Anatomy of a Murder*.

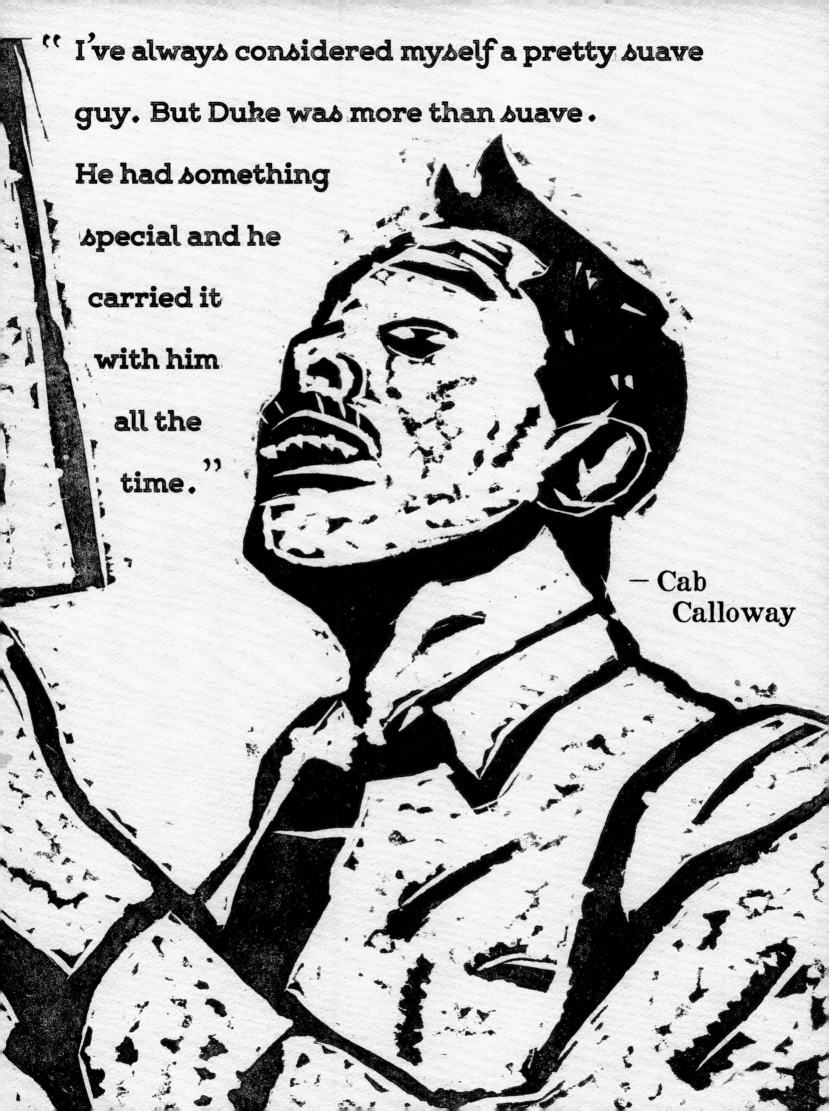

" I've always considered myself a pretty suave guy. But Duke was more than suave. He had something special and he carried it with him all the time."

— Cab Calloway

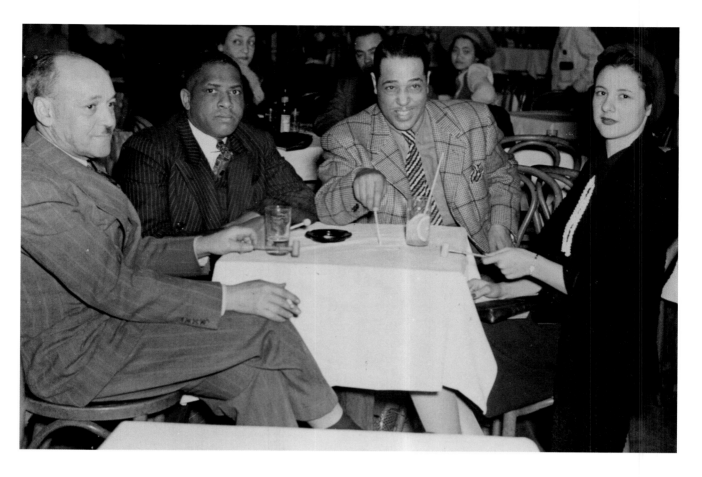

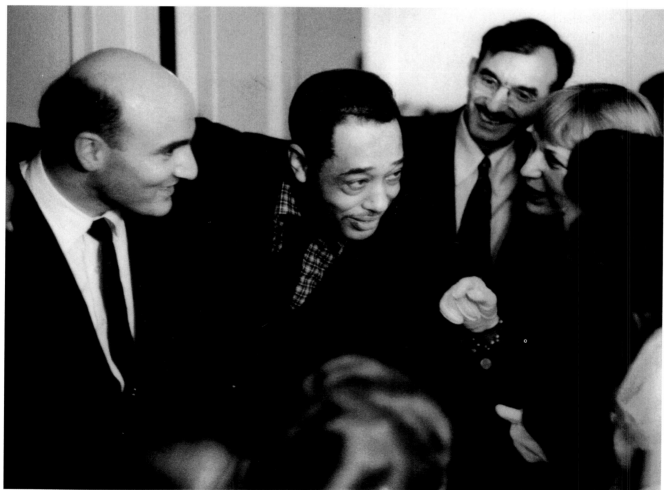

TOP: Duke with Evie Ellis and two friends. ABOVE: Duke with George Avakian and fans. RIGHT: Duke with Phoebe Jacobs and another vocalist, outside rehearsals at the Rainbow Room.

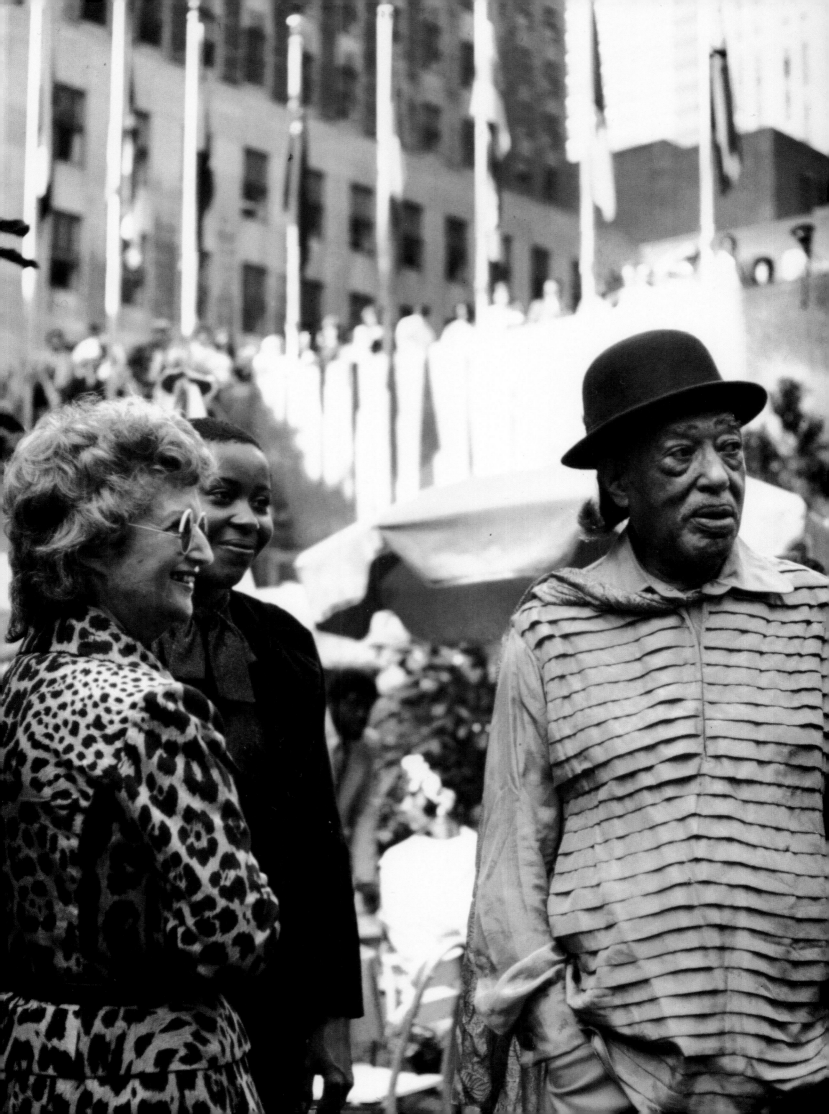

Painting by Kent Drake

Duke puts
everybody
on. - Miles
Davis

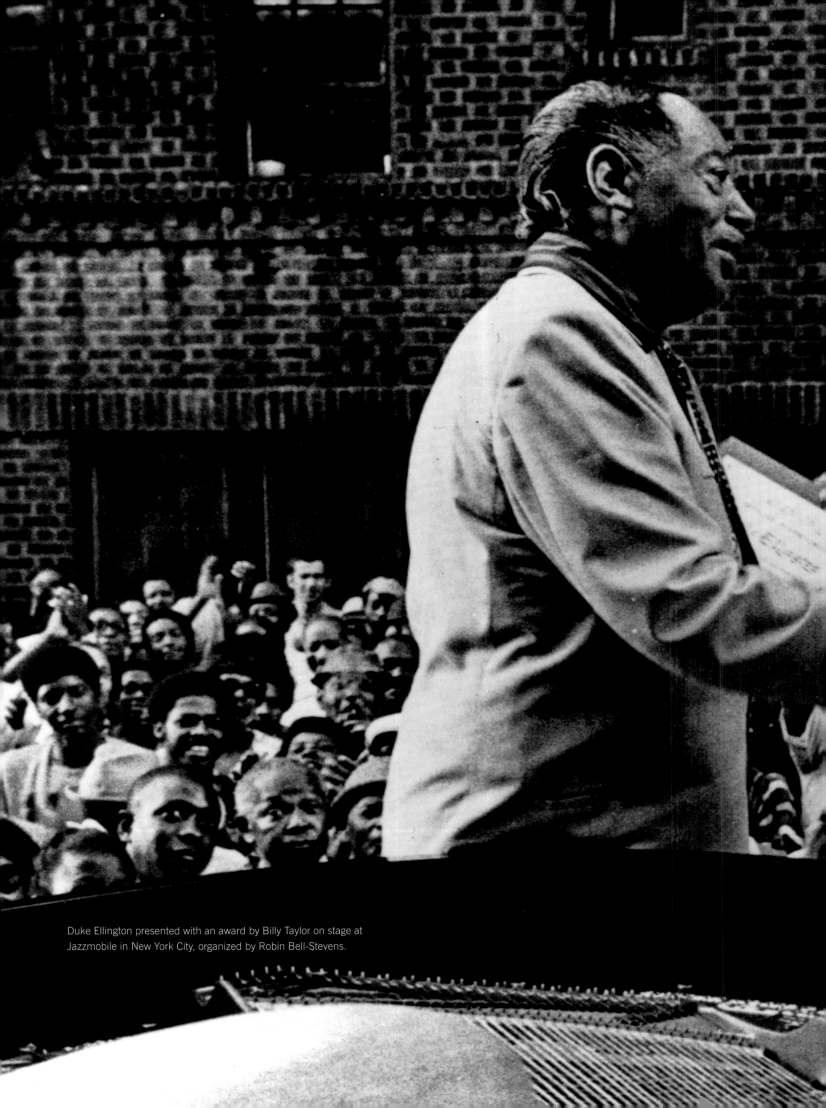

Duke Ellington presented with an award by Billy Taylor on stage at Jazzmobile in New York City, organized by Robin Bell-Stevens.

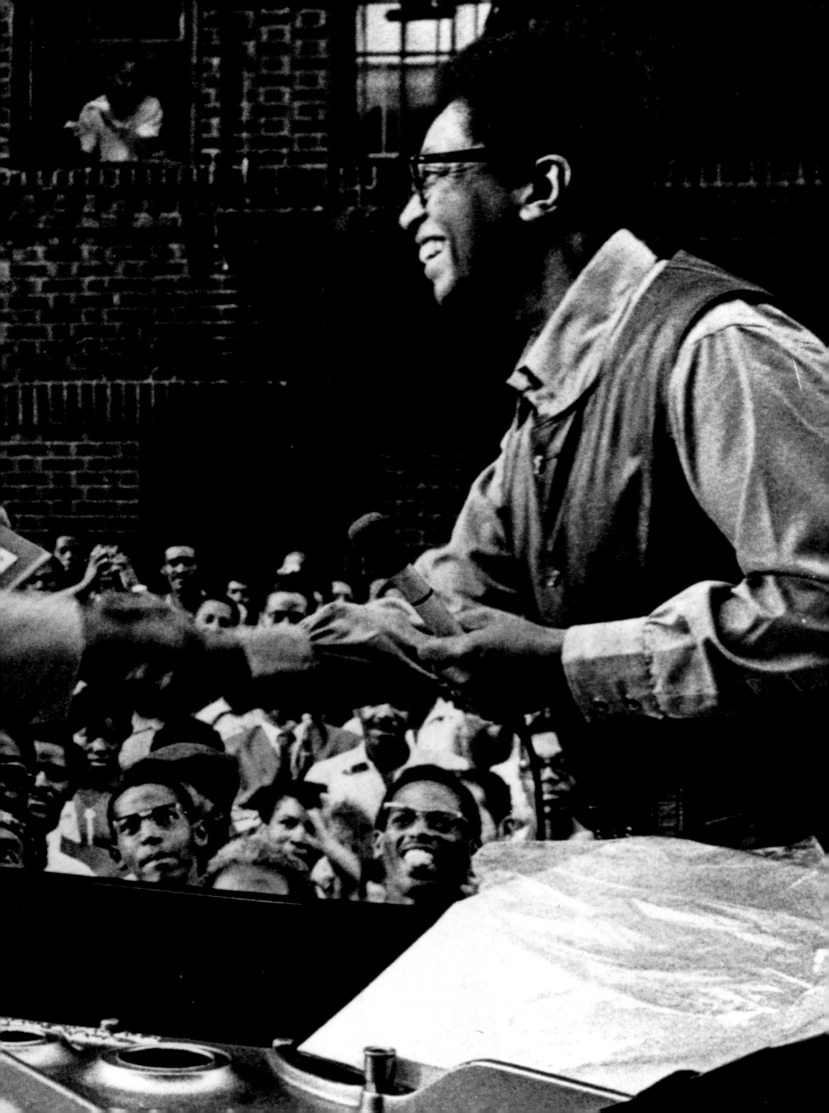

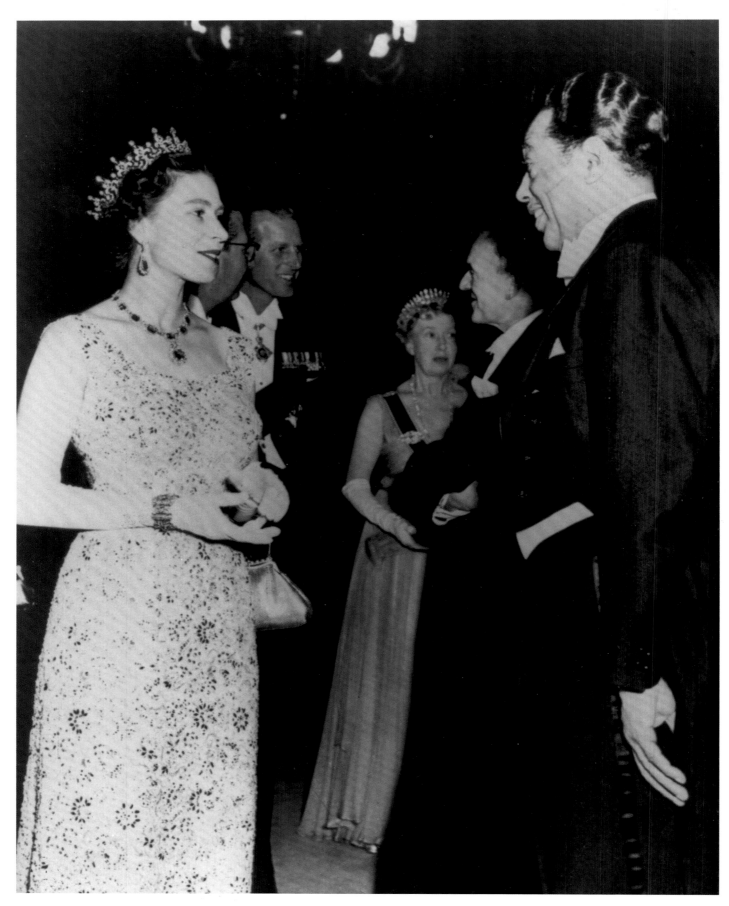

ABOVE: Duke with Queen Elizabeth, 1959. RIGHT: The same year Duke celebrates his sixtieth birthday with Evie.

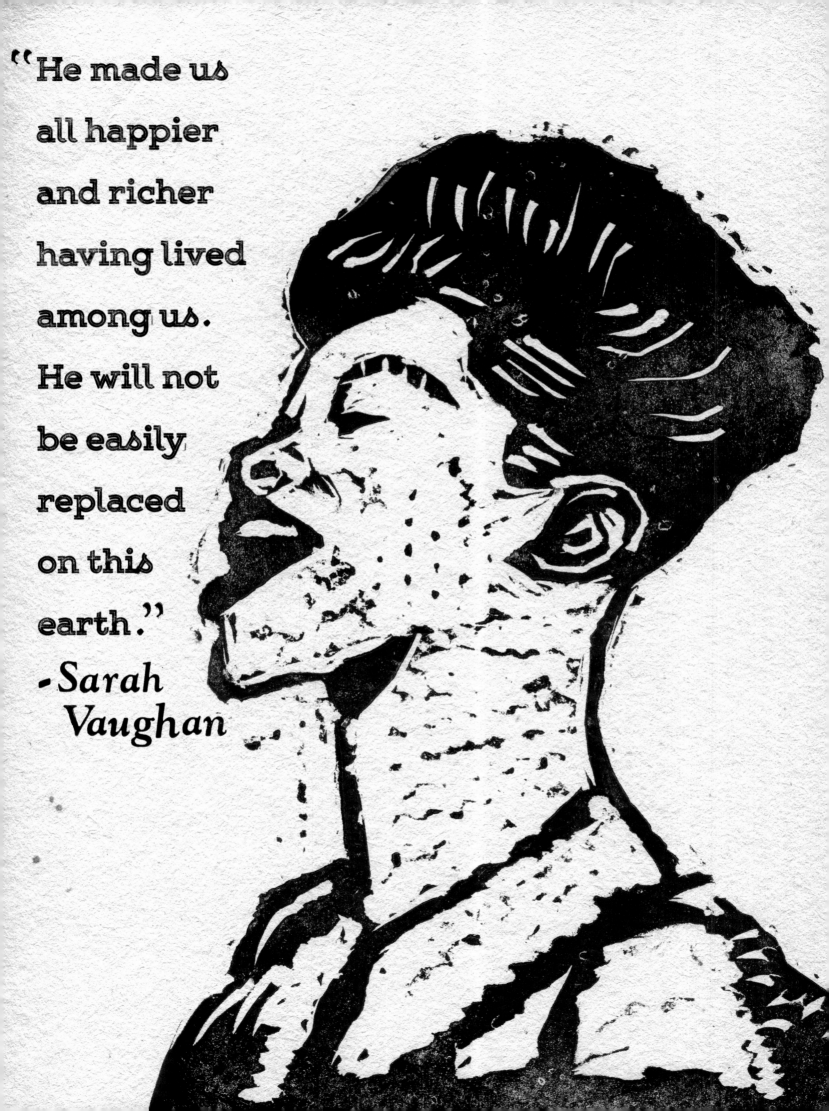

"He made us all happier and richer having lived among us. He will not be easily replaced on this earth."
- Sarah Vaughan

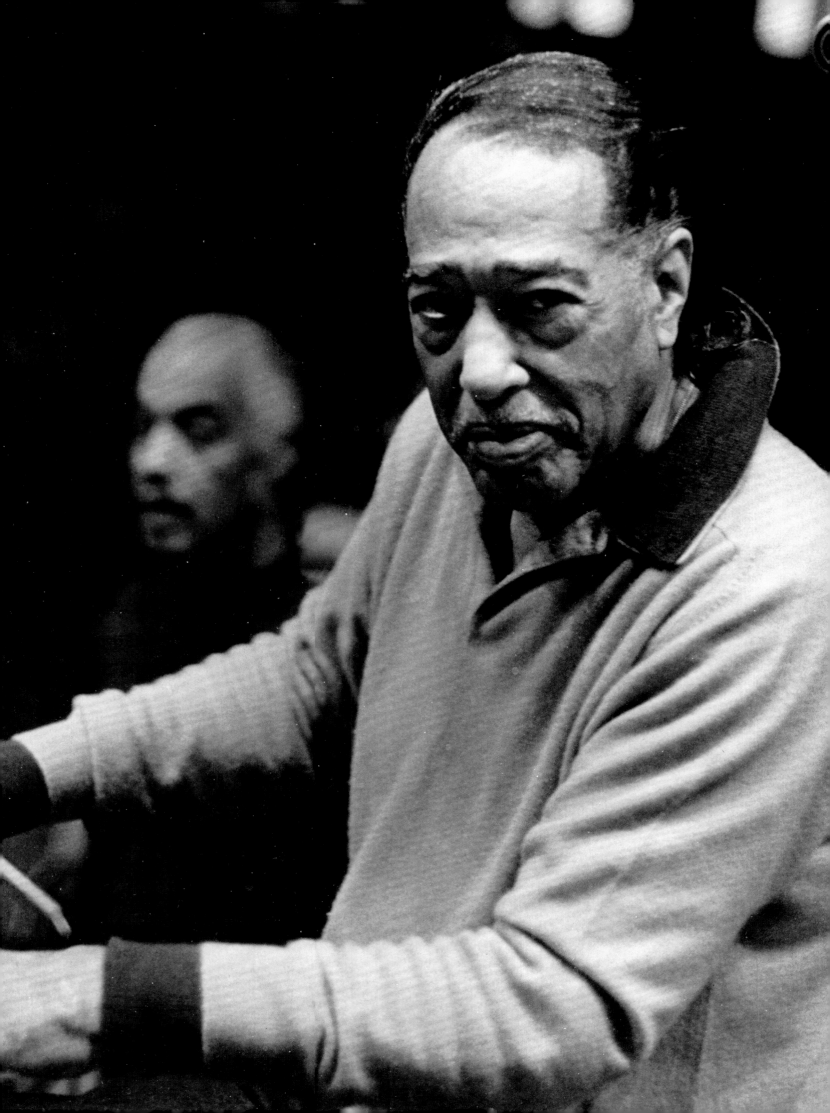

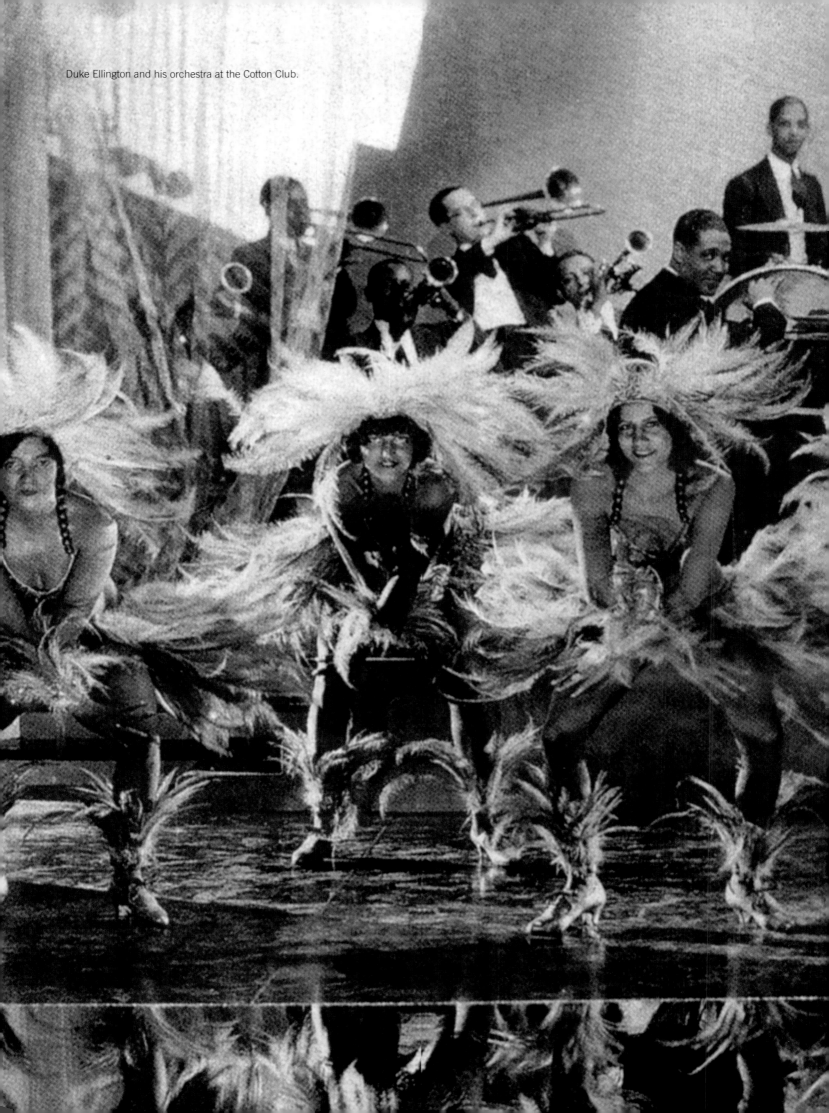

Duke Ellington and his orchestra at the Cotton Club.

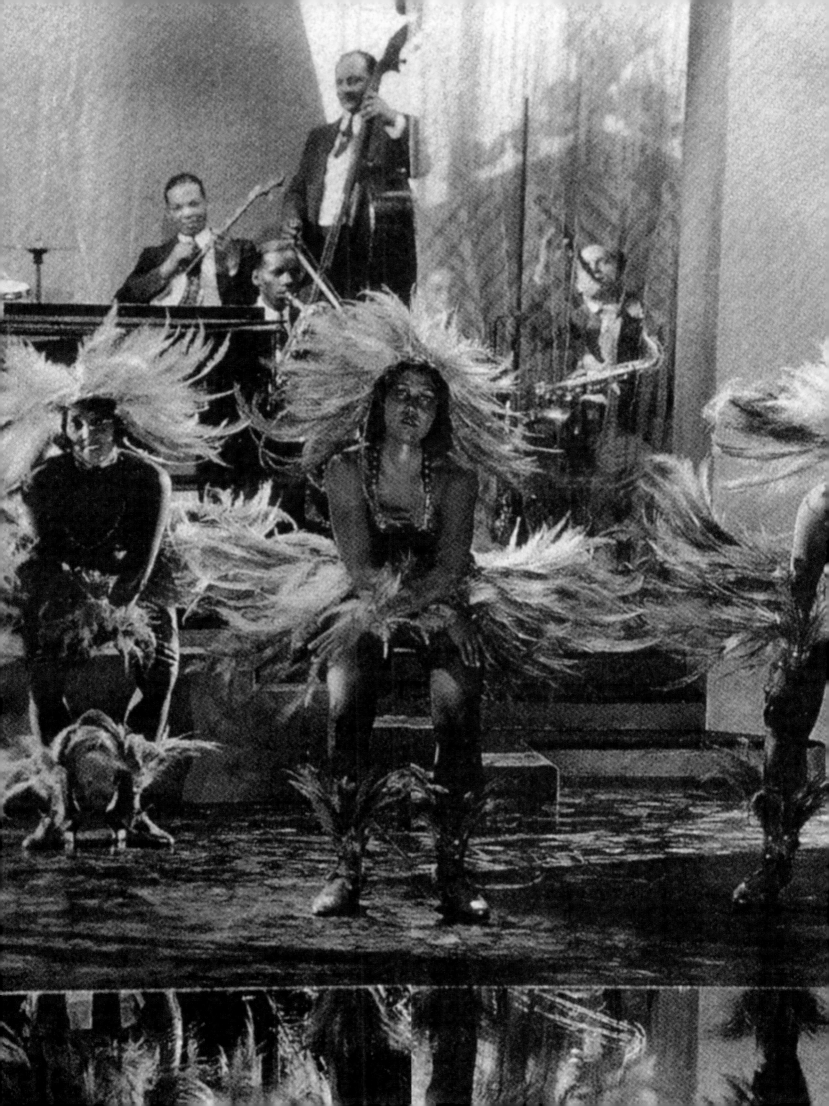

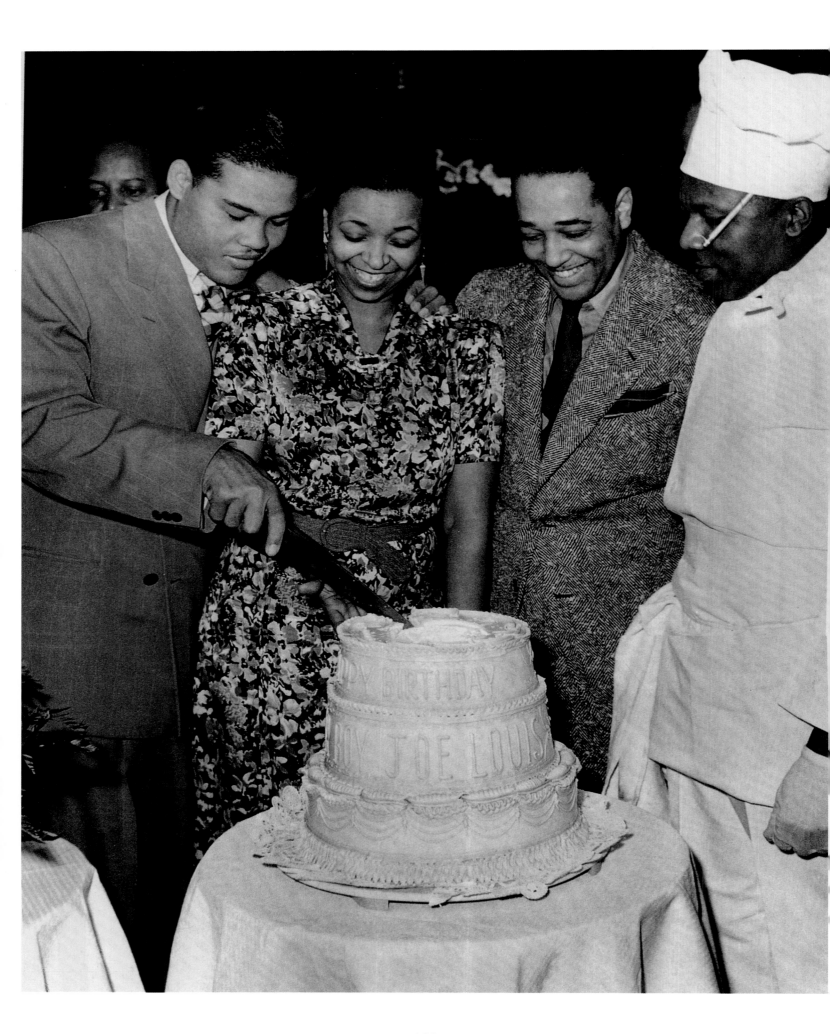

"I had a pal when I was in school who was a pretty flashy dresser and had pretty high social aspirations and he was a wonderful guy and a great pal and I think he felt in order for me to enjoy his constant companionship, I should have a title, so he called me the Duke, and it has been there ever since."
— DUKE ELLINGTON

LEFT: Birthday party for Joe Louis (left), with Ethel Waters and Duke.

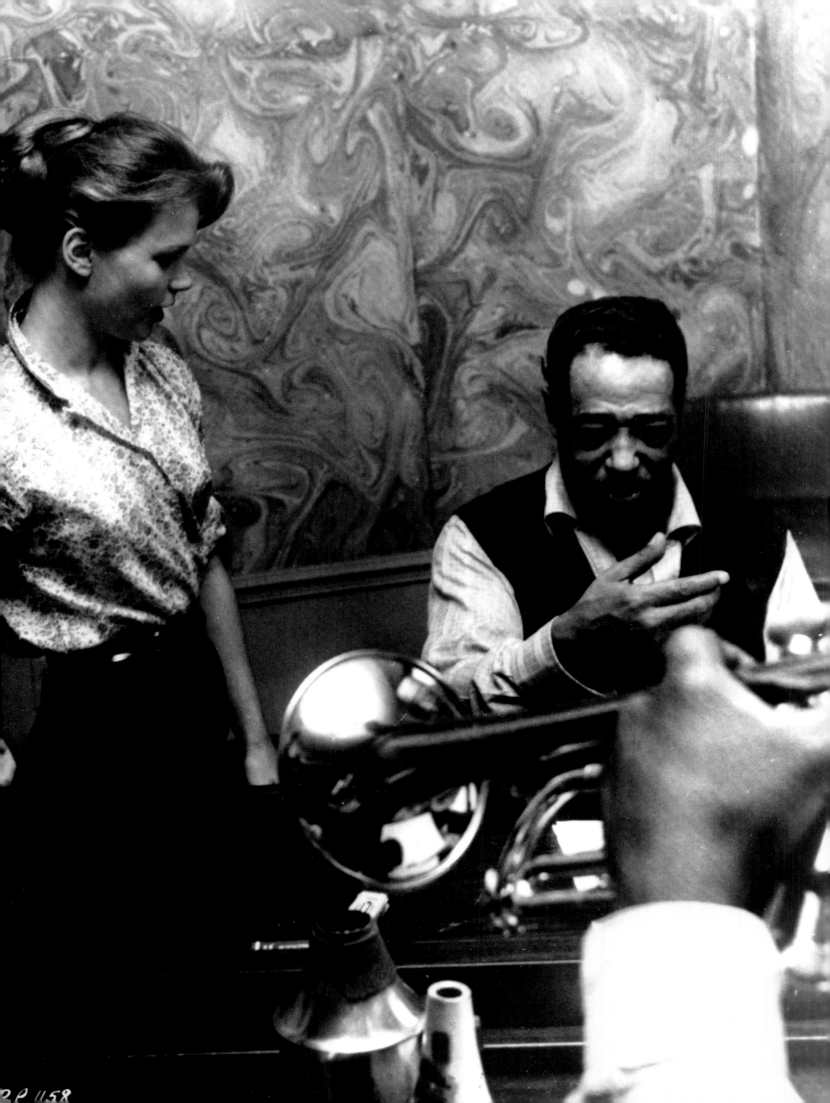

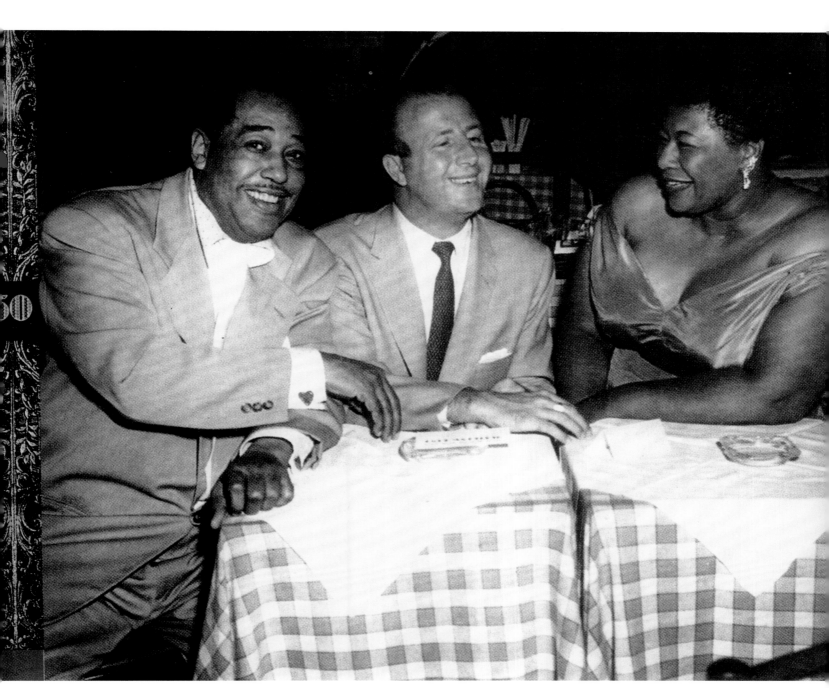

LEFT: Duke with a fan. ABOVE: Duke with Clive Davis and Ella Fitzgerald. NEXT SPREAD: Duke with fans backstage after a performance.

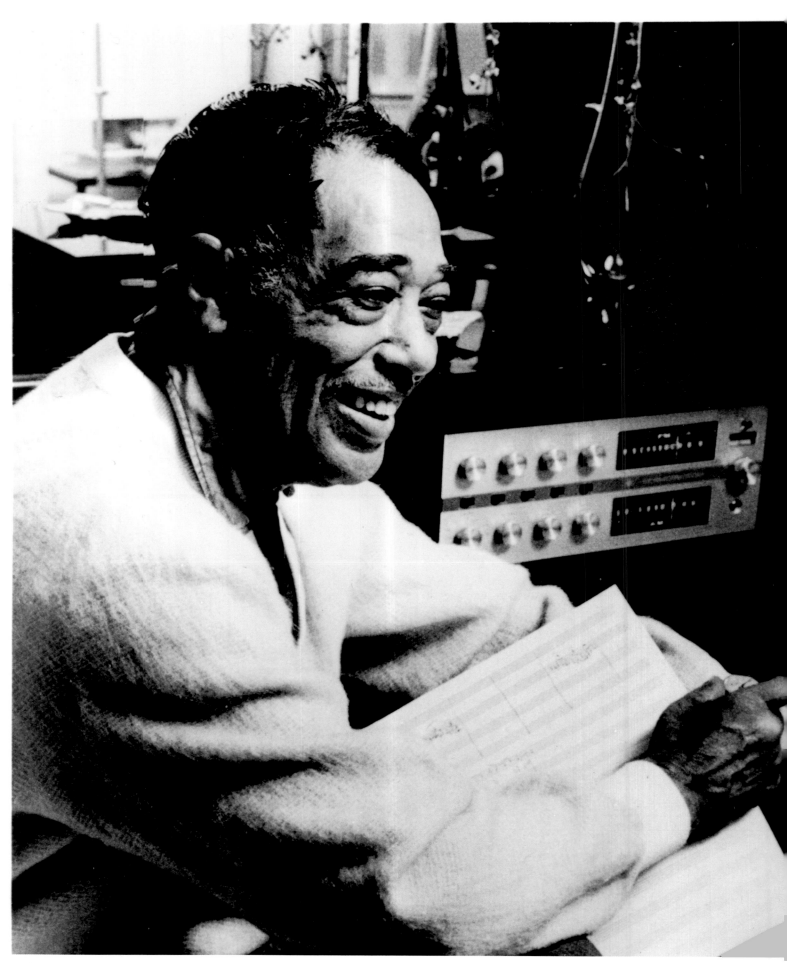

ABOVE: Duke in the studio at the Edison Hotel. RIGHT: Duke poses for
a promotional photograph

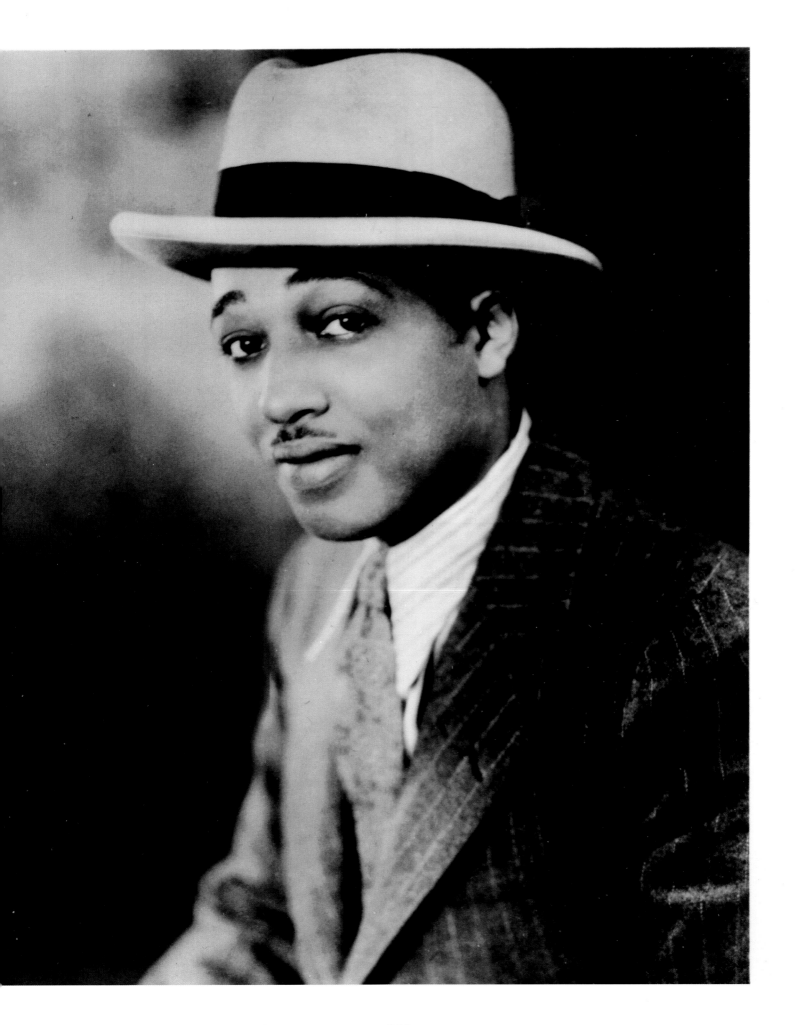

"My mother played music. She played those beautiful piano things written by Carrie Jacobs Bond, she wrote very pretty delicate music and it was so pretty when my mother played that I used to cry when she played it. My father used to play by ear and he played some of the old standard things and operatic things."

— DUKE ELLINGTON

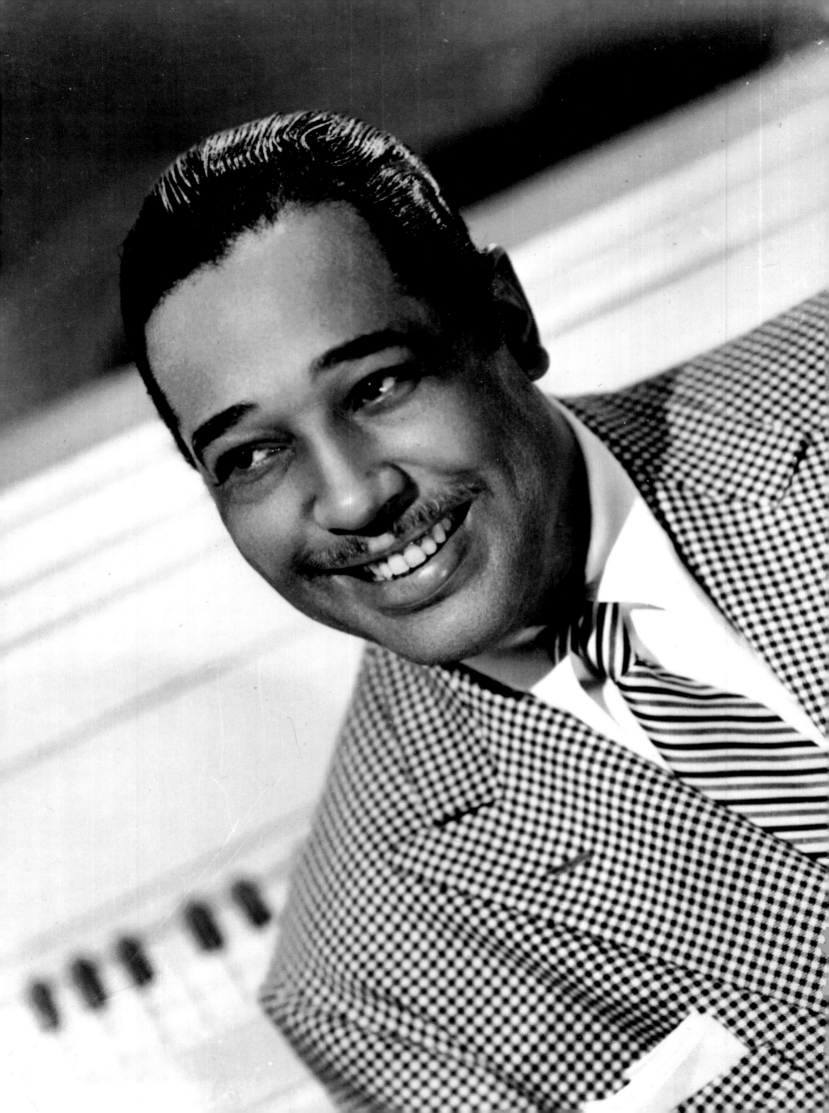

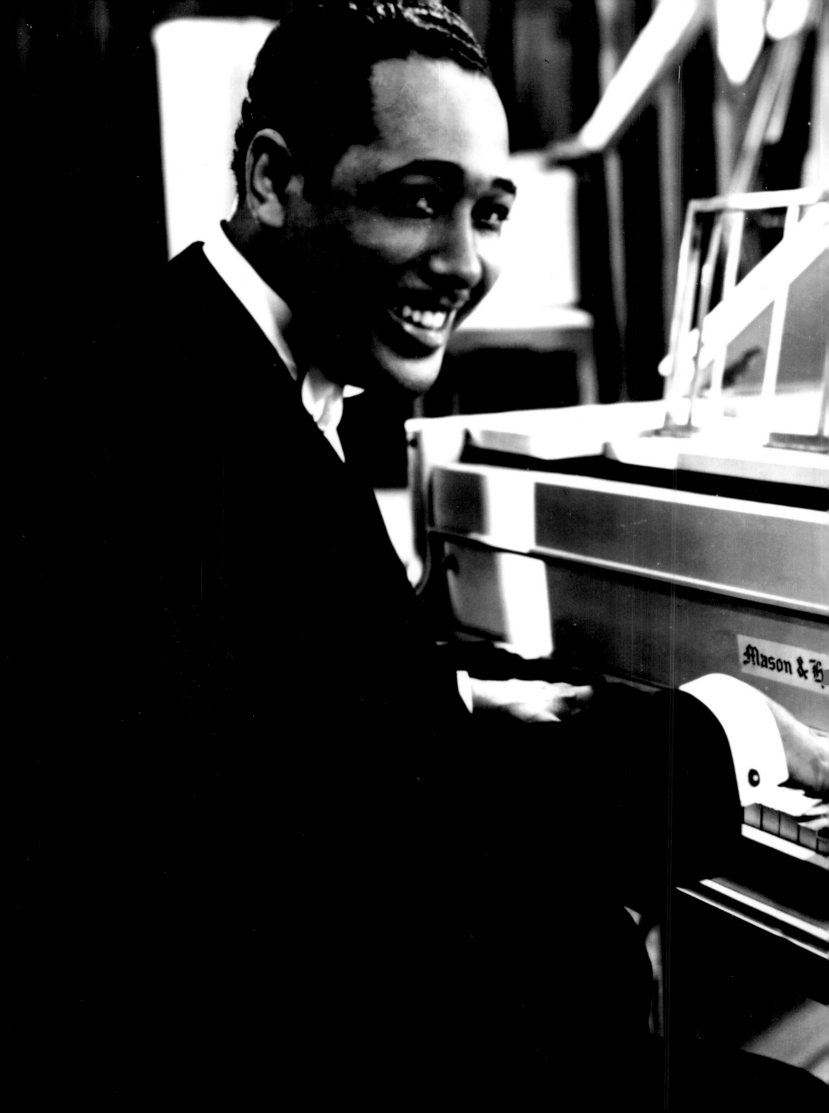

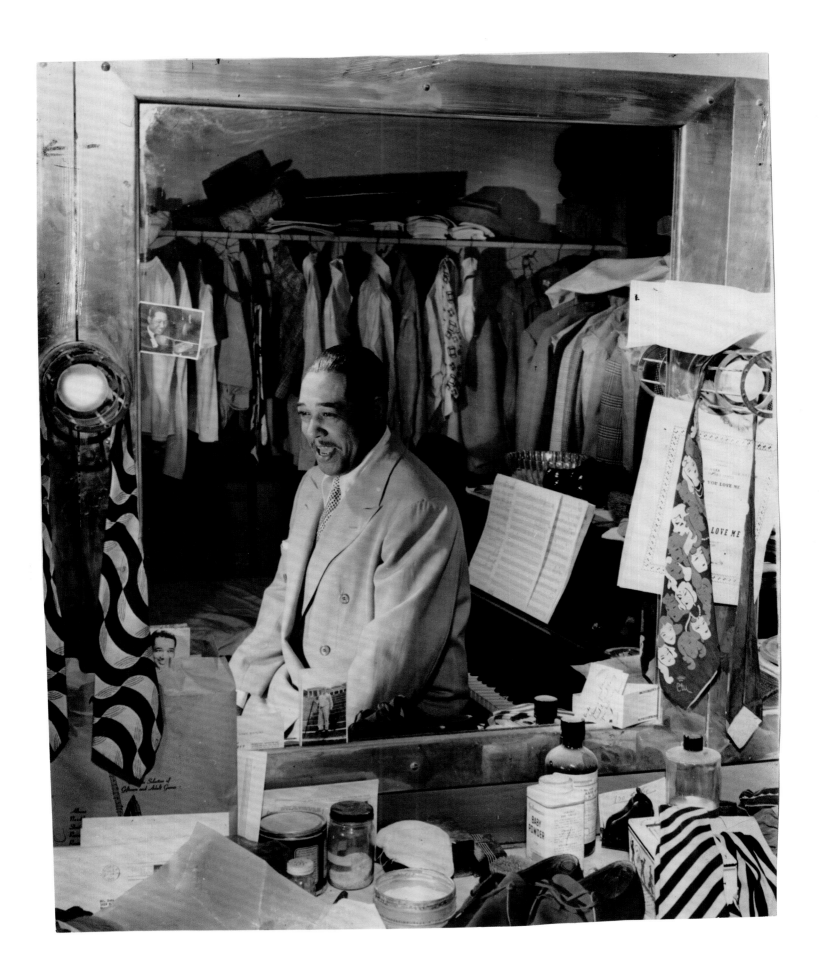

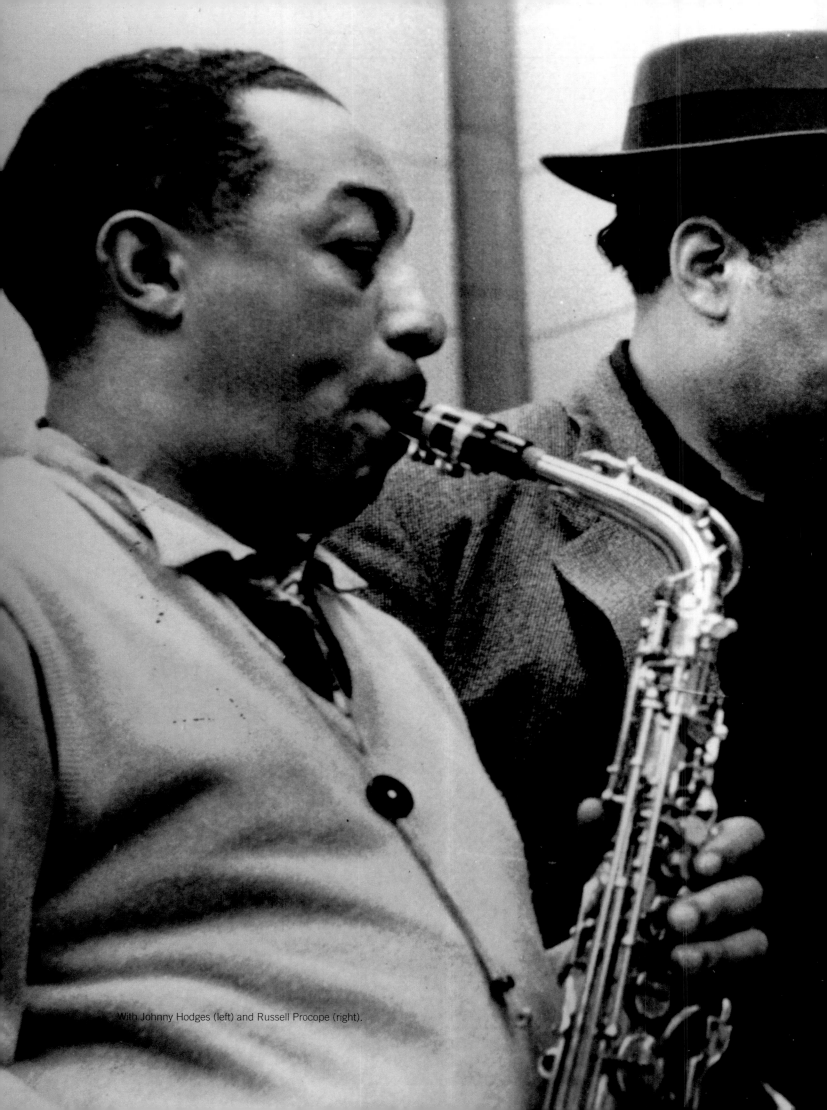

With Johnny Hodges (left) and Russell Procope (right).

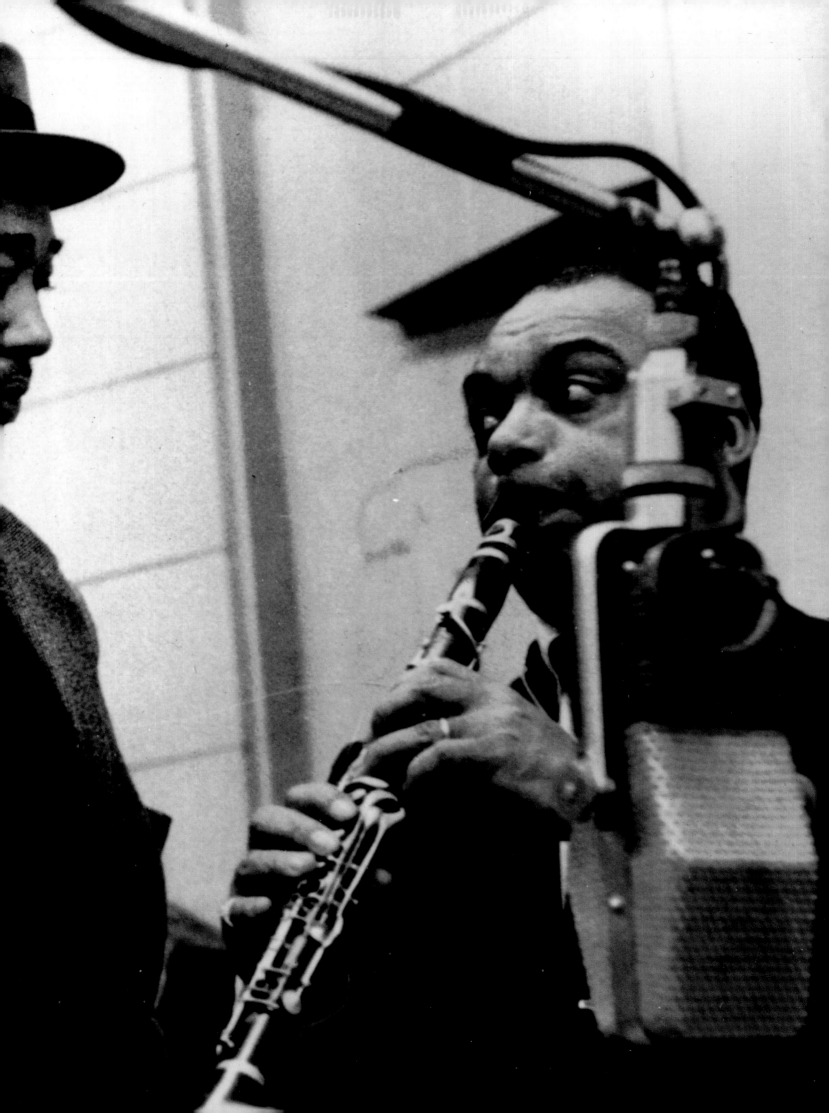

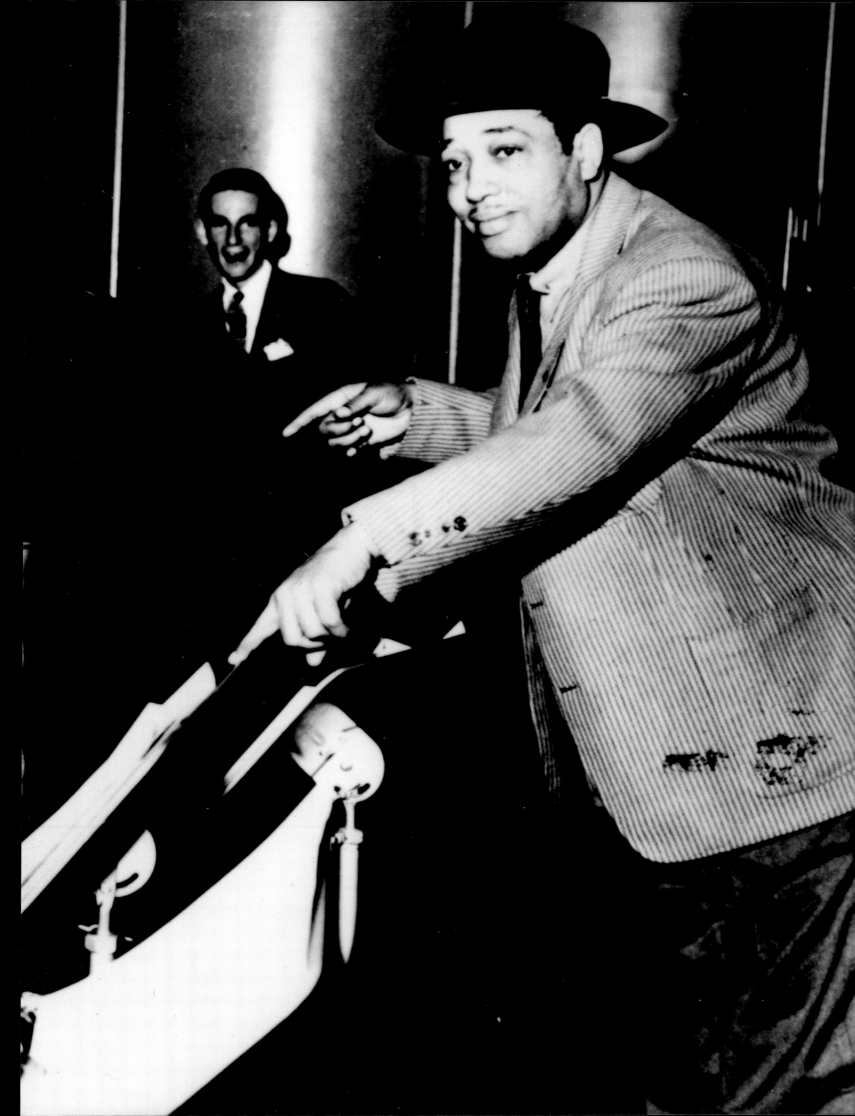

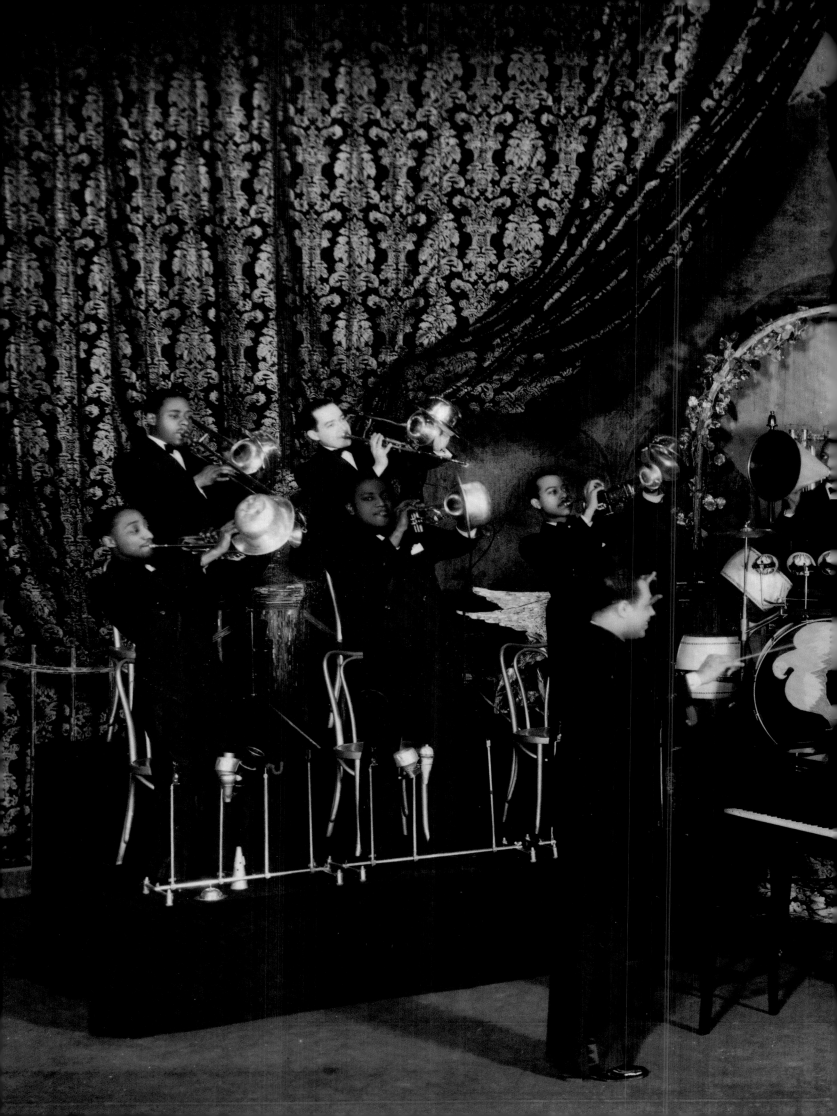

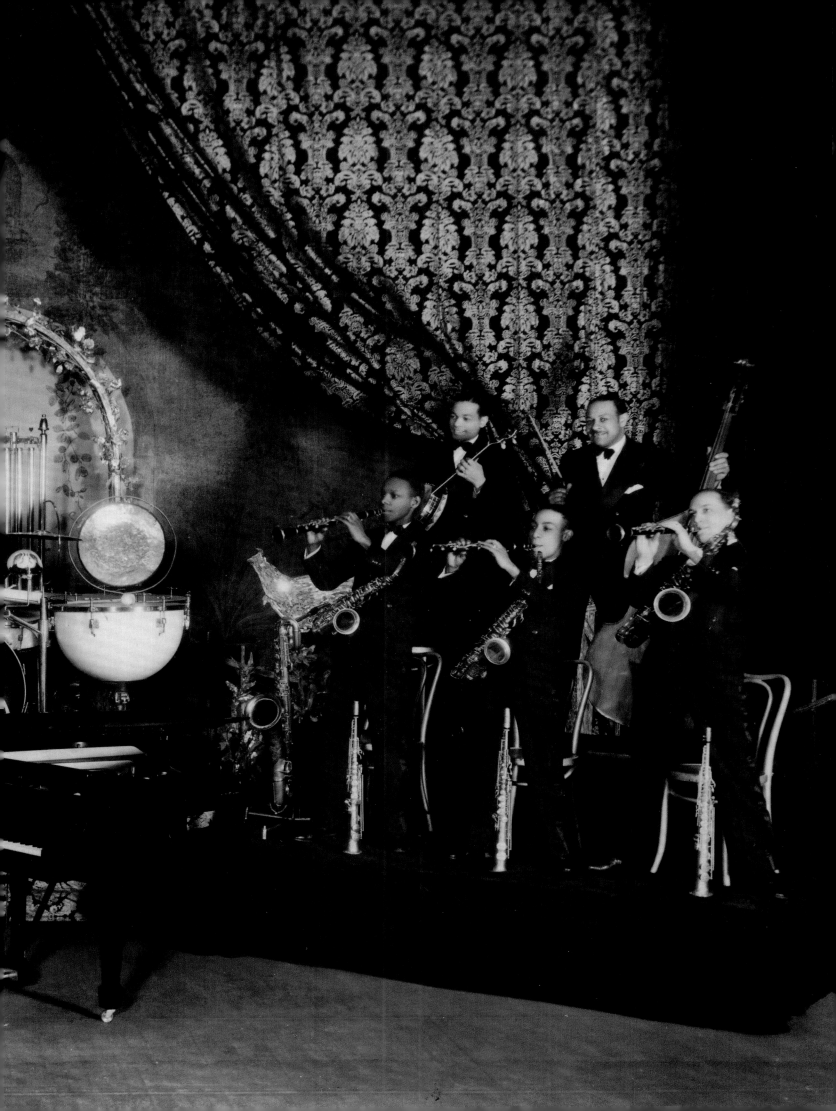

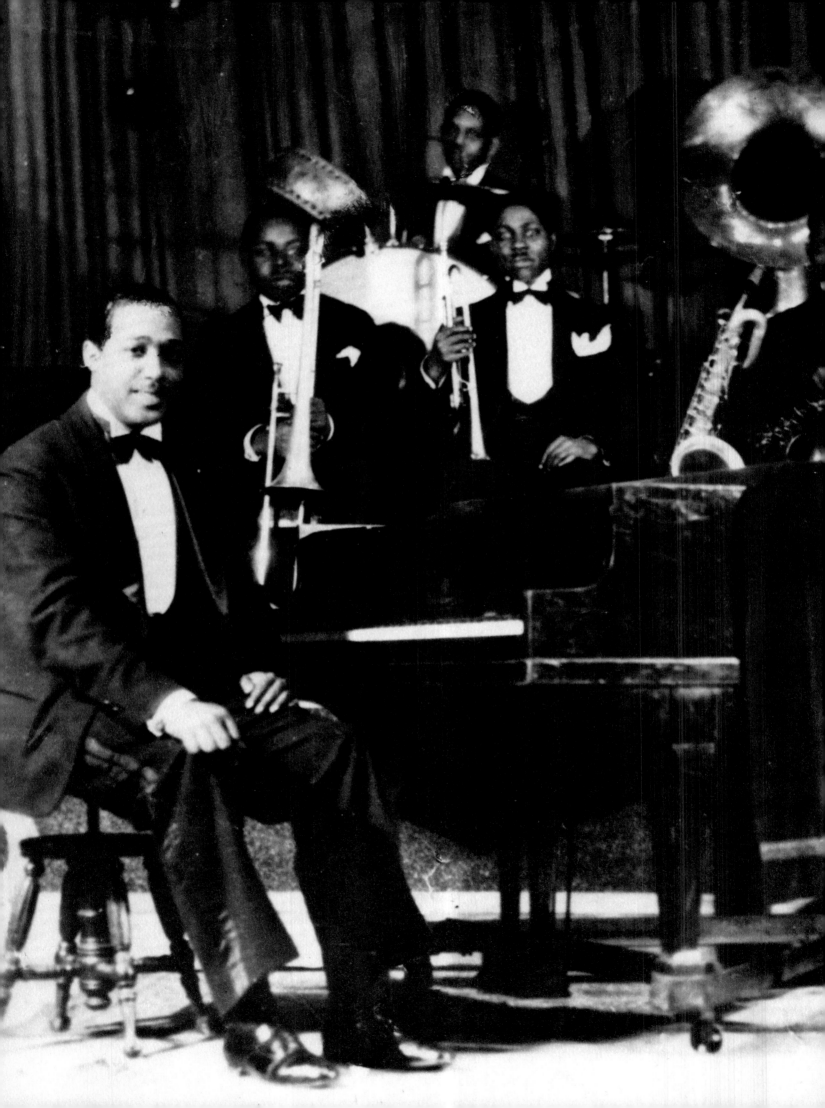

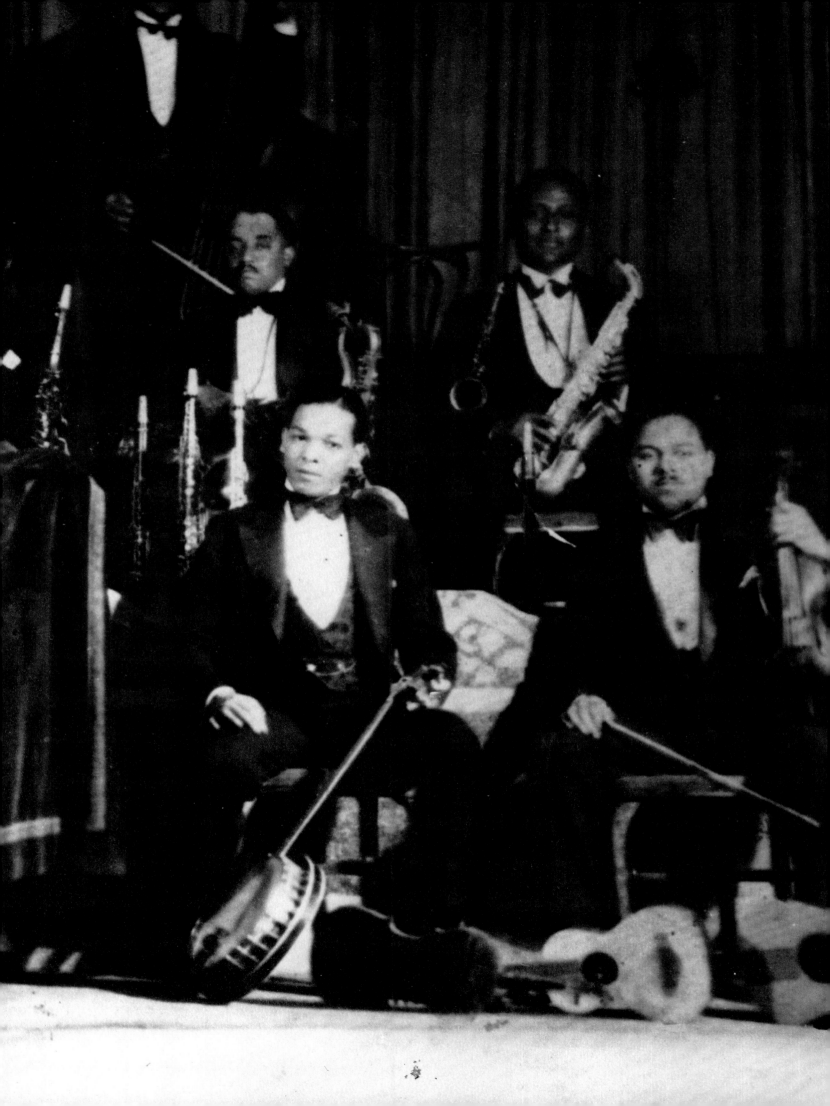

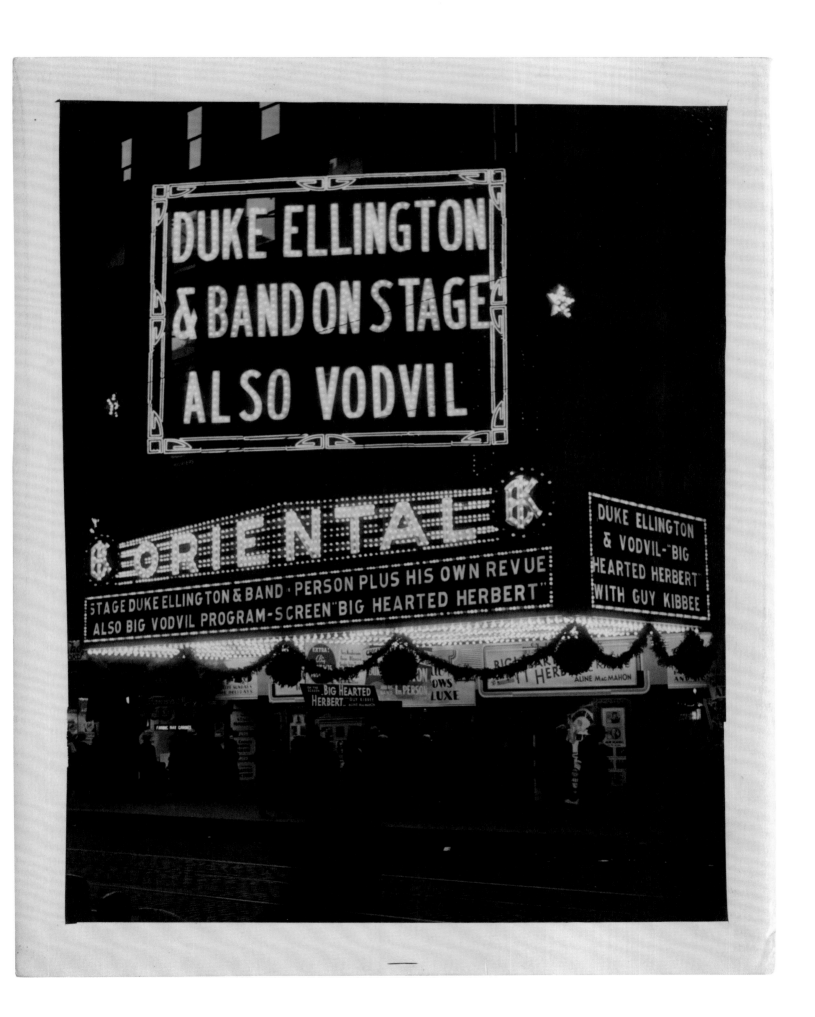

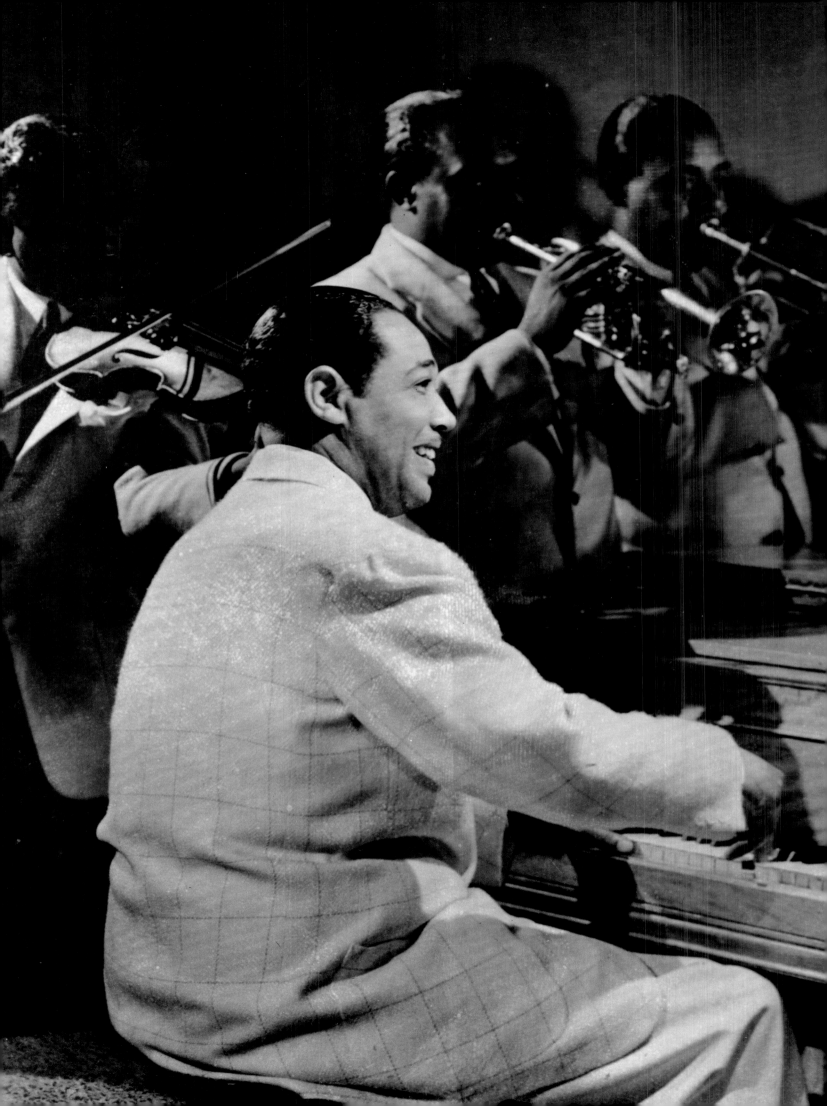

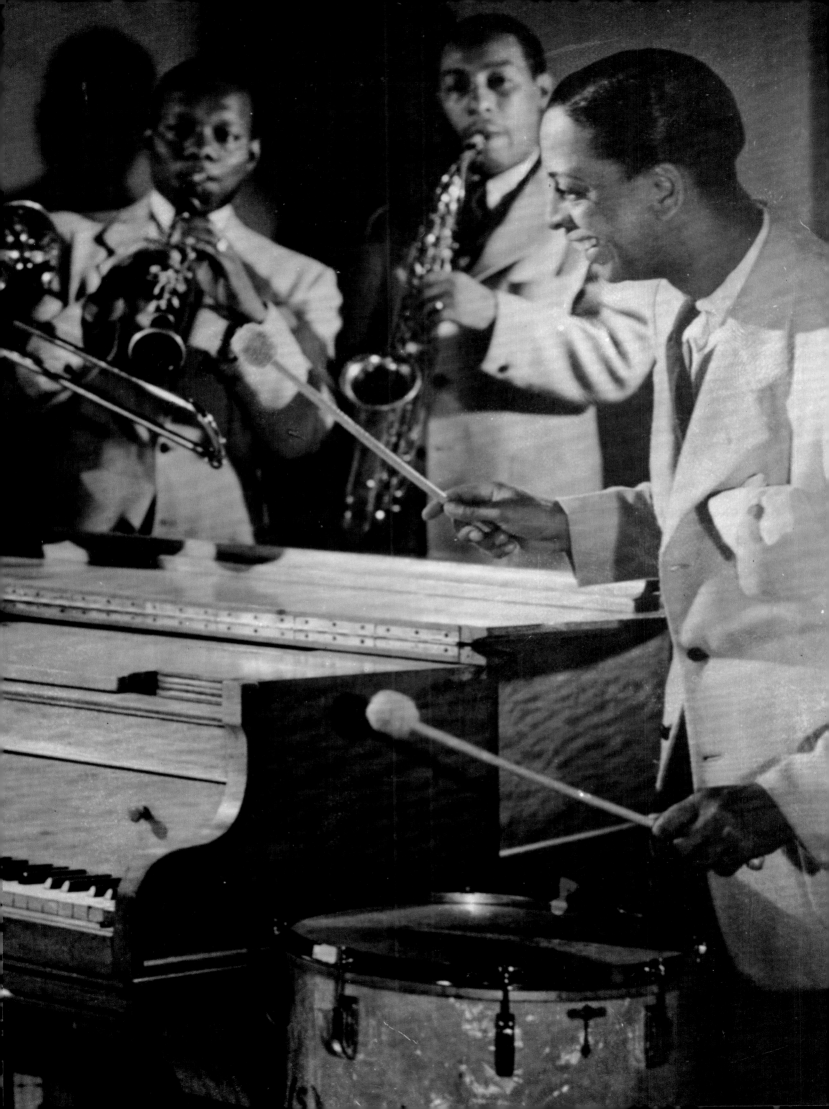

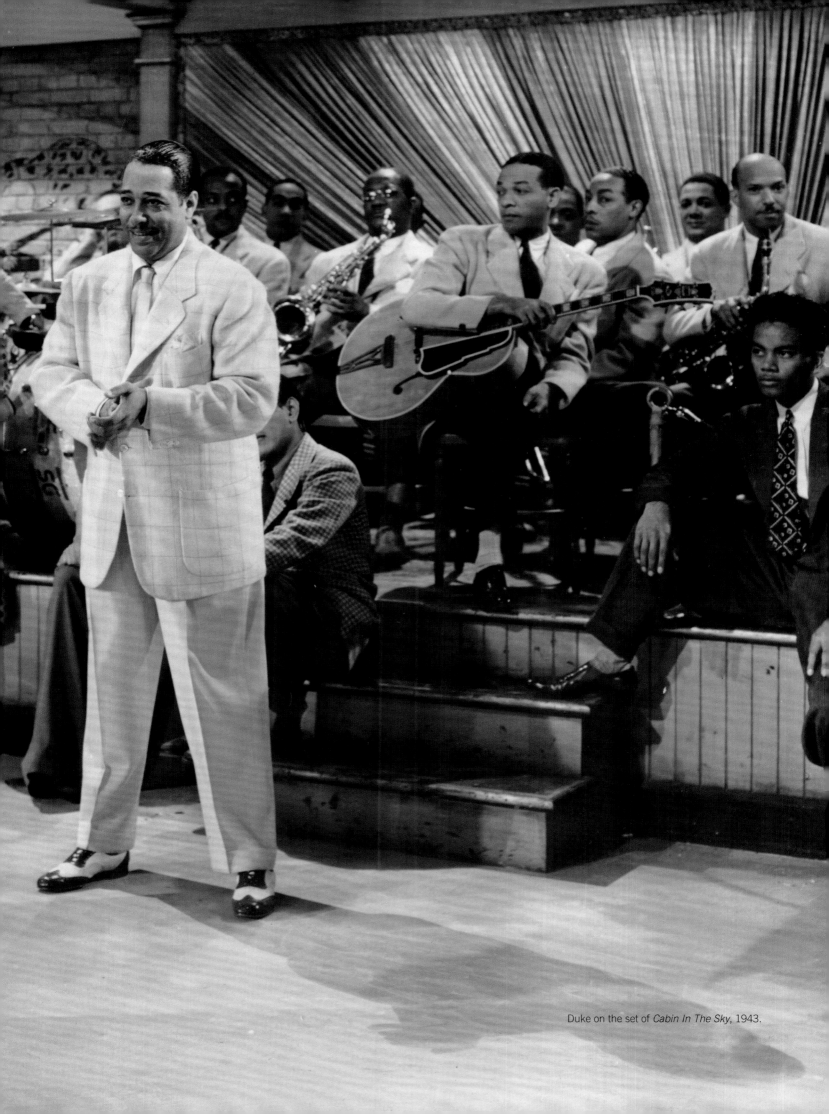

Duke on the set of *Cabin In The Sky*, 1943.

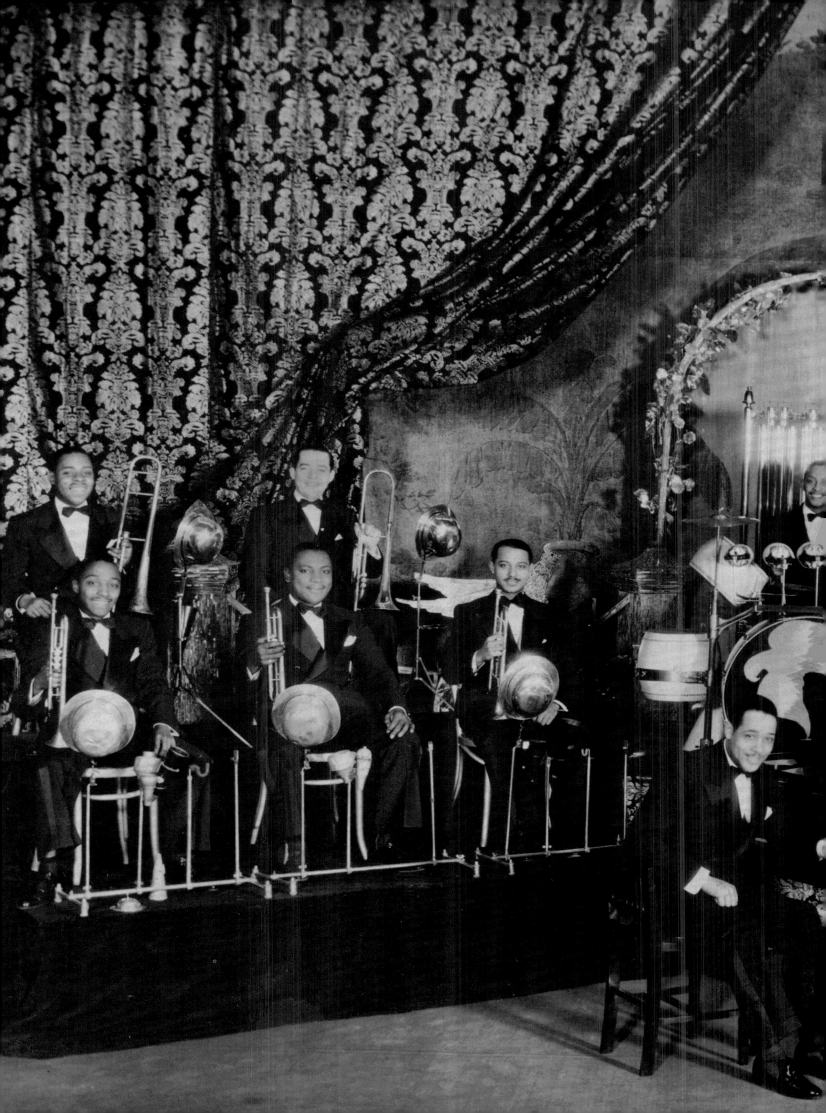

DUKE ELLINGTON
AND HIS FAMOUS
Orchestra
Management
MILLS DANCE ORCHESTRAS, Inc.
150 WEST 46th ST.
NEW YORK CITY

A promotional photograph shot for Irving Mills, who was a promoter and manager who would go on to take co-composer credits for many Ellington compositions.

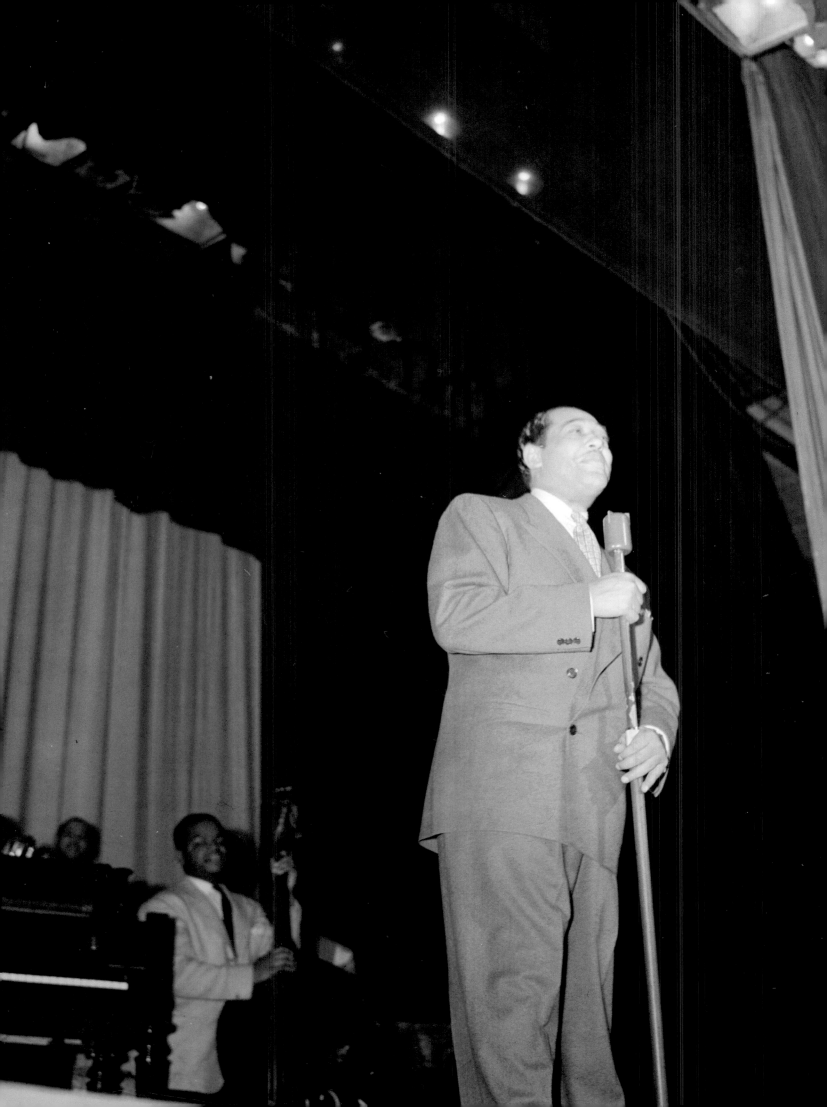

"Nightlife
is cut out
of a very
luxurious,
royal-blue bolt of
velvet."

— Duke Ellington

PREVIOUS SPREAD: Duke with W. C. Handy. LEFT: Duke Ellington and Junior Raglin, Howard Theatre, Washington, D.C. THIS PAGE: Illustration by John Kascht. NEXT SPREAD: Duke Ellington, Zanzibar, New York City, c. July 1946.

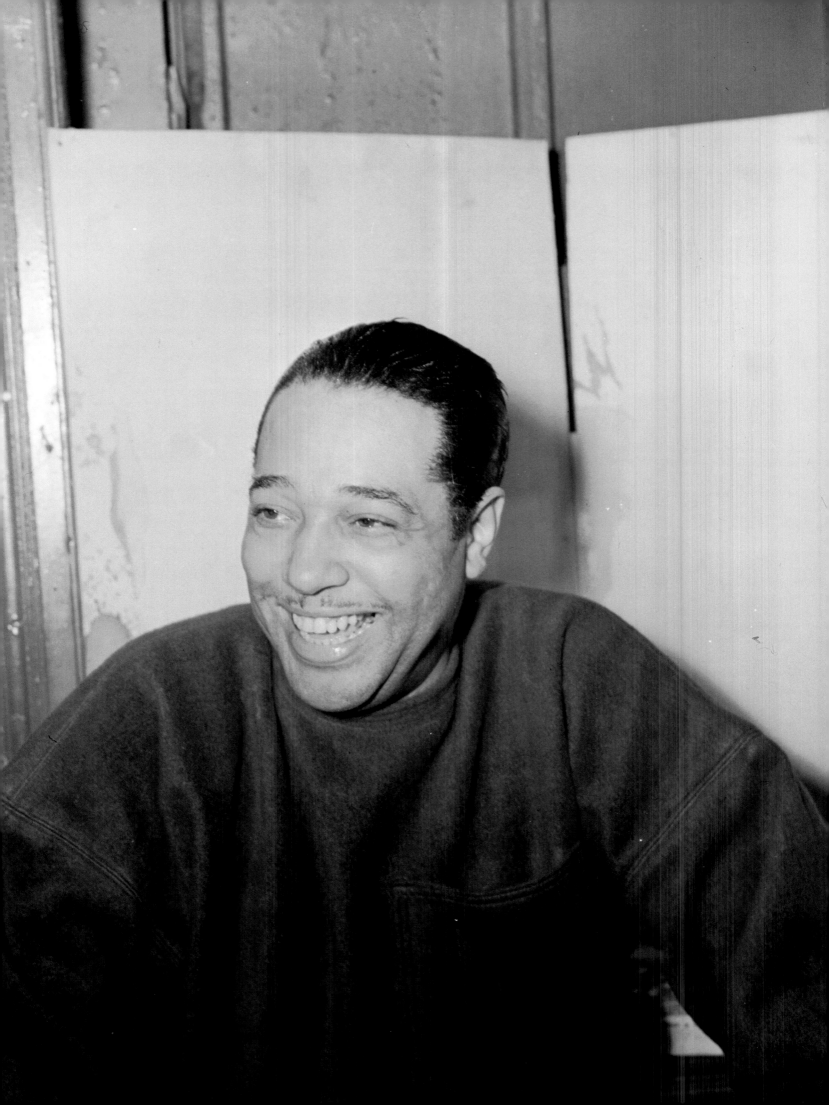

THIS PAGE AND NEXT: Aquarium, New York City, November 1946.

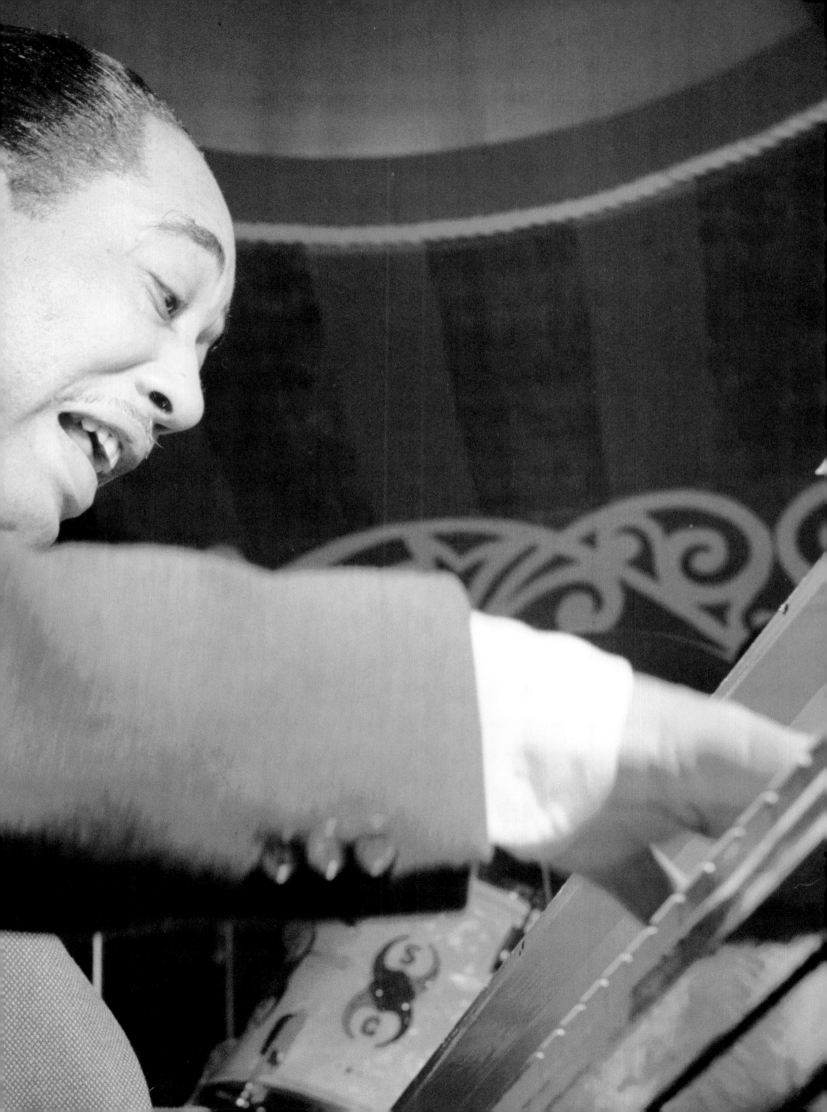

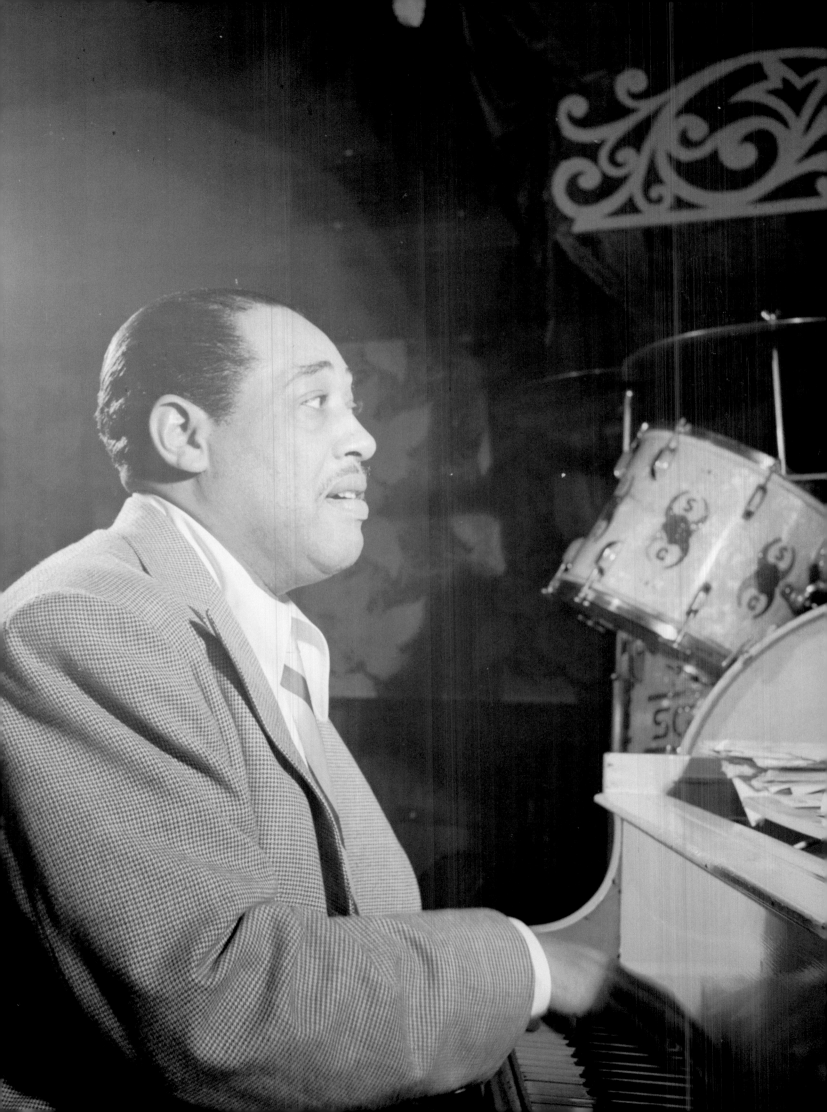

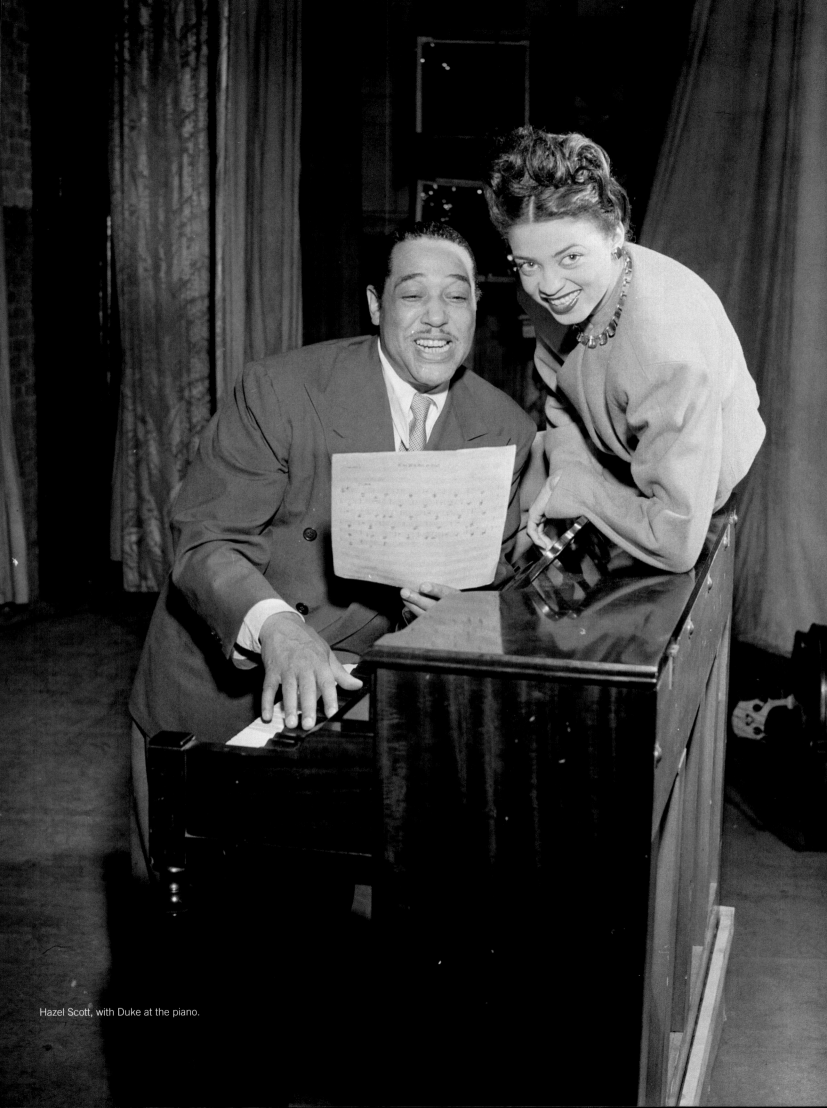

Hazel Scott, with Duke at the piano.

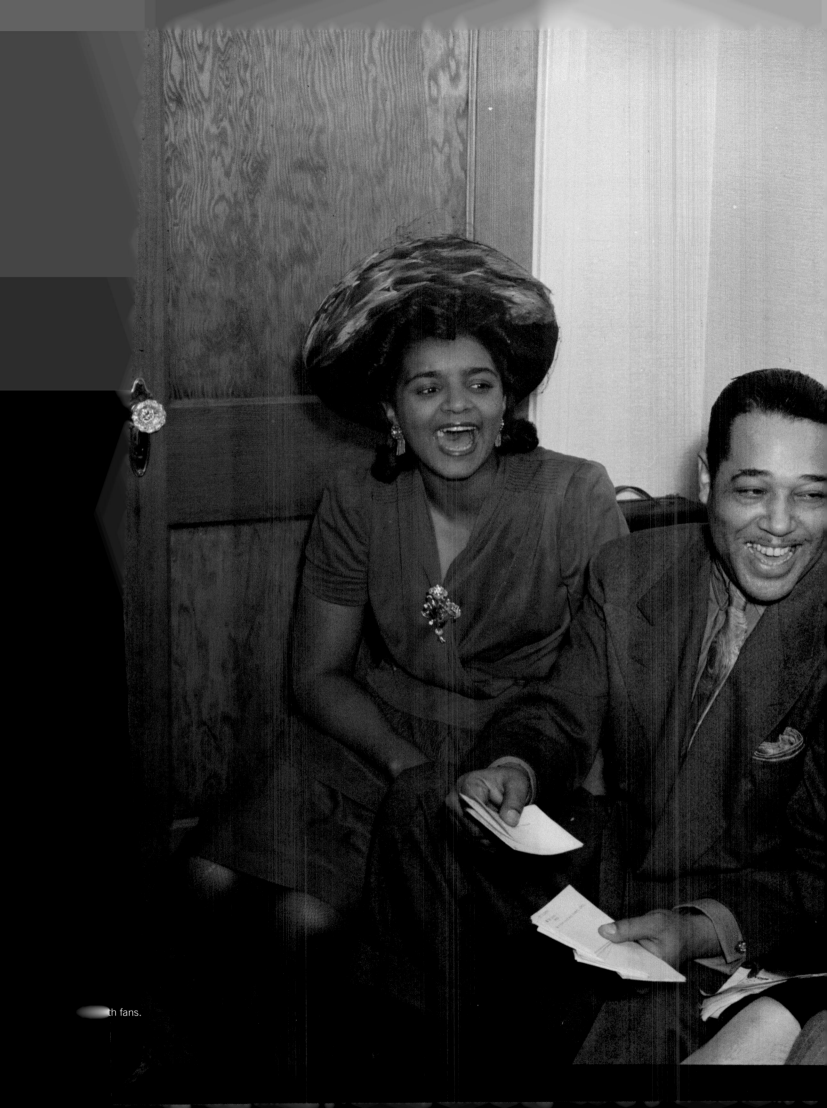

th fans.

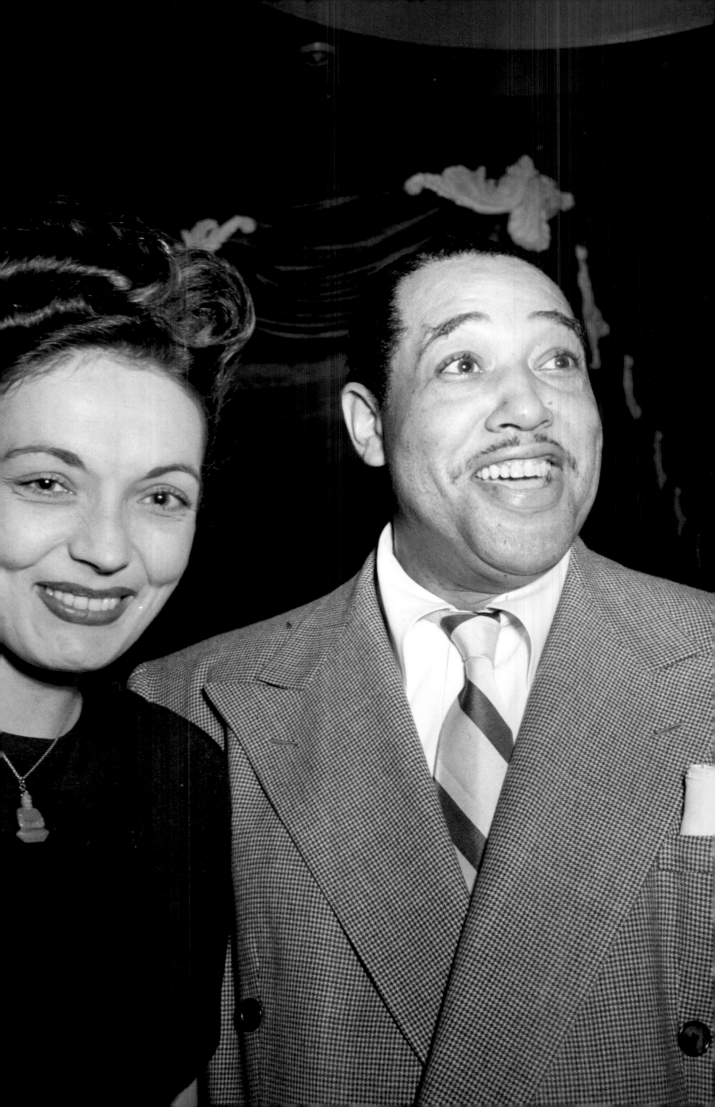

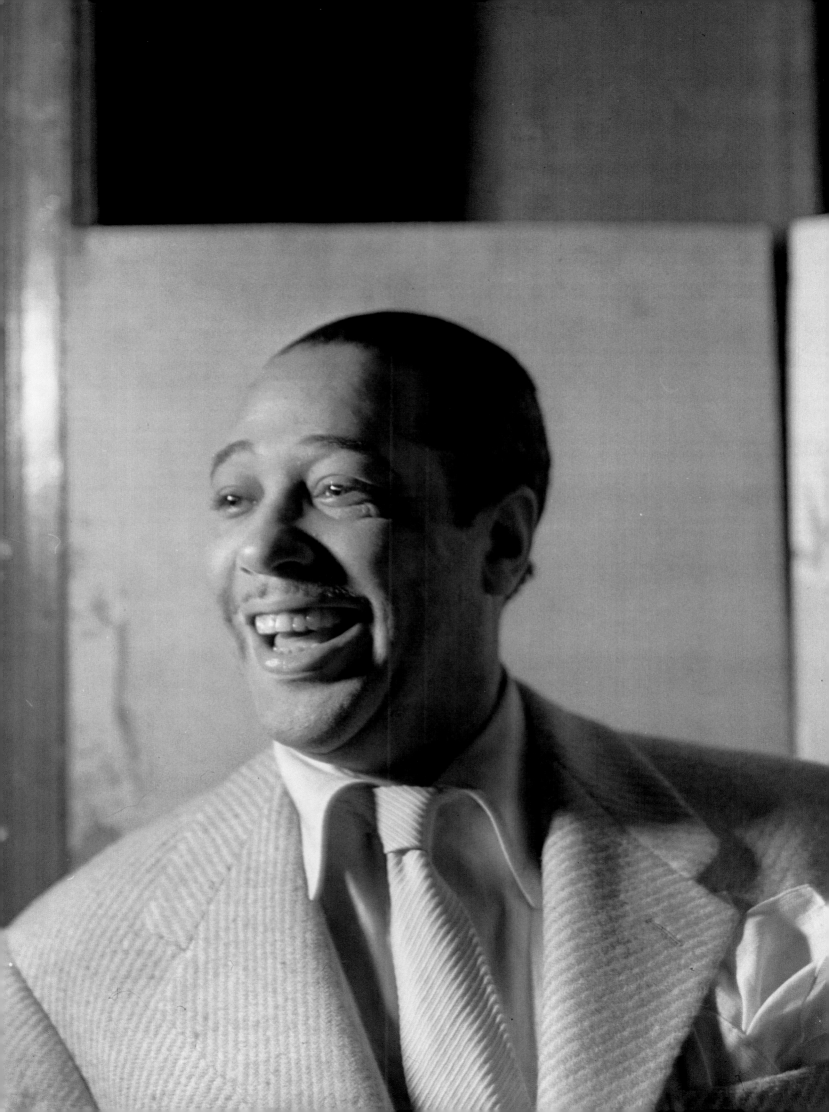

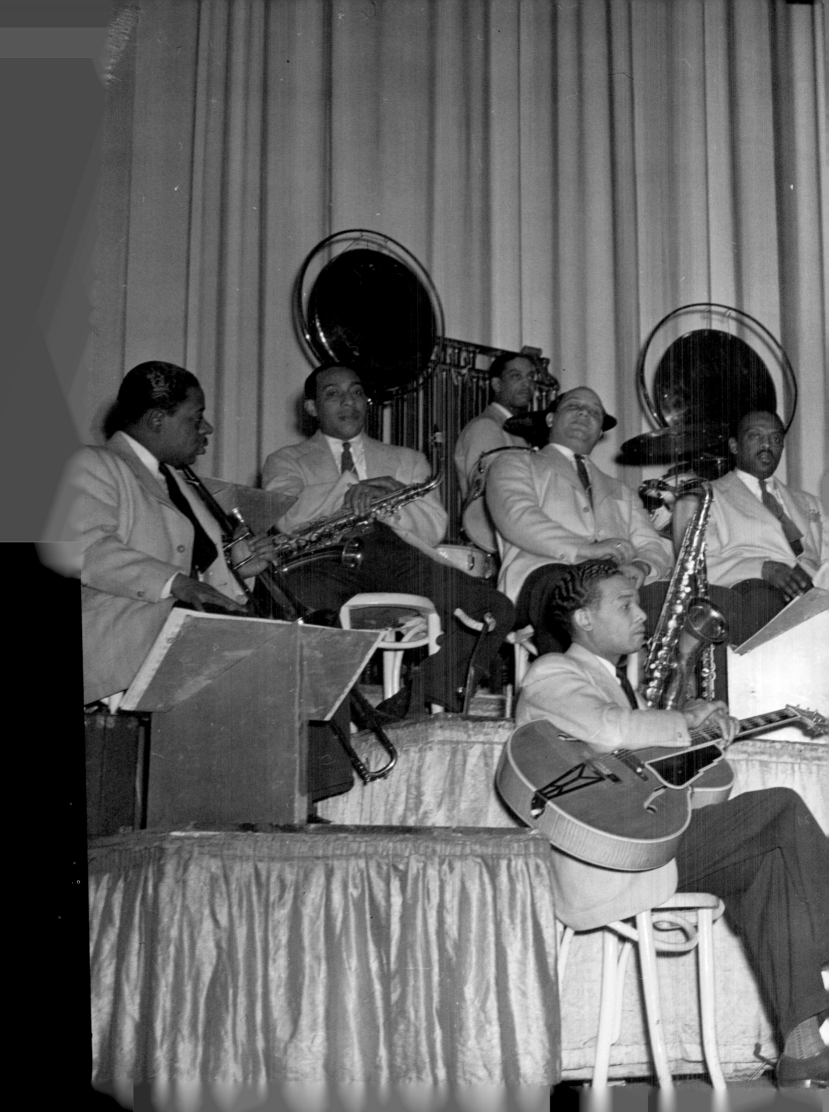

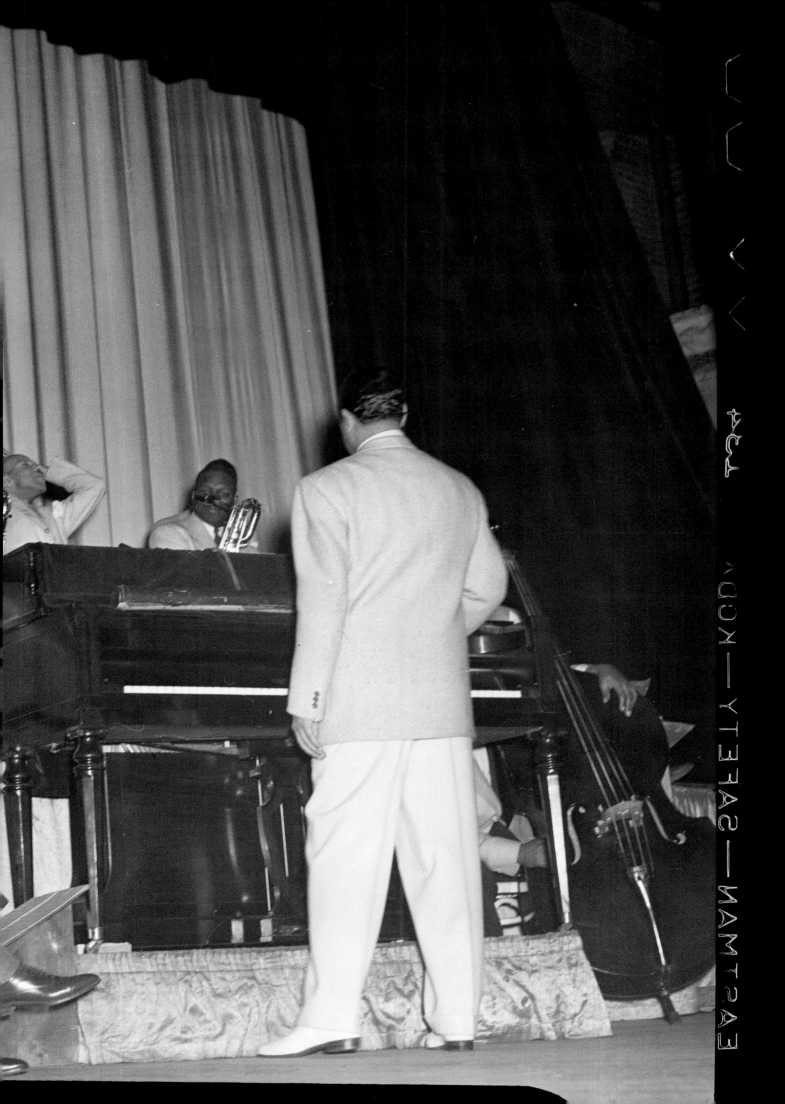

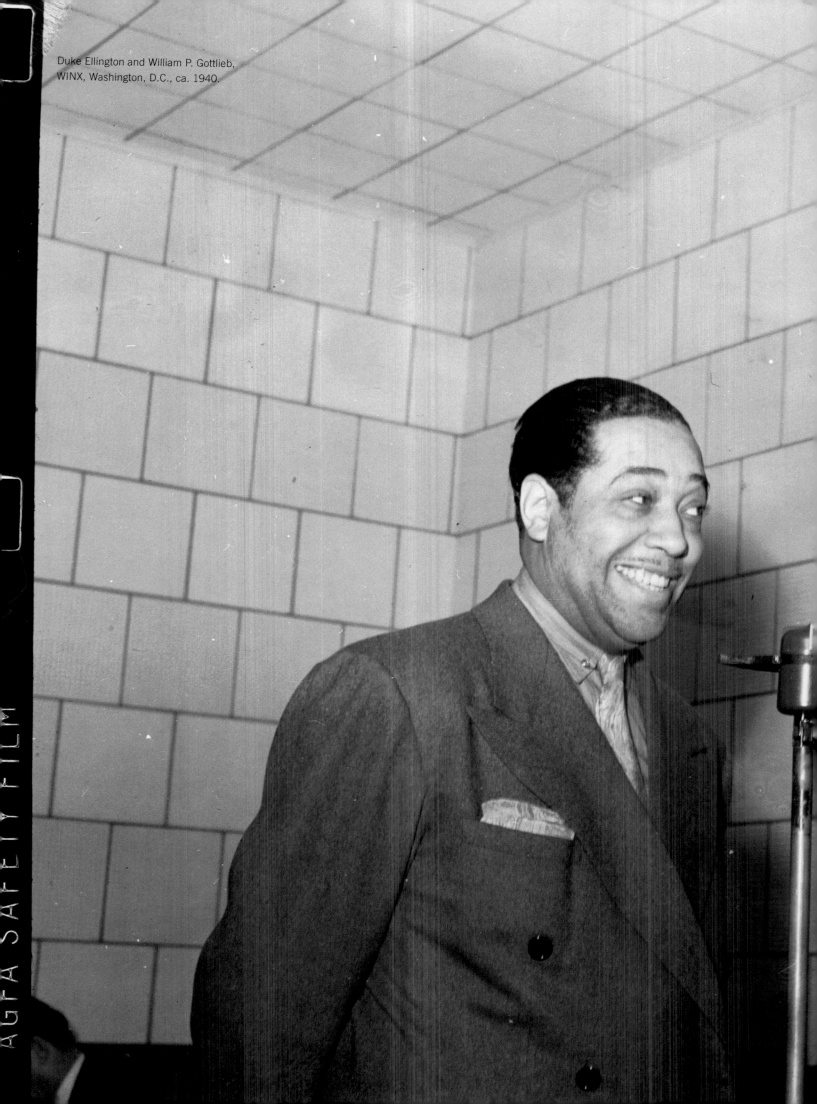

Duke Ellington and William P. Gottlieb,
WINX, Washington, D.C., ca. 1940.

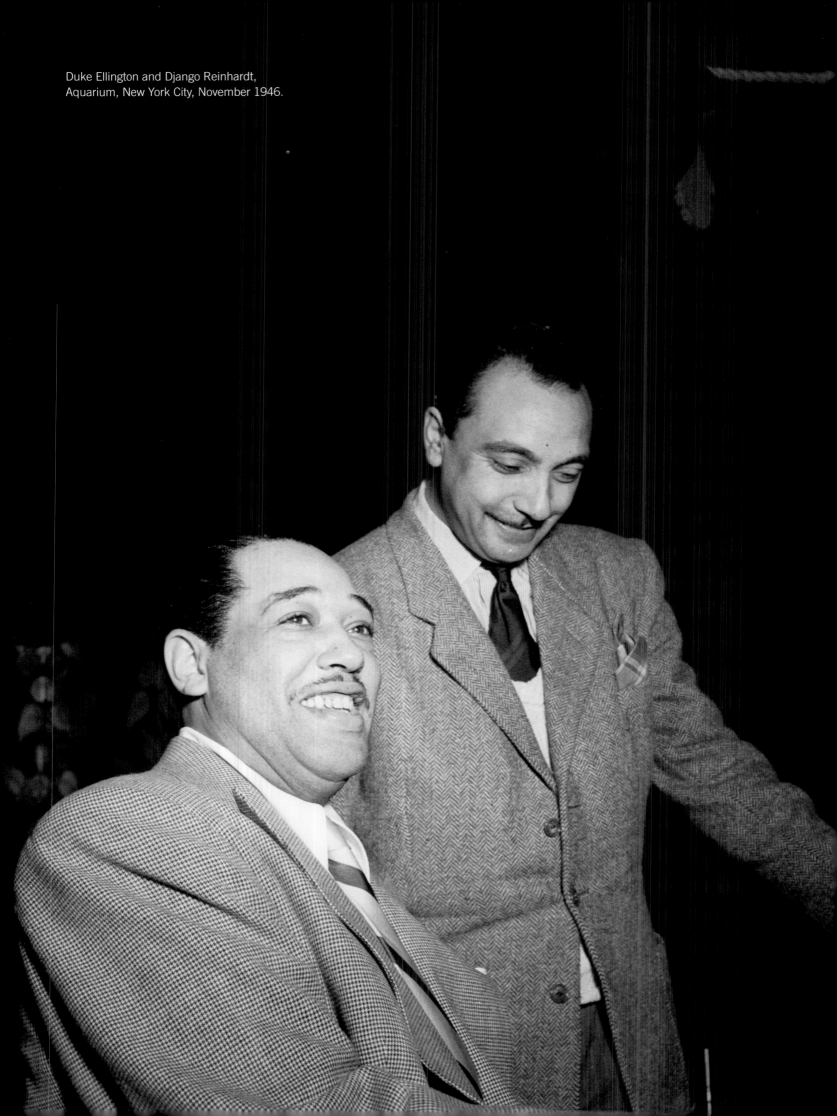

Duke Ellington and Django Reinhardt,
Aquarium, New York City, November 1946.

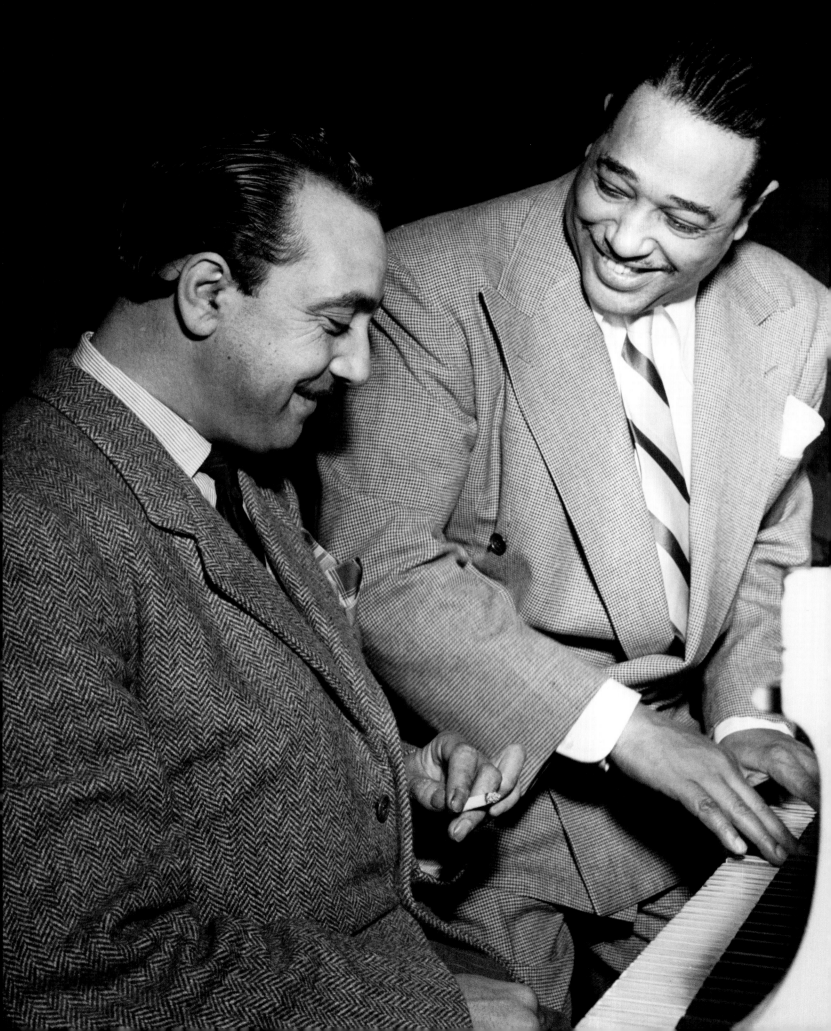

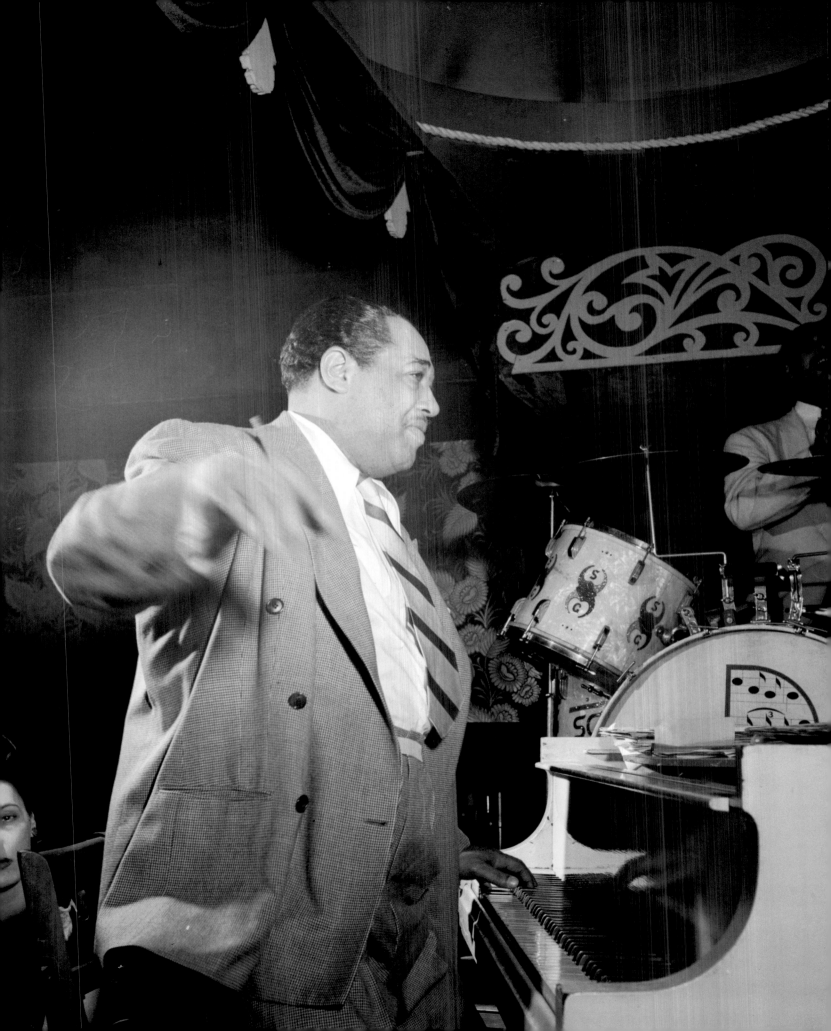

"Art is dangerous. It is one of the attractions: when it ceases to be dangerous you don't want it." -DUKE ELLINGTON

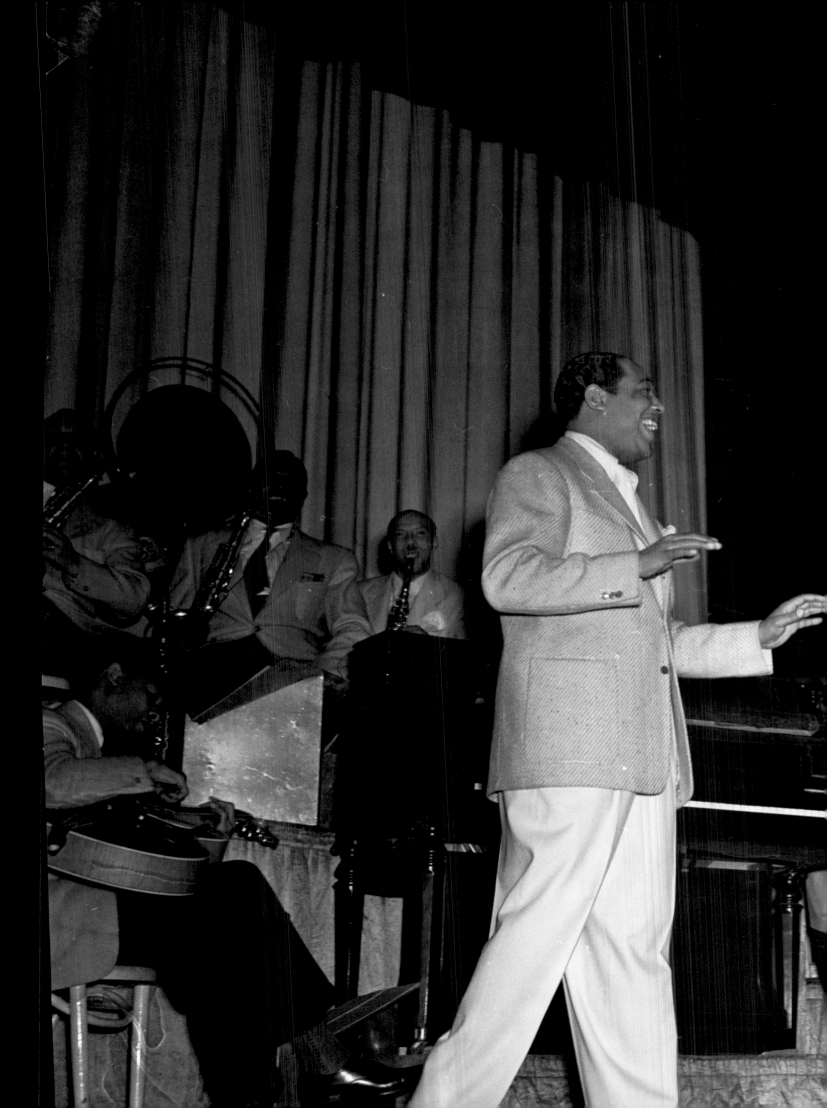

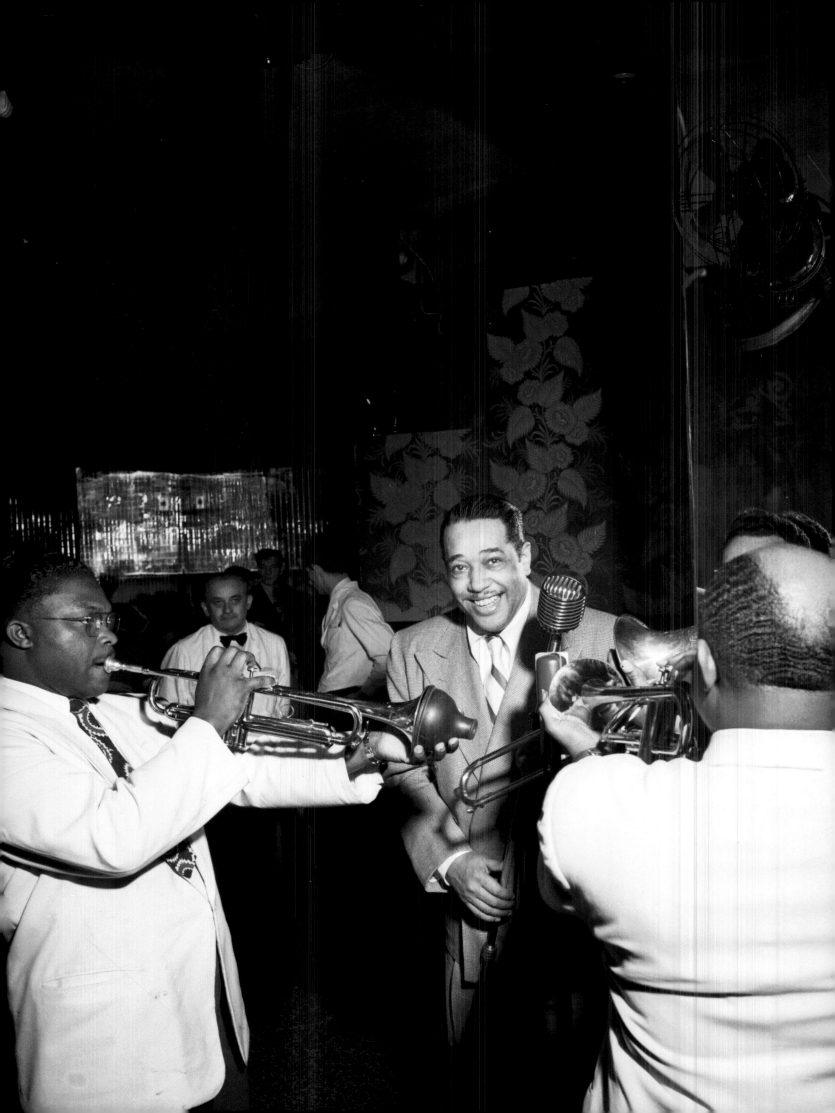

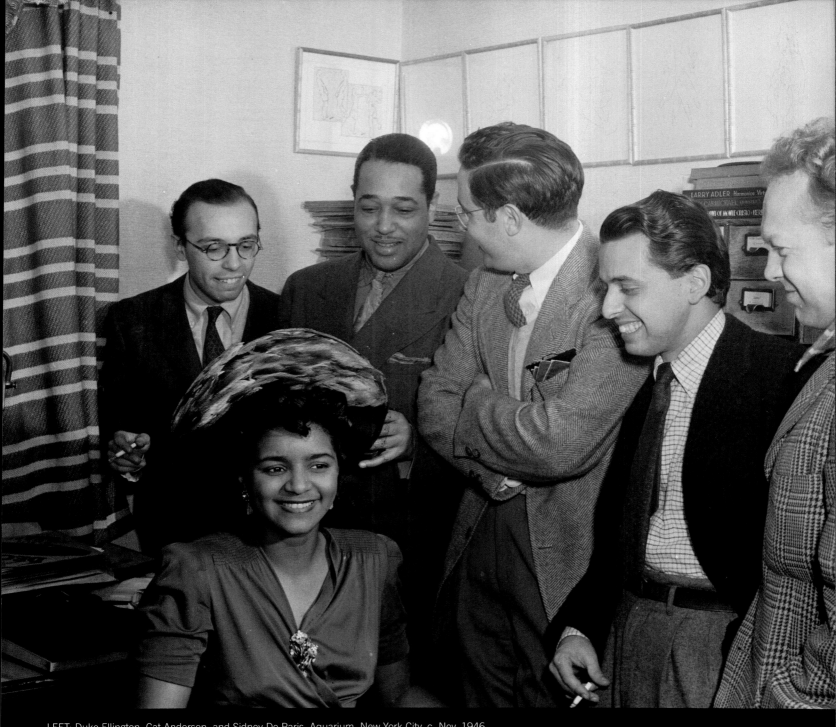

LEFT: Duke Ellington, Cat Anderson, and Sidney De Paris, Aquarium, New York City, c. Nov. 1946.
ABOVE: (Left to right) Ahmet M. Ertegun, Duke Ellington, William P. Gottlieb, Nesuhi Ertegun, and Dave Stewart.

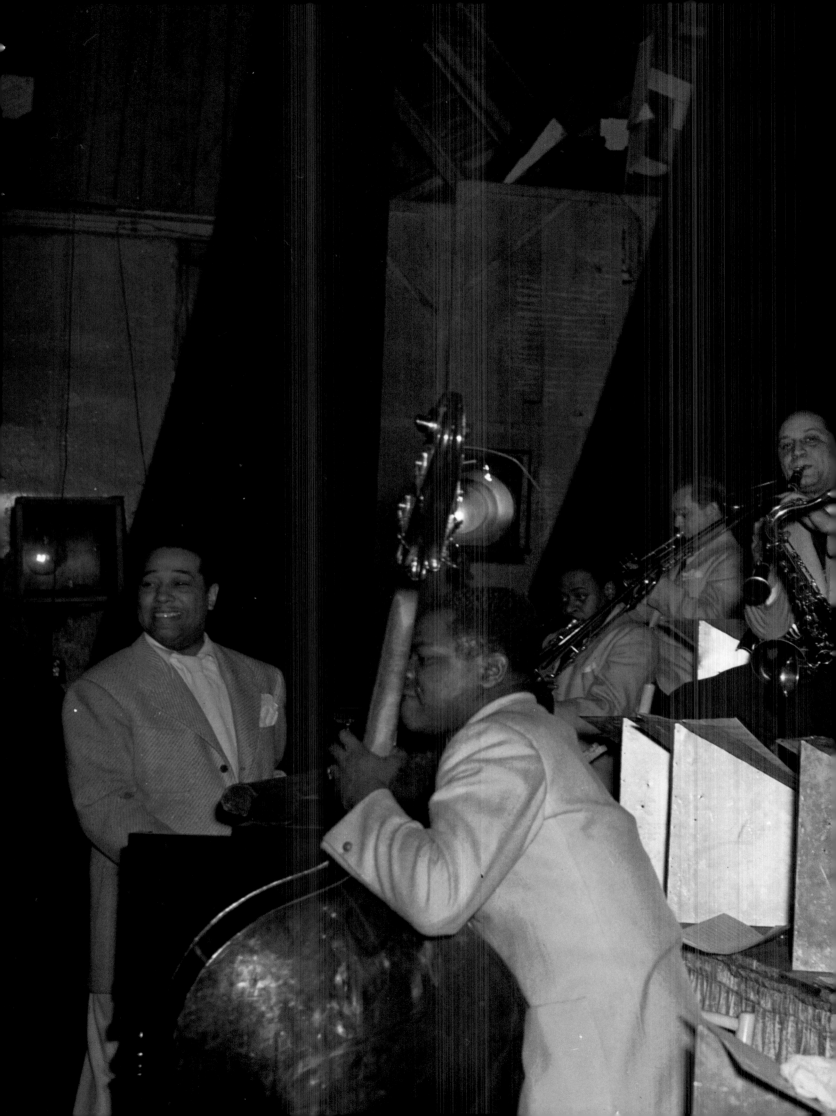

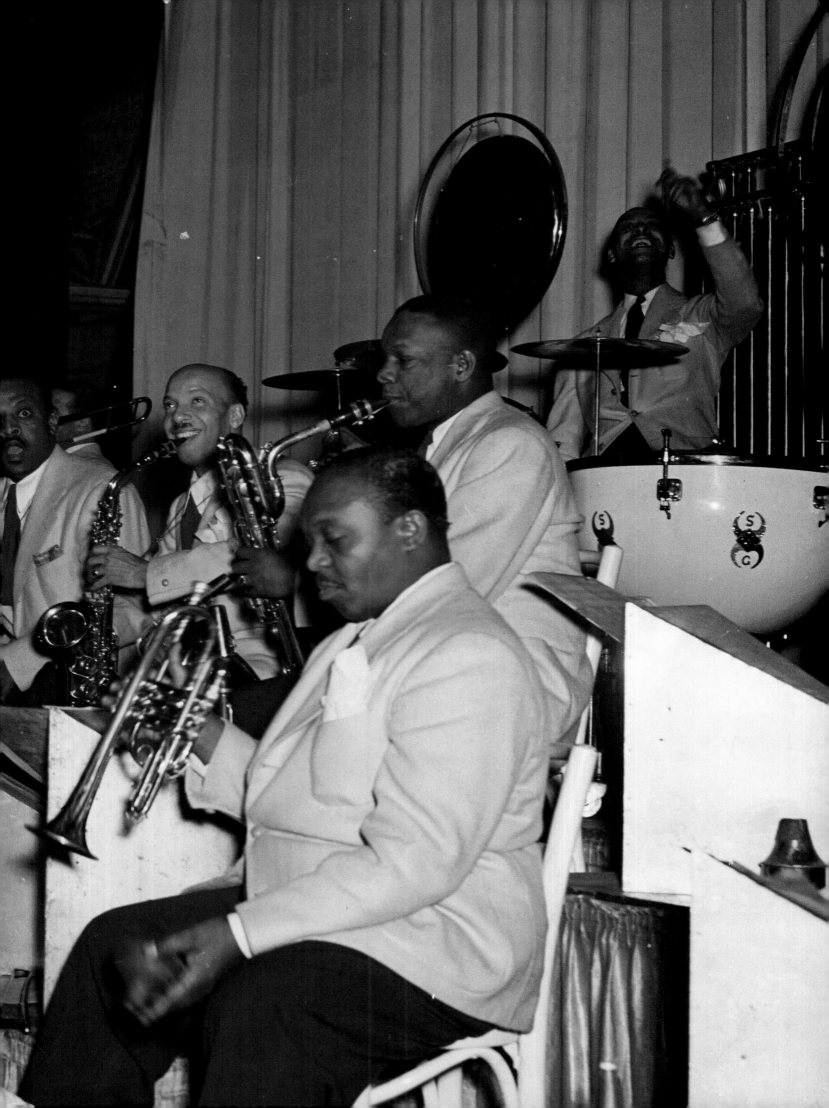

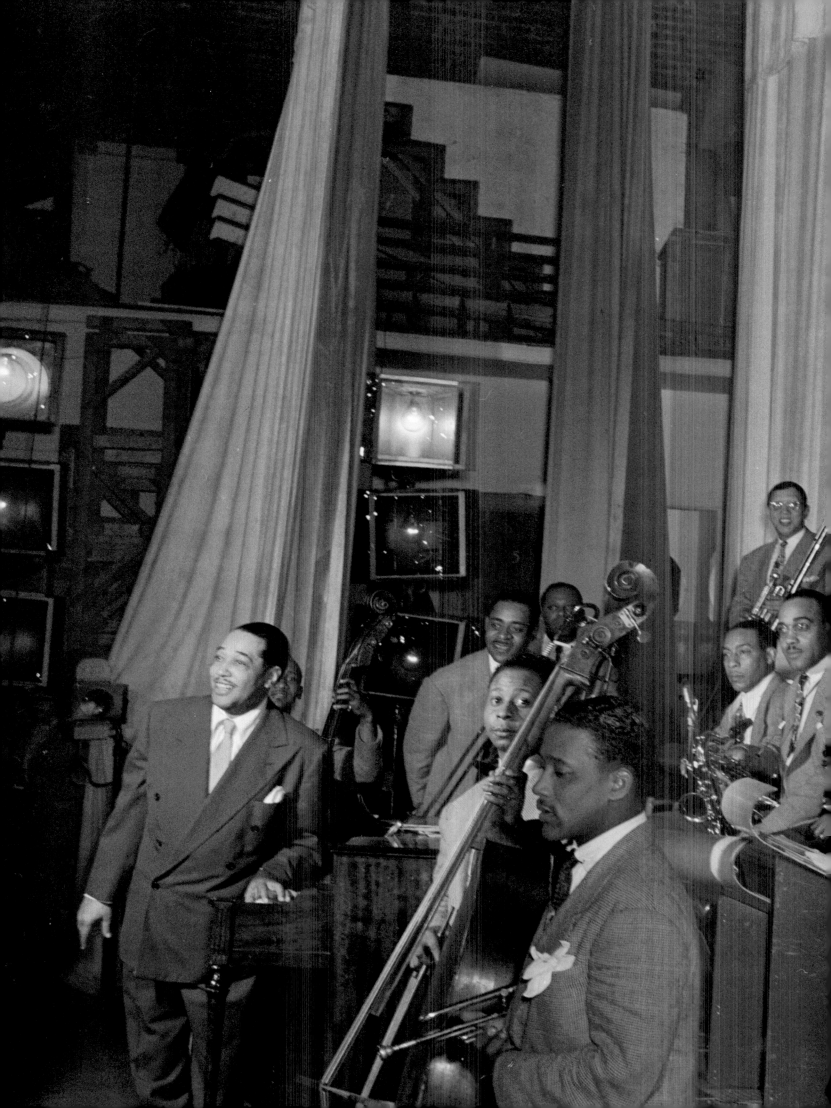

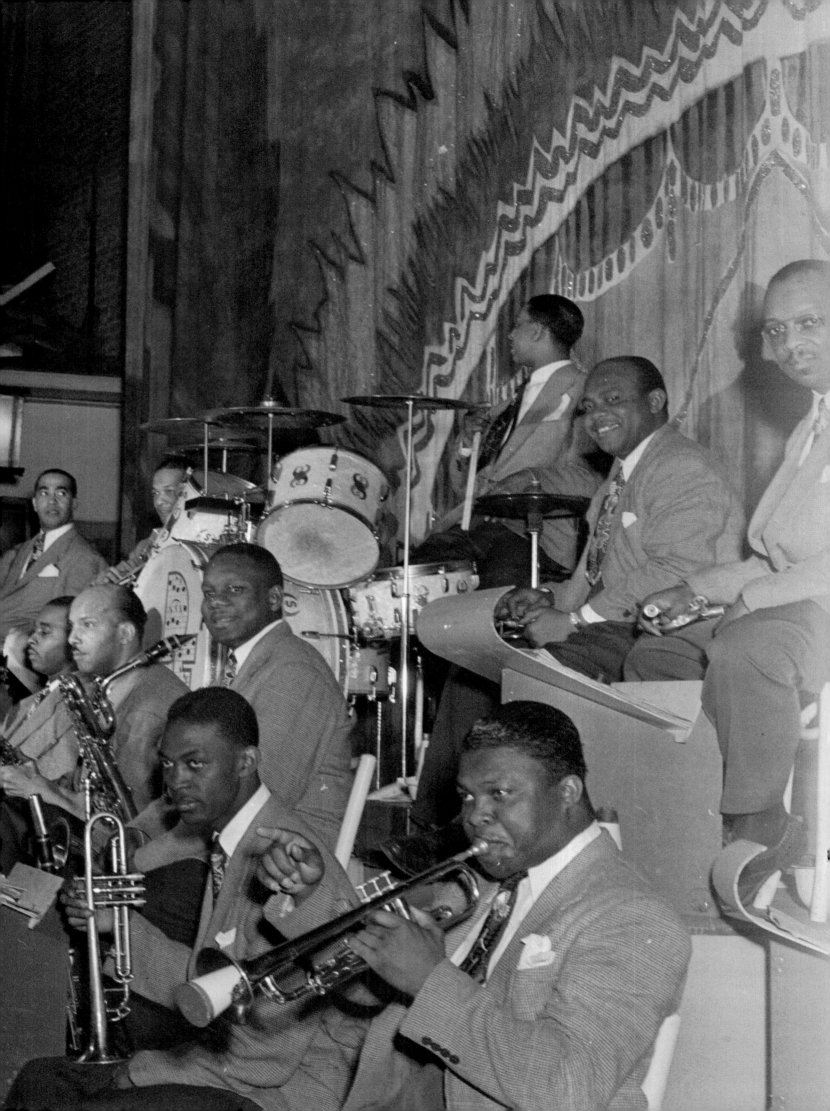

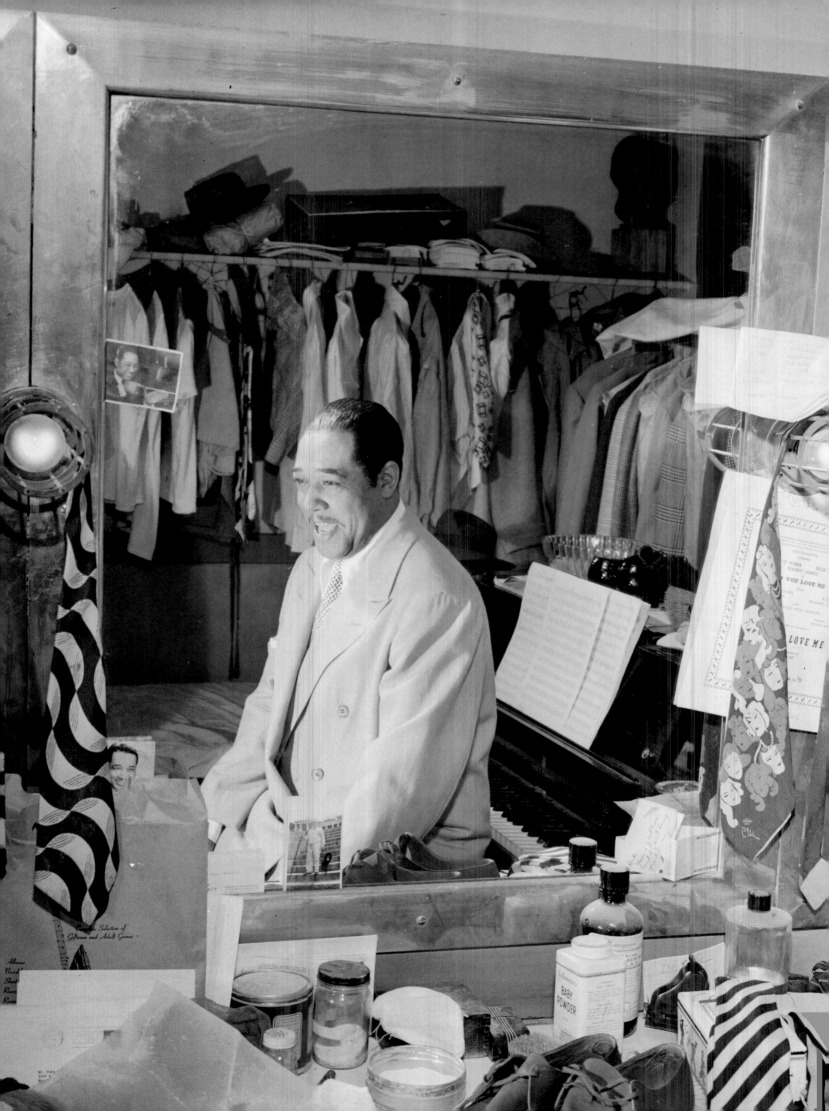

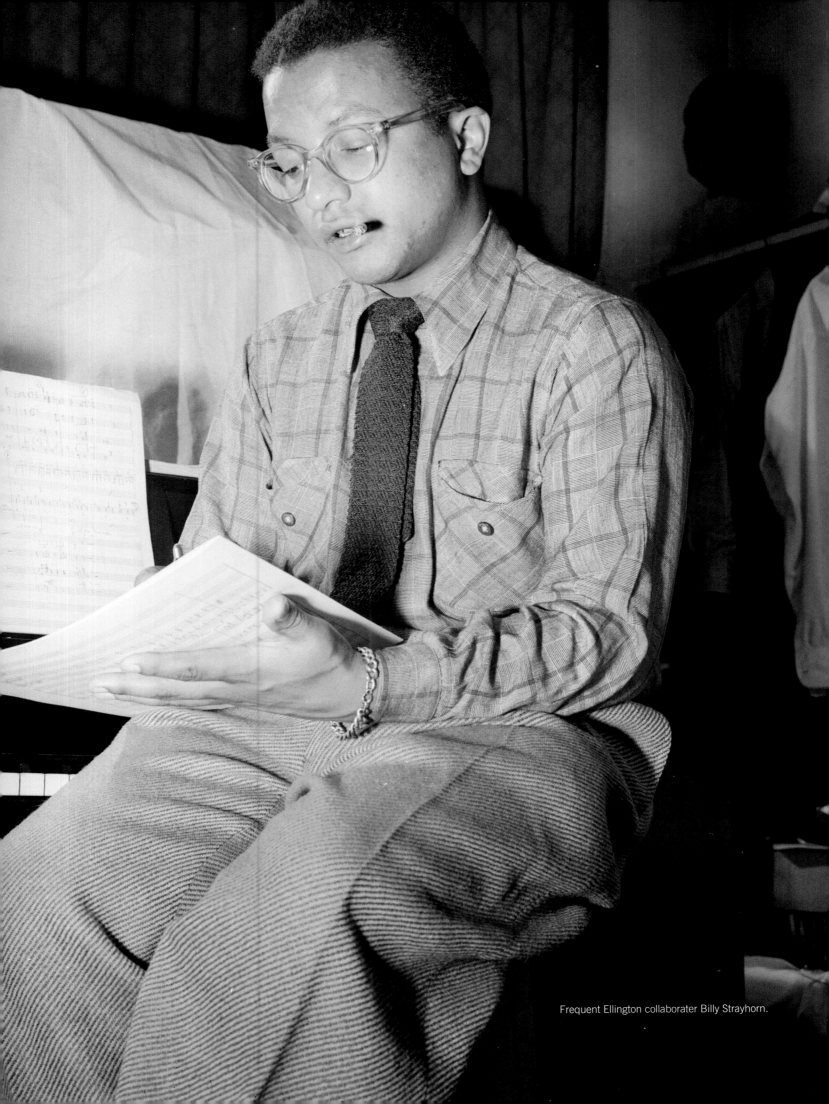

Frequent Ellington collaborater Billy Strayhorn.

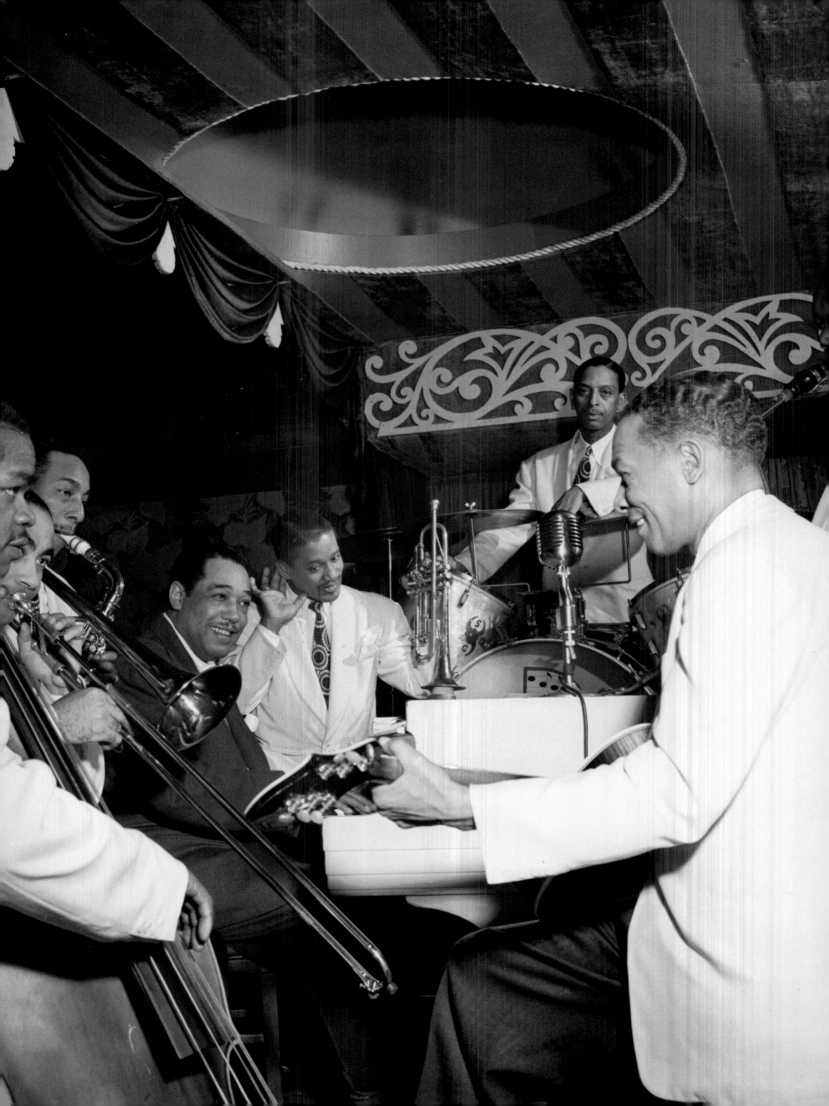

I didn't read very well way back there and I only knew four numbers when I got my first gig and I played them from eight to one o'clock in all different tempos on the worst piano imaginable... They used to have a piano player there and he'd get tired and sleepy and fall off his piano stool. They had to have a piano player so I'd go in as a relief man. ~ Duke Ellington

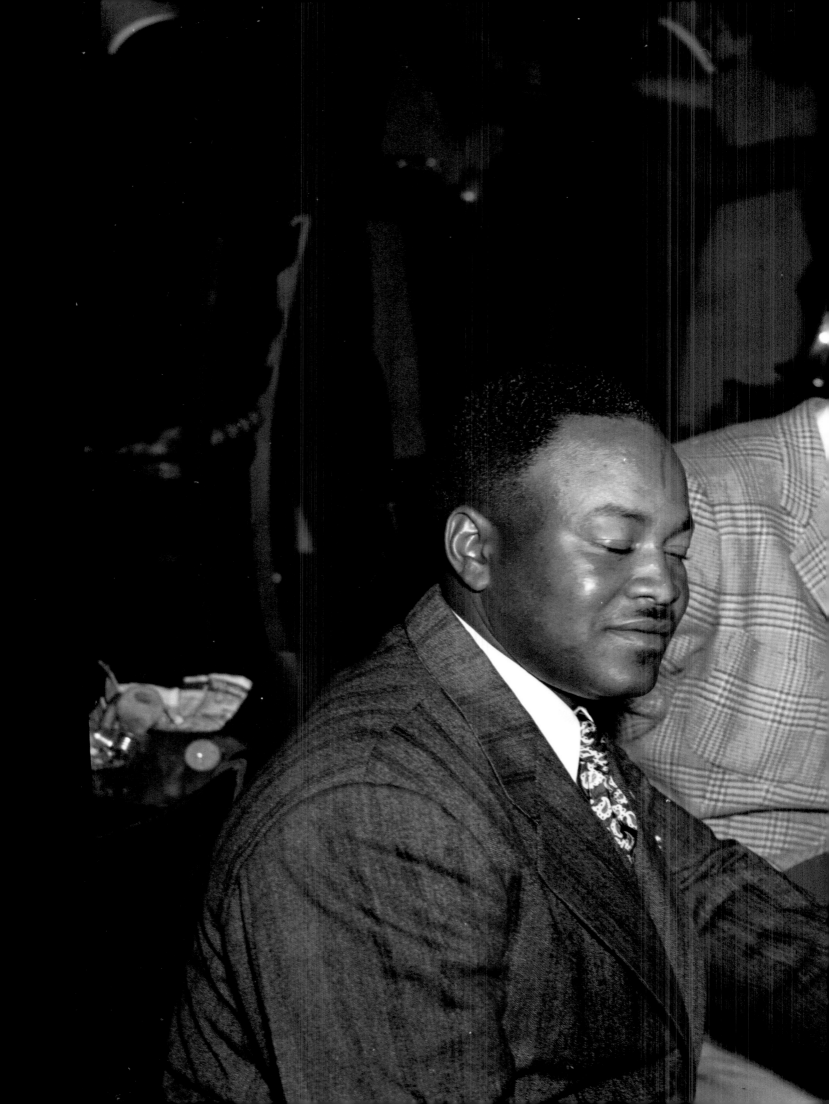

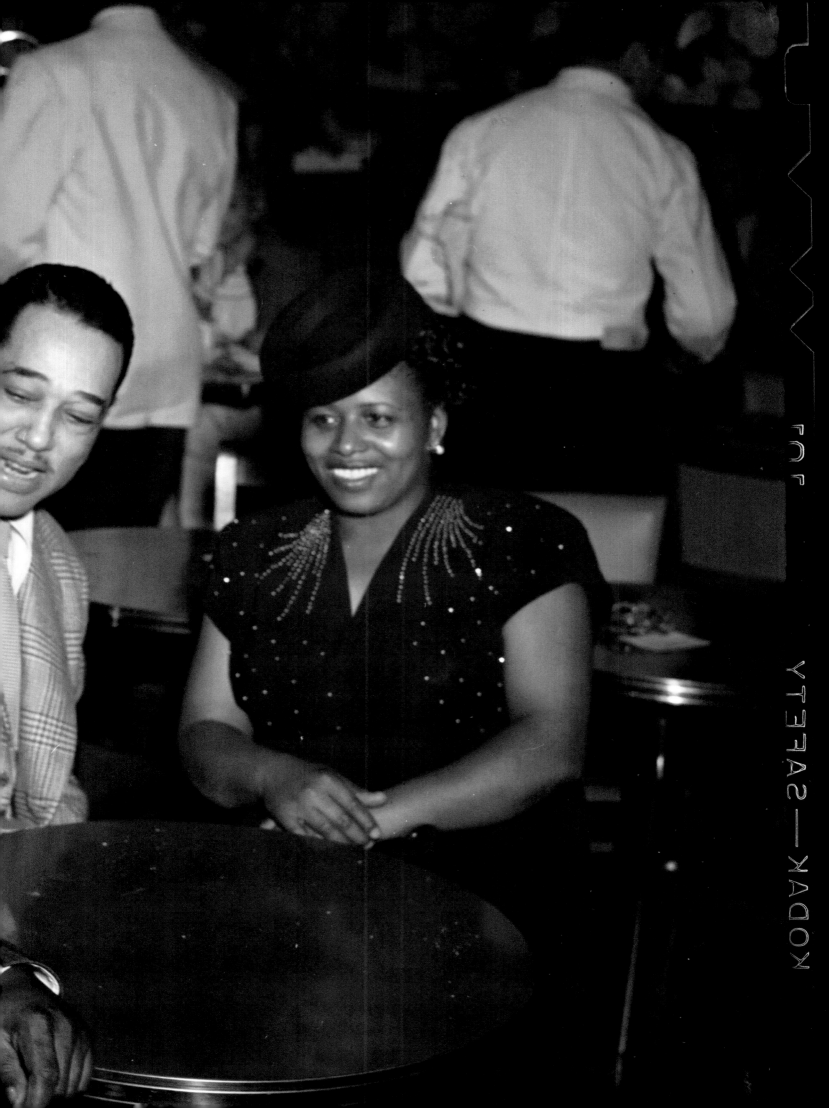

DUKE ELLINGTON, INC. 1619 BROADWAY N. Y. 19, N. Y.

June 28, 1955

Mr. and Mrs. Lorillard, George Wein, Charles

Bourgeoise, Marshall Stearn, ladies and gentlemen,

my friends of the Newport Jazz Festival and the

Institute of Jazz Studies, greetings.

Due to a commitment made some time ago, I

will have to forego the pleasure of being with

you.

Of course the purpose of this occasion is so

important that I cannot think of anything good enough

to say so I send you a word from the President of the

United States.

Love You Madly,

THE WHITE HOUSE

WASHINGTON

March 12, 1955.

Dear Mr. Ellington:

Once again I want to tell you how much I enjoyed your contribution to the entertainment at the dinner given by the White House Correspondents last Saturday night.

Thank you very much for your thoughtfulness in handing me an invitation in what I note is the form of "Ticket Number One" to attend the Second Annual Newport Jazz Festival, to be held this year from July 15th to 17th. I read with a great deal of interest the reports on the occasion last year, and I would truly like to be able to attend -- but a look at my schedule tells me it is practically impossible. Nonetheless I am most appreciative of your kindness, and I hope the Festival will be a tremendous success.

With warm regard,

Sincerely,

Dwight D. Eisenhower

Mr. Duke Ellington
935 St. Nicholas Avenue
New York, New York

SOUVENIR PROGRAM
OF THE
KENTUCKY STATE COLLEGE ALUMNI ASSOCIATION
(CHICAGO CHAPTER)
IN THE 14th ANNUAL SCHOLARSHIP DANCE
PRESENTS

DUKE

AND HIS

Famous

ORCHESTRA

Coming! **HARLEM'S** *Aristocrat* **OF JAZZ!**

ELLINGTON

IN HIS

Only

1940 SOUTHSIDE

APPEARANCE

"The Duke"

IN THE BEAUTIFUL

Parkway Ballroom
South Parkway at 45th Street

MONDAY EVENING, OCT. 28, 1940
CHICAGO, ILLINOIS

WESTERN UNION
TELEGRAM
W. P. MARSHALL, PRESIDENT

1220 (R 11-54)

NN115 RX LONG PD AR=NEW YORK NY 26 NFT= 1958 SEP 26 (03)..
=MR AND MRS MARSHALL W STEARNS= PM 4 04
 :DLR DONT PHONE 108 WAVERLY PL=

=YOU ARE CORDIALLY INVITED TO ATTEND OUR BON VOYAGE
CHAMPAGNE PARTY TO BE GIVEN IN THE CAFE DE PARIS ROOM ON
THE PROMENADE DECK OF THE ILE DE FRANCE PIER 88 NORTH
RIVER SATURDAY SEPTEMBER 27TH AT 945 AM SHARP THIS LITTLE
GET-TOGETHER MARKS THE BEGINNING OF OUR FIRST EUROPEAN
TRIP IN NEARLY A DECADE KNOWING THAT YOU WILL BE WITH US
WILL MAKE US LOVE YOU MORE MADLY TIME OF DEPARTURE
SCHEDULED FOR 1130 AM=
 :DUKE ELLINGTON=

SATIN DOLL

By JOHNNY MERCER, DUKE ELLINGTON, BILLY STRAYHORN

TEMPO MUSIC, INC.

10097

PRICE $1.00 IN U.S.A.

DUKE ELLINGTON
JAZZ FESTIVAL

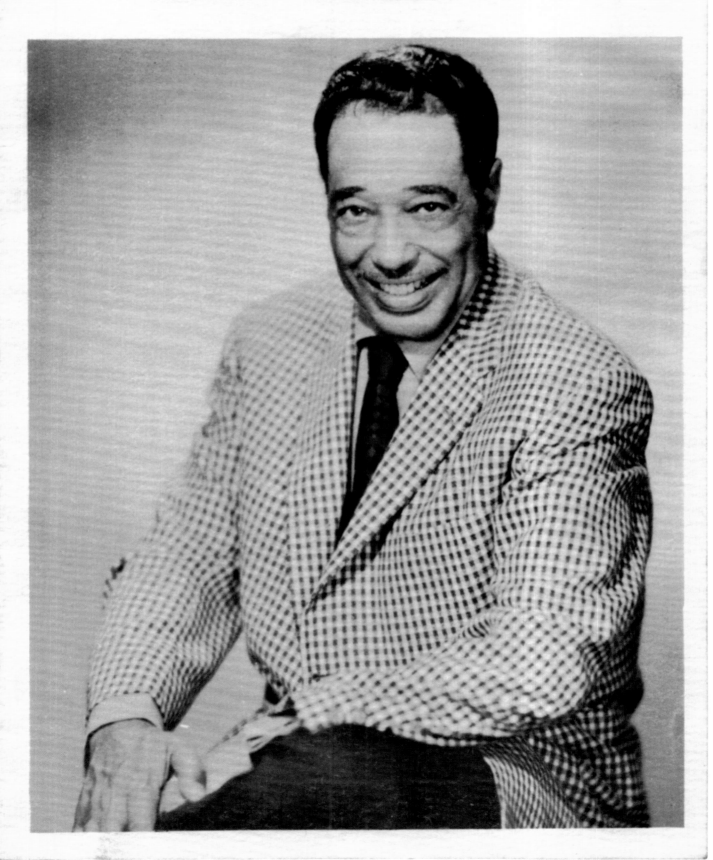

DUKE ELLINGTON

IN

2 SEPARATE RETROSPECTIVE SHIRT-SLEEVE

JAZZ CONCERTS

$1.50

$1.00 $2.00

$2.50

JULY 23 and 24
8:30 p.m.
PORTLAND CIVIC
AUDITORIUM

FOR RESERVATIONS

J. K. GILL CO.,
408 S. W. 5TH AVENUE,
PORTLAND 4, OREGON

MAIL ORDERS—SEND CHECKS (MADE
PAYABLE TO GENERAL EXTENSION
DIVISION) TO J. K. GILL CO., ENCLOS-
ING STAMPED AND ADDRESSED RE-
TURN ENVELOPE.

Sponsored by:
Portland Summer Session
General Extension Division
JAZZ WORKSHOP
Oregon State System of Higher Education

ELLA FITZGERALD SINGS WITH DUKE ELLINGTON

SOUVENIR BROCHURE TWO SHILLINGS & SIXPENCE

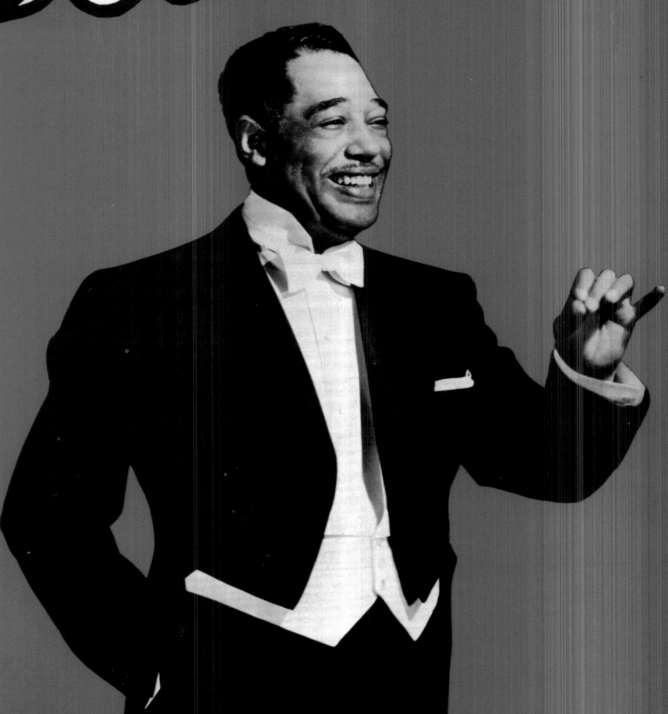

duke ellington festival

University of Wisconsin-Madison

Ailey Celebrates Ellington

Alvin Ailey City Center Dance Theater

New York State Theater

design by Bea Feitler

182

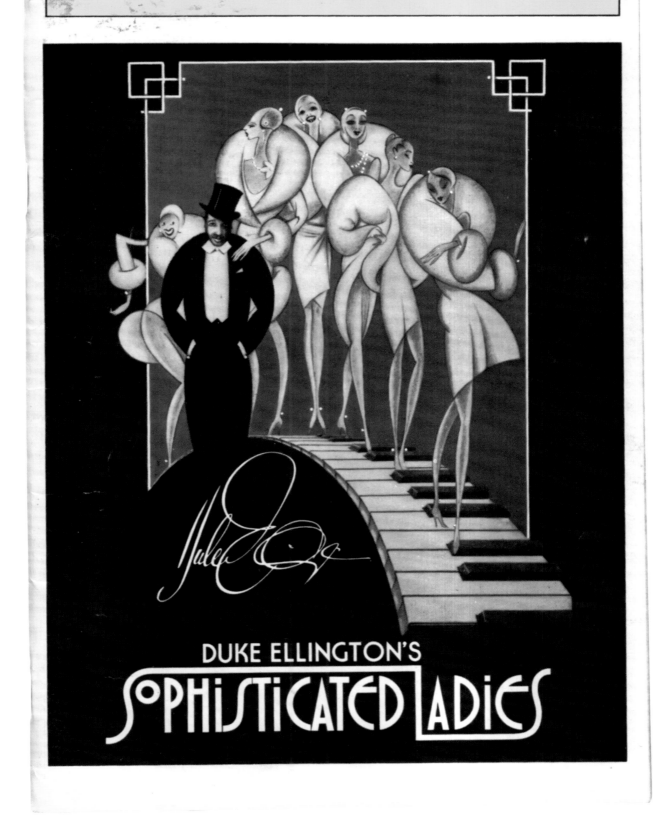

DUKE ELLINGTON'S
SOPHISTICATED LADIES

CARNEGIE HALL

THE SYMPHONY OF THE AIR
(Formerly the NBC Symphony)

"EXCURSIONS IN JAZZ"
featuring the music of
DUKE ELLINGTON and DON GILLIS
Conducted by the Composers

1944

ELLINGTONIA
VOLUME TWO

A Collection of Distinctive
Recordings Played by

DUKE ELLINGTON
and His Famous Orchestra

Creole Rhapsody (2 Parts) · · Awful Sad
Tiger Rag (2 Parts) · · Jazz Convulsions
Yellow Dog Blues · · · Tishomingo Blues

BRUNSWICK COLLECTORS' SERIES
ALBUM No. B-1011

ELLINGTONIA
Volume 1
A Collection of Distinctive Recordings by

DUKE ELLINGTON
and His Famous Orchestra

BRUNSWICK COLLECTORS' SERIES
ALBUM No. B-1000
COMPLETE ON FOUR TEN-INCH RECORDS

CONTENTS:

80000	EAST ST. LOUIS TOODLE-OO	Ellington-Miley
	BIRMINGHAM BREAKDOWN	Ellington
80001	ROCKIN' IN RHYTHM	Ellington-Carney-Mills
	TWELFTH STREET RAG	Bowman-Sumner
80002	BLACK AND TAN FANTASY	Ellington-Miley
	THE MOOCHE	Ellington-Mills
80003	MOOD INDIGO	Ellington-Mills-Bigard
	WALL STREET WAIL	Ellington

Notes
By Dave E. Dexter, Jr.

Possibly the most genuinely talented individual personality in the entire jazz realm, Edward Kennedy Ellington is proud of his race, and proud of the music of his race. It's no secret among those who know him that this passionate and eager devotion to the music of the American Negro is the prime factor in Ellington's amazing but hard-earned climb to success.

The Duke lives for jazz music, and that alone. It is his life. And it is through the medium of phonograph records that Ellington's genius can best be appreciated.

The selections by Ellington and his world-famous orchestra which appear in this collection are all from an earlier period — a period in the late 1920's and early 1930's when the Ellington organization had first emerged from the run-of-the-mill class of Harlem jazz bands and stepped out in polite society as the best of the dance band groups. Best because of its leader, its side men, its arrangements, its spirit and its sincerity in playing only a superior brand of jazz music.

The Duke was talented even as a child in Washington, D. C., where he was born on April 29th, 1899 .But instead of concentrating on music Ellington studied painting and drawing, later starting piano lessons when it became

Album cover design and typography by Huxley House, New York City

Copyright, 1943, Brunswick Radio Corporation

FAREWELL LONDON CONCERT

DUKE ELLINGTON

AND HIS FAMOUS ORCHESTRA

TROCADERO CINEMA
ELEPHANT AND CASTLE

Sunday, July 16th, 1933

PRICE

1/-

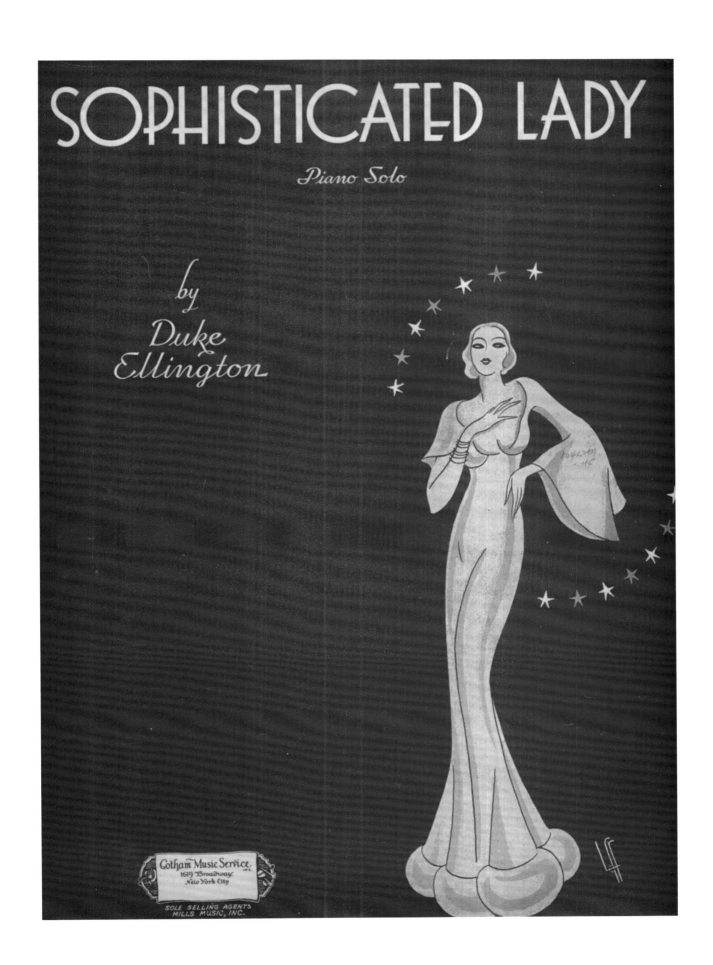

Metronome

Illington, Duke

DUKE and YA

PLAYBILL®

BROOKS ATKINSON THEATRE

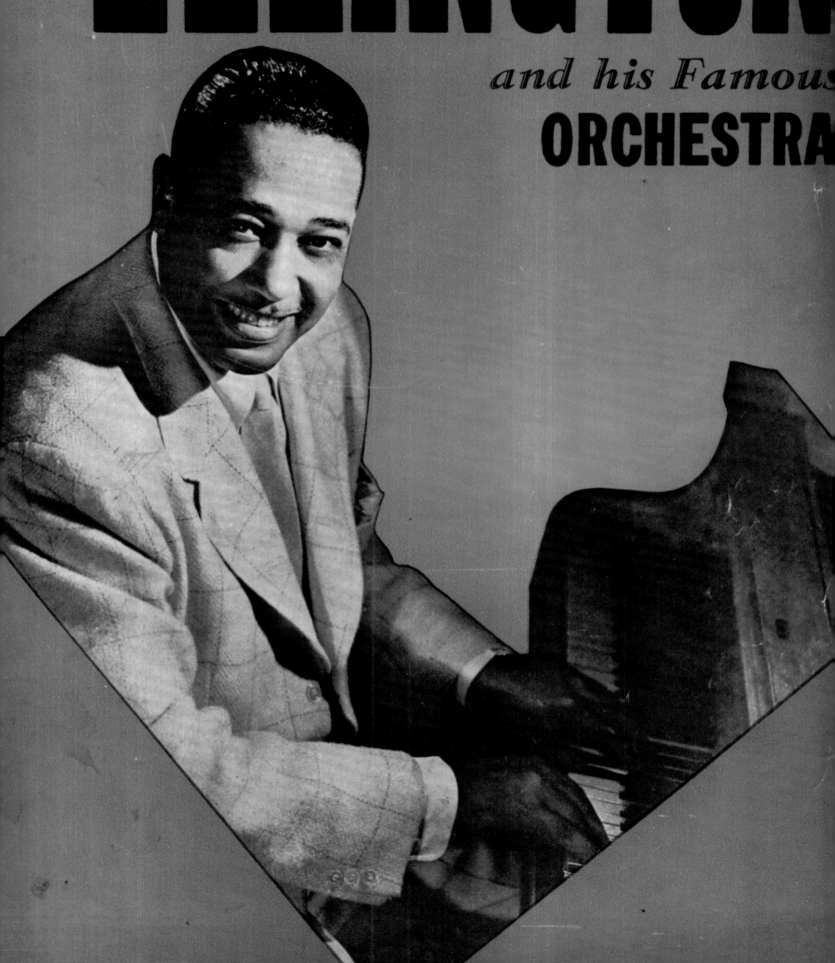

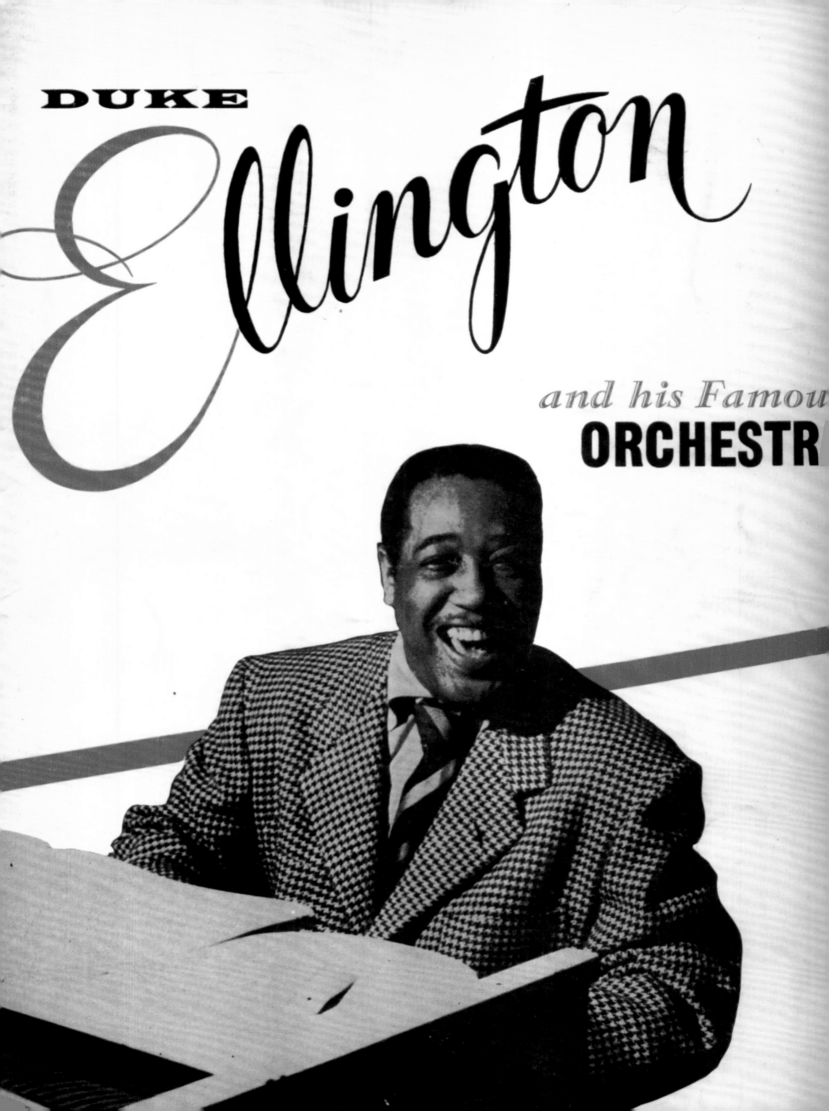

Duke ELLINGTON

Hansen

and his Famous ORCHESTRA

METROPOLITAN OPERA HOUSE CONCERT PROGRAM

OPERA HOUSE
ONE AFTERNOON and EVENING ONLY
Sunday, November 18
3:30 - 8:30 P. M.
Good seats now at Box office or by mail order

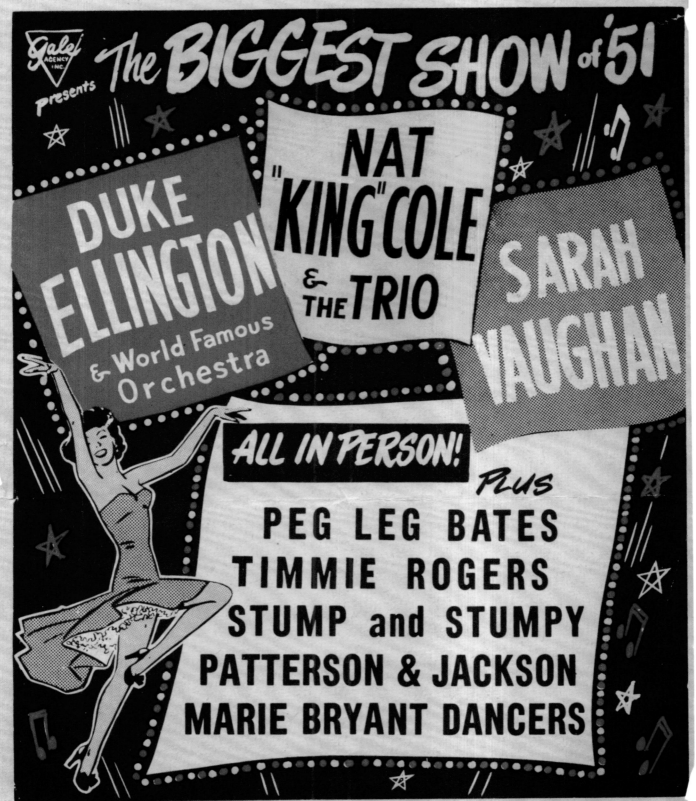

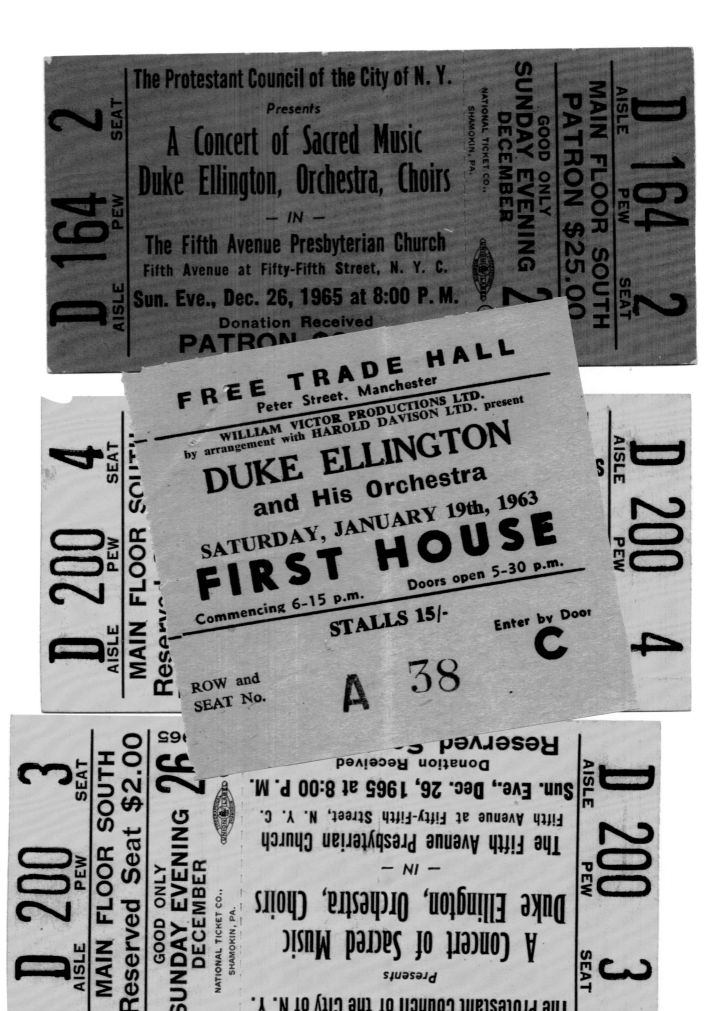

DUKE

DUKE ELLINGTON'S
ALL-TIME
DREAM BAND

NOVEMBER

50¢

A CATALOGUE OF MUSIC BY

DUKE ELLINGTON
BILLY STRAYHORN

MERCER ELLINGTON
JOHNNY HODGES
RANDY WESTON
JUAN TIZOL

CAT ANDERSON • JOE BENJAMIN
AARON BELL • LOUIS BELLSON
LAWRENCE BROWN • HARRY CARNEY
MATTHEW GEE • PAUL GONSALVES
JIMMY HAMILTON • LUTHER HENDERSON
CALVIN JACKSON • FREDDIE JENKINS
OSCAR PETTIFORD • PAULINE REDDON
REX STEWART • TOM WHALEY
MARY LOU WILLIAMS

CARNEGIE HALL

DUKE ELLINGTON

73 - 11 - 24E- 46 ALFRED SCOTT ● PUBLISHER ● 156 FIFTH AVENUE, NEW YORK

Duke
ELLINGTON
and his Famous ORCHESTRA

P1725-9

1/20/46

presents

America's Genius of Jazz

DUKE ELLINGTON

and His Victor Recording Orchestra

IN CONCERT

Afternoon and Evening Sunday, January 20th, 1946

OPERA HOUSE

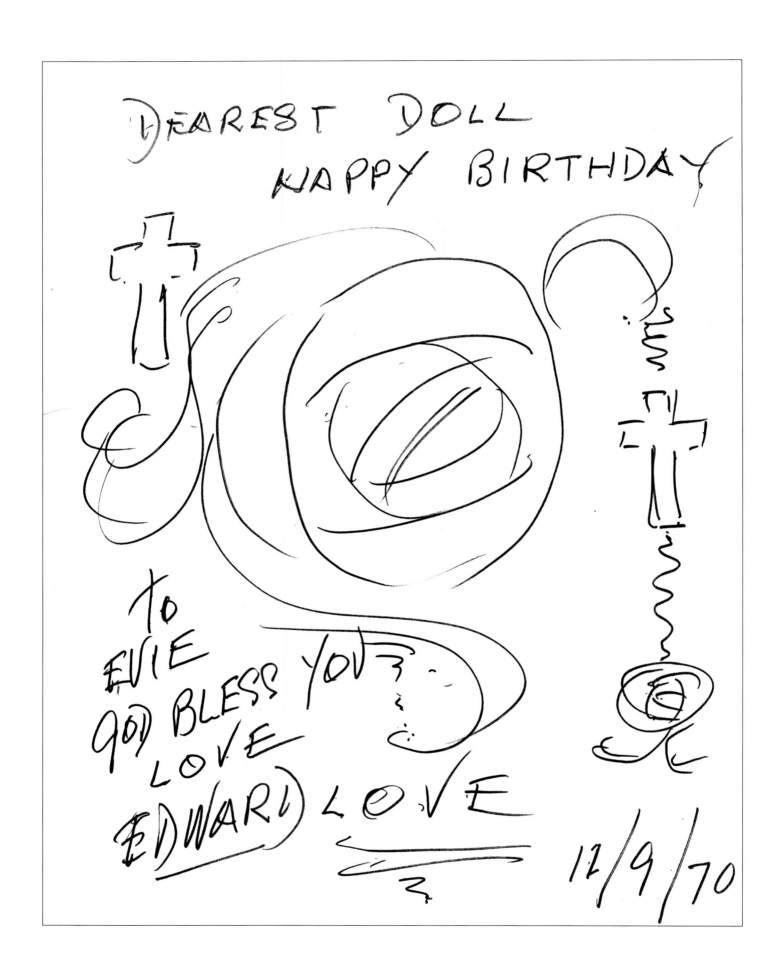

Ellington's hand-drawn birthday card. RIGHT: Introduction at the White House.

MR PRESIDENT AND MRS NIXON,
MR VICE PRESIDENT AND MRS AGNEW
DISTINGUISHED MEMBERS OF
THE ~~THE~~ ADMINISTRATION, JUDICIARY
AND GOVERNMENT OF OUR GREAT
COUNTRY —— AND - MY DEAR
AND PERSONAL FRIENDS WHO HAVE
COME ∧FROM PLACES NEAR AND FAR TO
SHARE THIS HAPPY AND MEMORABLE
EVENING —— THANK YOU.

I AM NOT SURE OF THE PROPRIETY
OF MY PROTOCOL - BUT THEN AGAIN
I DO NOT KNOW OF ANYTHING
IN PROTOCOL WHICH REQUIRES OR
EXPECTS THE KINDNESS AND GENEROSITY
OF THIS OCCASION - OR EVEN THE
OCCASION AT ALL.

THE RACE FOR SPACE

BY DUKE ELLINGTON

As a musician, jazz, that is, there would rightly be some question as
to what Duke Ellington is doing in a serious discussion on the race
for space. As the most adequate answer I can think of, I'm talking about
the race for space for the logical reason that what happens in the
race for the moon and other planets and the control of space affects me
as well as every other American and like you and others reading this, I
most certainly don't want Russian "moons" and other space projectiles
circling around over my head.

And being what might be called a musical opportunist, I'm way ahead of
a lot of my contemporary composers because my newest jazz opus, "Dance
of the Flying Saucers," is now in its polishing up stage. And I'm reason-
ably sure I'll be able to premiere it long before the United States gets
around to putting its first satellite into a space orbit. That, more or
less, is a summation of why I'm concerned in this controversy over the
control of space.

Sounds presumptious. Well, sort of. But that is how it is, for in my
medium, jazz, the viewpoint is also competitive and primarily creative
as well as unbelievably liberal. Which, I suppose, the scientists working
on space vehicles and the like may very well envy, seeing that on my side
of the fence we musicians are seldom hampered by congressional committees
checking on what we're having for dinner, or whether we played for a mixed
dance in Mississippi or not the other night.

Which adds up that the field of jazz has not yet become an arena of the
sort of racial conflicts based on color, national origin and the like that
I sincerely believe along with many other Negroes is pinning the United
States to the earth. Meanwhile, the Russians show their contempt for out
inability to straighten out our race problems and keep apce of them, by even
sending a dog into space!

For as I see it, and mind you my view is strictly that of a musician, a
citizen of the United States and a descendant of a family of this country's
earliest and most loyal settlers—we Negroes— the dreary bickerings over
the morals, ancestry, beliefs, thinkings and affil̶i̶a̶t̶i̶

Ellington's hand-annotated typescript, an essay on the race for space.

208

But this same regimentation has brought about its/~~maximu~~ results perhaps
because it doesn't permit race prejudice as we know it ~~inside Russia~~ to
interfere with scientific progress.For, as in music, harmony —harmony
of thought, must have prevailed in order for the ~~Red~~ scientists to make
a moon that would work. To attain harmony, the notes are blended in such
a fashion that there is no room for discord.

In America ~~we simply~~ don't have this all essential harmony. We don't have
~~it in politics, we don't have it in our~~ social life nor in the ~~frmm~~ daily
business of living. In religion where it should be a shining example, we
have Catholics against Protestants and Catholics and Protestants against
Jews and all of them against the Negro. In politics Democrats hate Republicans,
and Dixiecrats hate both.

Because so many Americans persist in the notion of the master race, ~~thus~~
millions of Negroes are deprived of proper schooling, denied the right to
vote on who will spend their tax money and are the last hired and first
fired in those industries necessary for the progress of the country.

When you stop and think of the way southern congressmen and senators tie
up Congress with filibusters and delaying tactics against the passage of
civil rights measures to protect minorities from persecution, when you
think of the lost time and effort President Eisenhower spent trying to
settle the Little Rock situation; in fact the time being lost all over the
South as well as places in the North over the school desegregation issue
ordered by the Supreme Court in 1954, you'll get an idea of how and why the
Russians may behaving breakfast on the moon by the time you read this.

It seems to me that in order to solve the problem of America's inability
so far to go ahead of or at least keep abreast of Russia in the race for
space can be traced directly to this racial problem which has been given
top priority not only throughout the country but by Washington, itself.
They're spending so much time trying to figure whether the potential Negro
vote is worth making the South mad by opening white schools to Negro kids,
by dropping the color bar in restaurants, railroad and bus stations, in
white collar jobs and in political appointments that those in charge of
the missle and nuclear programs don't know which way to go.

Especially when they are at the same time being insulted, policed and spied
upon by congressional committees, the FBI, the American Legion, the White
Citizens Councils and everybody else who know as much about advanced science
as I know about parsing a Russian noun!

Put it this way. Jazz is a good barometer of freedom. When/jazz is not accepted
and pseudo jazz with political and dogmatic coatings take over, you can look
for freedom of expression to step out of the picture. In its beginnings the
USA spawned certain ideals of freedom and independence through which, eventually
jazz was evolved and the music is so free that many people say it is the only
unhampered, unhindered expression of complete freedom yet produced in this
country. But if I were told to play my music in only the keys of F-sharp ~~xxx~~

CONCERT BY DUKE ELLINGTON

8:45 P. M.

ANNOTATIONS TO YOUR DINNER

1. CONCERTO FOR COOTIE ELLINGTON
 (Written especially for and played for
 Cootie Williams)

2. RACHMANINOFF PRELUDE in C sharp Minor
 (Full Band conception) RACHMANINOFF

3. SOPHISTICATED LADY ELLINGTON
 (Solos by Otto Hardwick, Duke Ellington,
 Lawrence Brown)

4. MARIE BRYANT
 (Harlem charactors in dance)

```
WU735(RI/68)

LLE190  (15) SYA304
SY LTA265 EB PDF TLT CORONA NY 29 250P EST
DUKE ELLINGTON, CARE SOCIAL SECTARY
     WHITE HOUSE WASHDC

HAPPY BIRTHDAY DUKE AND MANY MANY MORE .

YOU ARE THE GREATEST AND DESERVE IT ALL REGARDS.

     LOUIS "SATCHMO" ARMSTRONG AND LUCILLE.
```

211

ROCK CITY by DUKE ELLINGTON

ROCK..CITY...ROCK.......

ROCK................CITY ROCK

GOING TO ROCK CITY,

AND DO THE PRETTY, GIDDY, ROCK.

(2)
GOING TO ROCK, CITY ,

ON THE MOUNTAIN HIGH,

WHERE YOU SEE SEVEN STATES,

AND A LOT OF SKY

GOING TO TAKE OFF MY SHOES,

AND DANCE IN MY SOCKS,

AND DO THE (ad lib) TILL THE MOUNTAIN ROCKS,

ROCK,..................CITY, ROCK
(3)
ONE SHOULDER UP,

AND ONE SHOULDER DOWN,

YOUR HEAD UP HIGH,

AND YOUR EYE ON THE GROUND

AND DO THE ROCK.........CITY ROCK.
(4)
ACT LIKE YOU'RE LEAVING,

GETTING READY TO PACK,

TAKE TWO STEPS FORWARD,

AND FOUR STEPS BACK,

AND ROCK.............CITY, ROCK.

Duke Ellington lyrics.

213

Ellington's musical notation.

In Honor of
Edward Kennedy (Duke) Ellington

THE WHITE HOUSE
April 29, 1969

All music performed on this evening's
program composed by Duke Ellington.

Louis Bellson	*Drums*
Bill Berry	*Trumpet*
Dave Brubeck	*Piano*
Paul Desmond	*Alto Saxophone*
Urbie Green	*Trombone*
Jim Hall	*Guitar*
Earl (Fatha) Hines	*Piano*
Milt Hinton	*Bass*
J. J. Johnson	*Trombone*
Hank Jones	*Piano*
Mary Mayo	*Vocalist*
Gerry Mulligan	*Baritone Saxophone*
Billy Taylor	*Piano*
Clark Terry	*Trumpet*
Joe Williams	*Vocalist*

| Willis Conover | *Musical Coordinator and Master of Ceremonies* |

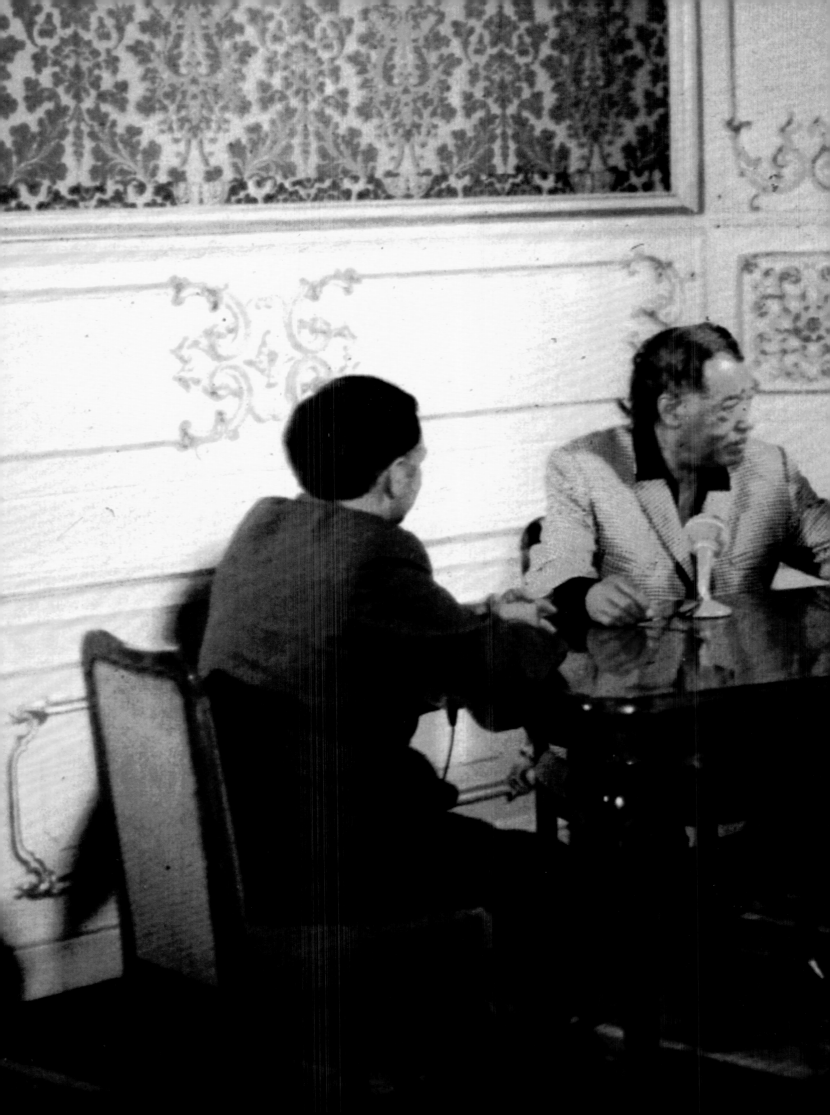

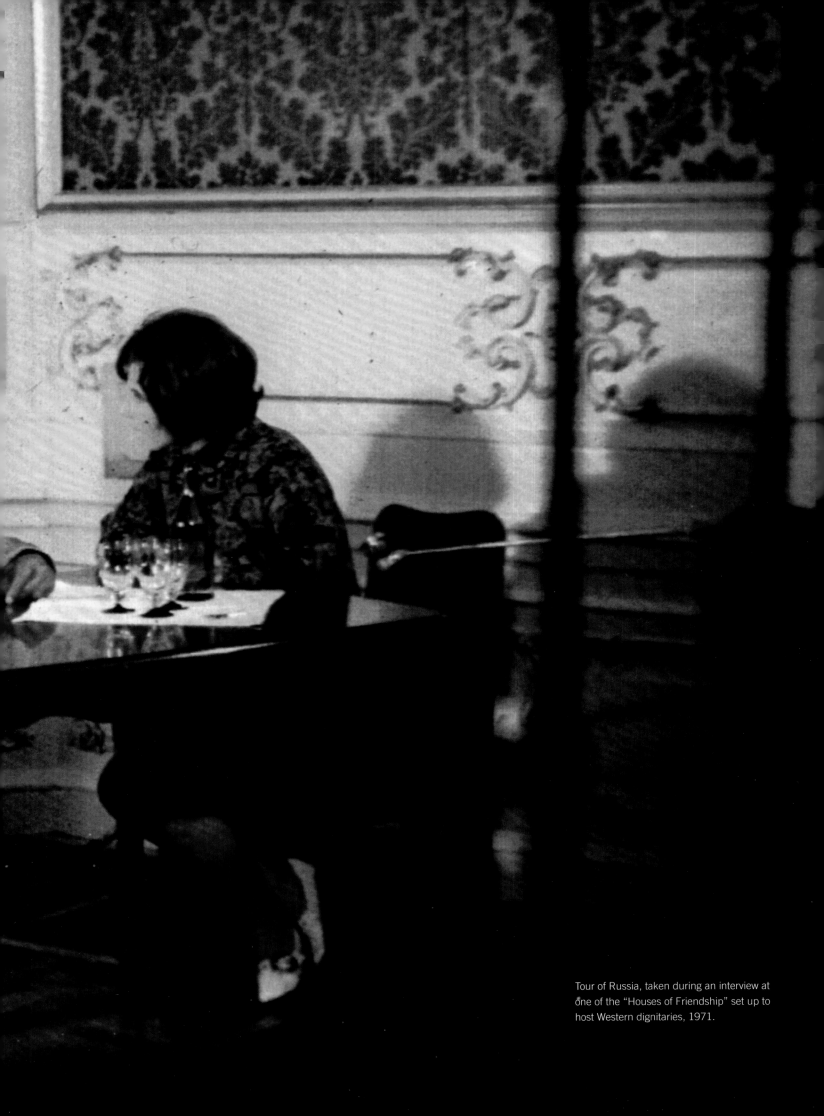

Tour of Russia, taken during an interview at one of the "Houses of Friendship" set up to host Western dignitaries, 1971.

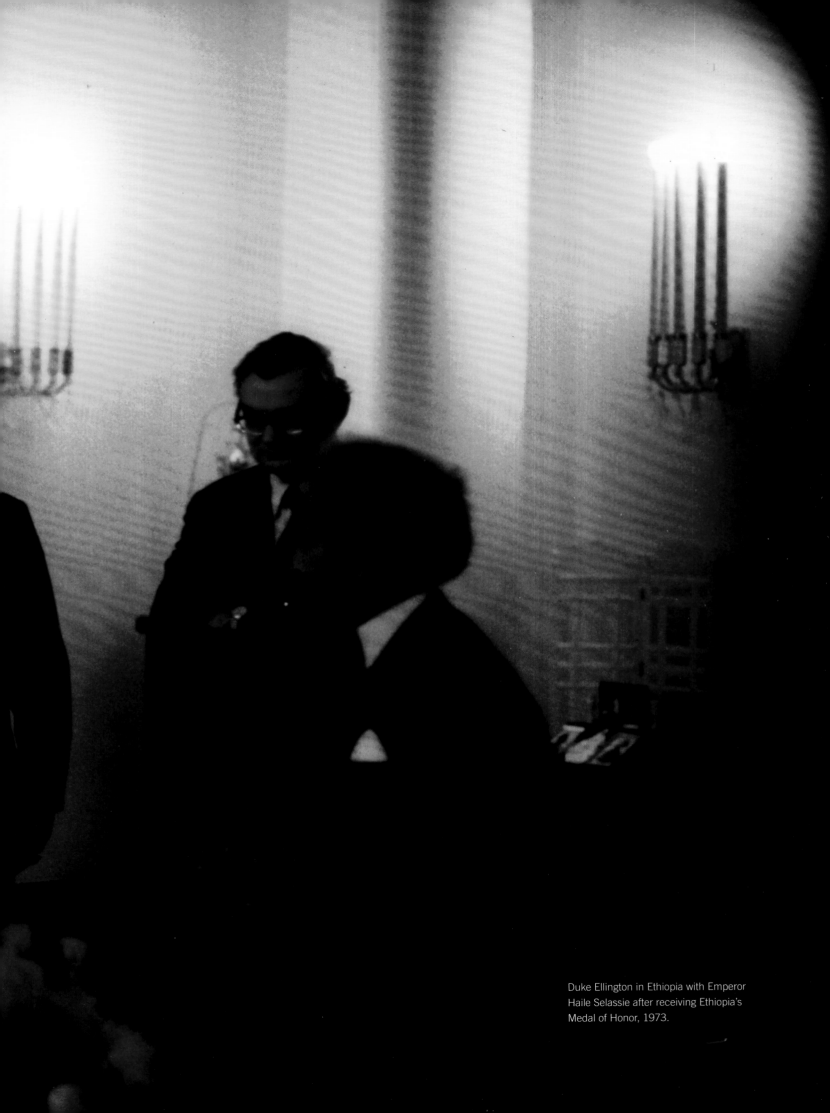

Duke Ellington in Ethiopia with Emperor
Haile Selassie after receiving Ethiopia's
Medal of Honor, 1973.

TRIBUTES

"The wit, taste, intelligence and elegance that Duke Ellington brought to his music have made him, in the eyes if millions of people both here and abroad, America's foremost composer. His memory will live for generations to come in the music with which he enriched his nation."
—*President Richard Nixon*

"It's a very sad day. A genius has passed."—*Ella Fitzgerald*

"The Duke was not only a remarkable composer and performer, but was in himself a significant chapter in the history of American music, I mourn his loss both as a musician and as a friend."
—*Leonard Bernstein*

**"When someone like Duke Ellington dies, we haven't lost him. Every time I sing one if his songs, I realize how lucky I am and how lucky we all are to have his exquisite talent to draw joy and sustenance from."
—*Dinah Shore***

"He was one of the few men who may have died and been at peace with himself because of his astounding accomplishments musically and also as a humane human being."
—*Max Roach*

"The genius of Duke Ellington, along with his insistence of respecting a musician 'by paying them' stays with us as a great model of integrity within the music world. Duke Ellington's influence on traditional and modern music, his constant relevancy in extracting music

from the sounds, relationships, and rhythms of life, have touched, influenced, and inspired my life as an artist forever!"—*Antoinette Montague, Jazz and Blues Vocalist*

"In every way, Ellington's achievement is one of pure American genius. He created an environment in which each musician in his band was encouraged to reach the limits of their individuality while at the same time retaining their responsibilities to the overall good—the ensemble. Ellington made them model citizens, and his music reflects these values, taking the American experience and turning it into song." —*Loren Schoenberg, Musician, Historian, Educator, Artistic Director of The National Jazz Museum in Harlem*

"**Ellington's mark on American music and culture will last into perpetuity. He is a role model for young males and an example of tenacity, talent, genius, ingenuity, and courage.**" *—Jackie Harris, Executive Director, Producer, Louis Armstrong Summer Jazz Camp; Executive Director Louis Armstrong Educational Foundation*

"The music of Duke Ellington represents the mark of a new era in not only the history of jazz but the history of American Music. As bandleader of PitchBlak Brass Band, I am constantly learning and adapting my approach to our music and how to compose for the ensemble. When you listen to Duke Ellington, you start to see how amazing he was at composing and arranging for his musicians. That is a skill that Duke truly mastered." *—Chanell Crichlow, Tuba Player, Arranger-Composer, Founder of PitchBlak Brass Band*

"With music that is at the same time silky smooth and pungent, the suave originality of Duke Ellington is always an inspiration to me as a composer. And as a player, his rhythm and sonic variety on the piano are the roots of so much Monk and deliciousness, it takes my breath away."—*Jessica Jones, Jazz Musician, Composer, Educator*

"As a musician, performing Ellington's music always gives me a sense of what it means to be part of this wonderful American art form called jazz. And, as a composer, Ellington's musical legacy is an enormous influence on the way I explore writing music for jazz orchestra."
—*Deborah Weisz , Jazz Trombonist, Composer and Educator*

"Duke Ellington's music to me is pure jazz inspiration, groove, colors, mystery, storytelling, and magic."—*LaFrae Sci, Drummer, Composer; Founding Faculty: Willie Mae Rock Camp for Girls; Faculty, Middle School Jazz Academy: Jazz at Lincoln Center*

"Duke astounds me every time I hear him. I think, why do I ever listen to anything else? So much beauty. He is the supreme sonic story teller, loving and listening closely to the people around him, never giving up, seeing the opportunity in each obstacle, embracing the blues in every mood. Duke leaves me in awe, but better still, makes me feel invited to share his world to participate, collaborate and strive for his high standard, beyond category, classic and completely modern at once."—*Eli Yamin, Pianist, Composer, Educator, Artistic Director of The Jazz Drama Program, Head of Instruction at Jazz at Lincoln Center's Middle School Jazz Academy Center for the Arts*

Duke Ellington's genius is undisputed.

Over the course of his life he wrote approximately three thousand pieces of music in all genres. His accomplishments match and even exceed those of the history's greatest composers. He won citations, awards and honors too numerous to mention—on an almost yearly basis. His fame was international. He was greatly loved—a phenomenon, a star, an icon.

Duke Ellington—composer, arranger, orchestrator, pianist, bandleader, artist, poet, writer, leader, and Renaissance Man—cut a wide swath across the history and culture of America.

His legacy is written for the ages.

—Marilyn Lester, Executive Director, The Duke Ellington Center for the Arts

Mercedes Ellington is Duke Ellington's granddaughter and a composer of dances and theatrical situations. She made history as the first and only person of color in the June Taylor Dancers on *The Jackie Gleason Show*. She has performed in many Broadway productions, including *No, No, Nanette* and *Sophisticated Ladies*, and programs at the Alvin Ailey American Dance Center. She is the founder of the Duke Ellington Center for the Arts.

www.thedukeellingtoncenter.org

Acknowledgments

Steven Brower

First and foremost I would like to thank to my late friend Phoebe Jacobs, whose idea this book was. Mercedes and Kent for their incredible generosity and encouragement. Marilyn Lester for all her help and support. To all those who took the time to write an essay: Tony Bennett, Dave and Iris Brubeck, Quincy Jones, Dr. Cornel West, Jonathan Batiste, David O. Moore, Dan Morgenstern, Robin Bell-Stevens, and those who provided additional quotes. To others who helped towards that end: Sylvia Werner, Shaun Lee, Garrett Caples, Aine Rose Campbell. And the illustrators and artists who generously provided their work: Milton Glaser, Nancy Stahl, Joe Ciardiello, Mark Ulrikson, Harry Pinus, John Kascht. At the Smithsonian, Kay Peterson. And at Rizzoli, a big thank you to Charles Miers for his continued good cheer and willingness to publish beautiful books, Leah Whisler for seeing this through, Jacob Lehman for his encouragement and guidance, and Pam Sommers for getting the word out. My Agent Sandy Choron for making this happen. And thanks again and love to my wife Kati and my daughter Janna, who I thank once again fro her production help.

Mercedes Ellington

For my four mothers: my grandmother, who raised me; my mother, who birthed me; June Taylor, who gave me standards; and Phoebe Jacobs, who taught me about my family.

First published in the United States of America in 2016 by Rizzoli International Publications, Inc.
300 Park Avenue South
New York, NY 10010
www.rizzoliusa.com

Edited by Steven Brower with Mercedes Ellington

Designed by Steven Brower
All original linocuts and letterpress work by Steven Brower

All artwork courtesy the Ellington estate with the exception of the following: p 8/9, 10 copyright Tony Bennett; p 54 copyright Milton Glaser; p 57 copyright Mark Ulriksen; p 61,75 copyright Harry Pincus; p 65 copyright Joe Ciardiello; p 69 copyright Nancy Stahl; p 84, 88, 93, 97, 102, 157 copyright Steven Brower; p 139 copyright John Kascht.

ISBN: 978-0-8478-4813-3

Library of Congress Catalog Control Number: 2015948384

2016 2017 2018 2019 / 10 9 8 7 6 5 4 3 2 1

Printed in China

DUKE ELL

AN AM
COM
ICO